To Grandpa Tom

(2015)

Merry Christmas, love Pat, Lyse, Alix & David

KENTUCKY

WIDE II

JEFF ROGERS PANORAMICS

RatDog Publishing
Lexington, Kentucky

© Jeff Rogers, 2009

Photography by Jeff Rogers
Design and production: Sumo Design
Introduction: Patti Edmon
Forward: Matthew Sleeth, M.D.
Photo editing: Jeff Hancock
Transparency scans: National Geographic Imaging
Color Correction: Richard Sisk
Transparency film processing: Impact Photo
Printing: Moonlight Press
Help mate and encourager: Missy Rogers

Kentucky Wide II is available in a special quantity discount when published in bulk by corporations,
organizations and special interest groups. Custom imprinting or excerpting can also be done to fit
special needs. For more information, please email jeff@jeffrogers.com or call 859.255.9917.

Library of Congress Control Number: 2009905445
ISBN 978-0-9772400-1-2, hardbound edition

Printed in China

Jeff Rogers Photography, Inc. 859.255.9917 www.JeffRogers.com
P.O. Box 368 Lexington, Kentucky 40588-0368

KENTUCKY

WIDE II

JEFF ROGERS PANORAMICS

In memory of Mimi and Sally

This book was created without any commercial
endorsements, supplies or support.
Deo est Gloria!

A NOTE FROM THE PHOTOGRAPHER

There is a story behind most every image in this book and I can easily recall my thoughts and feelings as I created each scene. One example is the photograph I took after being invited on an outing by one of three brothers who had grown up hunting together. We spent an overcast, November day on a farm in Central Kentucky, which in most ways was not extraordinary. But one of the brothers had been diagnosed with Multiple Sclerosis and the damage had already become apparent. I felt privileged to be part of that trip, which turned out to be the last time all three were able to go together. While there isn't room or need to tell them all, there are two stories that I want to share in some detail. They represent two different seasons.

Sunrise at Owsley Fork Reservoir, Madison County

Long after the original "Kentucky Wide" had been released and sold out I was still shooting panoramics. Creating art has always been very therapeutic for me, even as a child. This image was created when my former wife, Sally, was undergoing chemotherapy for complications due to Stage IV colon cancer. One night we watched "The Painted Veil," a beautiful, haunting film and the scenery from the Lijiang River in China was breathtaking. I was motivated to get up early enough to shoot a sunrise outside of Berea at the Owsley Fork Reservoir, even though I had never been there. On the way, I was listening to a message on the radio about how God was faithful. Sometimes that does sound perfectly reasonable, but through the filters of suffering and terminal illness it is not a topic to be taken lightly. Before cancer I had always been quietly critical of those who cry out in anguish, "Why did God do this to me?" or more like my personal theology, "Why did God allow this to happen?" Even though I had struggled not to judge God, emotionally I could not stop myself. As I stood there watching the sun rise over the hill and cut through the fog, somehow, I knew in my spirit that God was faithful and that He was good. An incredible peace washed over me during those moments, as it did for both of us many, many times until Sally went to be with the Lord and afterward. That particular image will always allow me to identify with the 1873 hymn that says, "It is well with my soul."

Flat Lick Falls, Jackson County

Over 15 years ago, a friend invited me to her grandfather's property to photograph a waterfall. Upon our arrival, I was overwhelmed by the beauty and I captured a couple of images. In preparation for this book, I tried to find more information — not only how to find it again but how to actually gain access to the private property. After calling government agencies in Jackson County, I learned that the city had purchased the property and planned to create a public park. After getting permission to visit, and armed with very sketchy directions, I headed down there early one morning. I passed through the little town of Gray Hawk without seeing the road I was supposed to turn on to, so I pulled in to a little hardware store.

A guy named Carl said he would take me there, since it would give him a good reason for not working on his project at home. I gratefully followed him a few miles, ending up on a muddy, lightly graveled road. In the middle of nowhere. Did I mention it was raining? I had expected him to point the way, but he offered to be my guide! I gave him an umbrella and we headed out in the field toward some trees. As we walked and talked I explained to him about being there 15 years ago with a lady and her baby. "That lady" was actually his cousin and this property had been in their family for generations. As we got closer, the roar got louder; he said that because of recent rain and near flash flood conditions, no one had probably seen the waterfall so powerful and active. I had a particular image and perspective in mind but was unable to shoot it due to the high water and inability to maneuver around. Fortunately, there was a small clearing of trees so I was able to get this one shot.

During my extensive travels both in the USA and Europe, I've always encountered nice people. However, there is just something different and very refreshing about the folks you run into in Kentucky.

The boundary lines have fallen for me in pleasant places.
–Psalm 16:6

KENTUCKY WIDE II

by Patti Edmon

Kentucky Wide, published in 2006, was the result of a leap of faith. Jeff had taken nearly half of the panoramic images over a period of several years when he felt called to render his vision of a Kentucky in the form of a book. Unsure of anything other than his sense of responsibility to do the work, he continued traveling the back roads in search of locations that would depict a sense of place and lend themselves to panoramic photography.

When the final galleys were proofed and sent off to press, the campaign to publicize and promote *Kentucky Wide* began. The early enthusiasm and success of the book reinforced Jeff's belief that, while many beautiful photographs of Kentucky exist, there is a need for telling the story of Kentucky through this challenging yet remarkable format. The panoramic dimensions, similar to what the human eye can see, allow the viewer to enter and experience the scene in a unique way.

If he had expectations for *Kentucky Wide*, they would have been quickly surpassed. Jeff was pleasantly surprised by the variety of buyers and, aside from the obvious quality of the images; the many reasons people purchased the book. He heard from people who bought the book in hopes of luring relatives home from places as distant as Alaska and St Croix and copies were sent across the globe by Kentuckians proud of their home state. While on an art history trip to Paris, France with Asbury College students, they visited a popular bistro. There, he was introduced to a woman who had traveled to the United States to attend the Breeder's Cup race in 2007; she was delighted when she realized that he'd created the book she had received as a gift.

One might be tempted to think that the 75 images in *Kentucky Wide* say it all. But as Jeff continued to pursue panoramic photography after the book's release, it wasn't long before he realized he was planning for a second edition and began to shoot more intentionally. Still a fan of getting lost on the back roads, he also considered aspects of the state he hadn't included in *Kentucky Wide*. One of the most difficult challenges in putting together this edition was paring down the images from the nearly 300 to the 83 that appear on these pages.

The culture and terrain vary widely across Kentucky, from the pastoral horse farms to fields of soybeans, cattle and tobacco; the swinging bridge and historic covered bridge to the Purple People Bridge that connects Newport, in Northern Kentucky, to Cincinnati; the festivals and country stores and the Louisville skyline at night. The foothills of the Appalachian Mountains and the caves in contrast to the placid splendor of the Land between the Lakes.

Kentucky is known for its wineries as well as distilleries, for horse racing and the Three-Day Rolex Event, an international qualifier for the Olympics; the Louisville Slugger bat, Corvettes; the coal tipples and hay fields. The State is rich in landscapes and landmarks — the Abbey at Gethsemane, Camp Nelson, Red River Gorge and Cumberland Gap. The one thing they all have in common is an undecipherable charm, a people steeped in rich tradition and a landscape of change.

Much has changed in the three years since the initial publication. Cities have grown and small town squares have been renovated; countryside has been converted to real estate and historic buildings to condos. The settings that initially drew Jeff to photography are sadly becoming less common; however, the one quality that is a constant is the beauty intrinsic in every detail of these photographs.

The popularity of digital photography, both commercially and for personal use have also increased the complexity of shooting traditional film in a historic but little-used format. Many panoramic enthusiasts now stitch wide-angle images together to achieve a digital panoramic image. The challenges in the field — fewer than 20% of images lend themselves to the panoramic format — are further complicated by the difficulty in finding labs for processing and scanning the transparencies.

Jeff has long been known for his ability to portray the best of Kentucky. His photographs are frequently used by the Lexington Convention and Visitor's Bureau in advertising campaigns and featured in many national publications like *Southern Living* and *Travel & Leisure*. His stock photographs regularly appear on websites and billboards, in business consumer and travel publications and in the photomurals at the Lexington Bluegrass Airport. His art photographs have been exhibited in solo and group shows across the region.

Will there be a *Kentucky Wide III*? It would take several more books to plumb the depths of our geographically and demographically diverse state. While that remains to be seen, take this edition and sit back, relax, enjoy a lush, narrative tour of the Bluegrass State.

FOREWORD

If one picture is worth a thousand words than each of the images contained in this collection are worth two thousand. They are stunning and speak for themselves. No writing of mine can improve them.

What I can do is share a portrait of the artist behind the camera. It has been my great privilege to get to know Jeff Rogers. My hope is that learning more about Jeff will add even greater meaning to his work.

I met Jeff at a dinner party a couple years ago, soon after I moved to Kentucky. It was a time of sorrow for him. He had just lost his wife, Sally, after her long battle with cancer. Who can imagine the grief of someone who has lost his better half? Our hearts naturally fly to anyone in that position.

Jeff and I began a friendship. We started to get together on a regular basis to talk, eat, and pray. Jeff always wanted to know how my day was going, or how my wife and children were doing. He dealt with his loss by concerning himself with the lives and needs of others.

Jeff also sought healing by spending time in God's creation. On many a misty morning, Jeff is up before the sun, in position to capture another special image of the state he knows and loves dearly. Neither rain nor snow nor dark of night prevents him from getting to the most remote locations. There is a dignity and joy to his work that springs straight from his faith and his heart.

For me, Jeff's work is a visual invocation and reminder of the Twenty-third Psalm:

> *The Lord is my Shepherd; I shall not want.*
> *He maketh me to lie down in green pastures;*
> *he leadeth me beside the still waters*
> *He restoreth my soul:*
> *He leadeth me in the paths of righteousness for his name's sake.*
> *Yea, though I walk through the valley of the shadow of death,*
> *I will fear no evil:*
> *For thou art with me;*
> *Thy rod and thy staff comfort me*
> *Thou preparest a table before me in the presence of mine enemies:*
> *Thou annointest my head with oil;*
> *My cup runneth over.*
> *Surely goodness and mercy shall follow me all the days of my life:*
> *And I will dwell in the house of the Lord forever.*

Jeff has taken us to the still waters and the quiet pastures of our state. His soul was restored by getting out and doing what this ancient song recommends. We become part of his journey simply by turning the pages of this book.

I know Jeff as a man of God, and as a rare individual filled with integrity. He is the kind of person who is quick to spot the needs of others. He is generous with his time, money, and forgiveness. Viewers of his art can sense the dignity of the man behind the camera.

The story of Jeff's recent years has a fairy tale twist. When I was guest preaching at Crossroads Church in Lexington, Jeff arranged to meet my wife Nancy and me there. Nancy had previously met a wonderful woman, Missy, who is not only a physician but a teaching pastor at Crossroads. During the first service, Missy and Nancy sat together; after the second service, Nancy introduced Jeff and Missy. I think after the third service they began to suspect that God had brought them together.

If ever there was a marriage made in heaven, it has been Jeff's and Missy's. It makes me break out smiling to think of the joy they share. Their heads are anointed by God, and their cups run over with love.

Kentucky is blessed by having every season. We have beautiful long springs and autumns. We have mountains, pastures, and, of course, horses.

As you look again and again at this book, you will see all of creation framed as only a talented artist can. Occasionally you may get a glimpse of quiet, or sadness. Sometimes you will experience exuberance, joy, and even love.

I have been through several seasons of life with Jeff. I thank my Creator for letting me know this wonderful man and friend. May you be blessed by seeing the world through Jeff's eyes. It is a big, wide place full of wonders worth preserving.

Matthew Sleeth
Executive Director, Blessed Earth
www.blessedearth.org

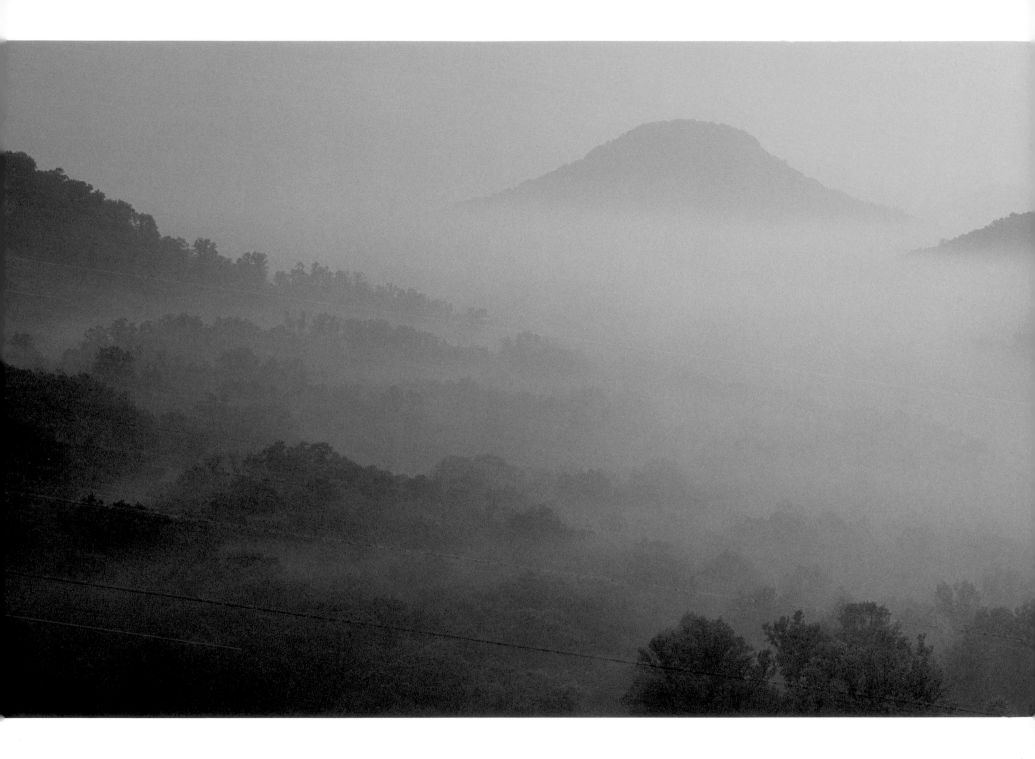

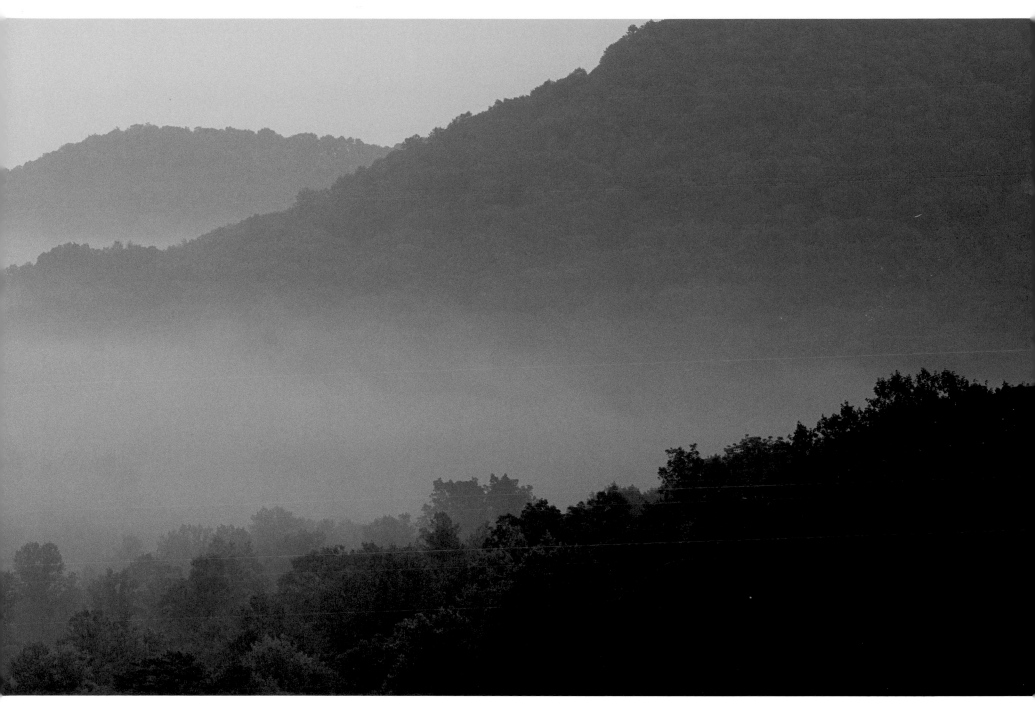

Pilot Knob • Madison County

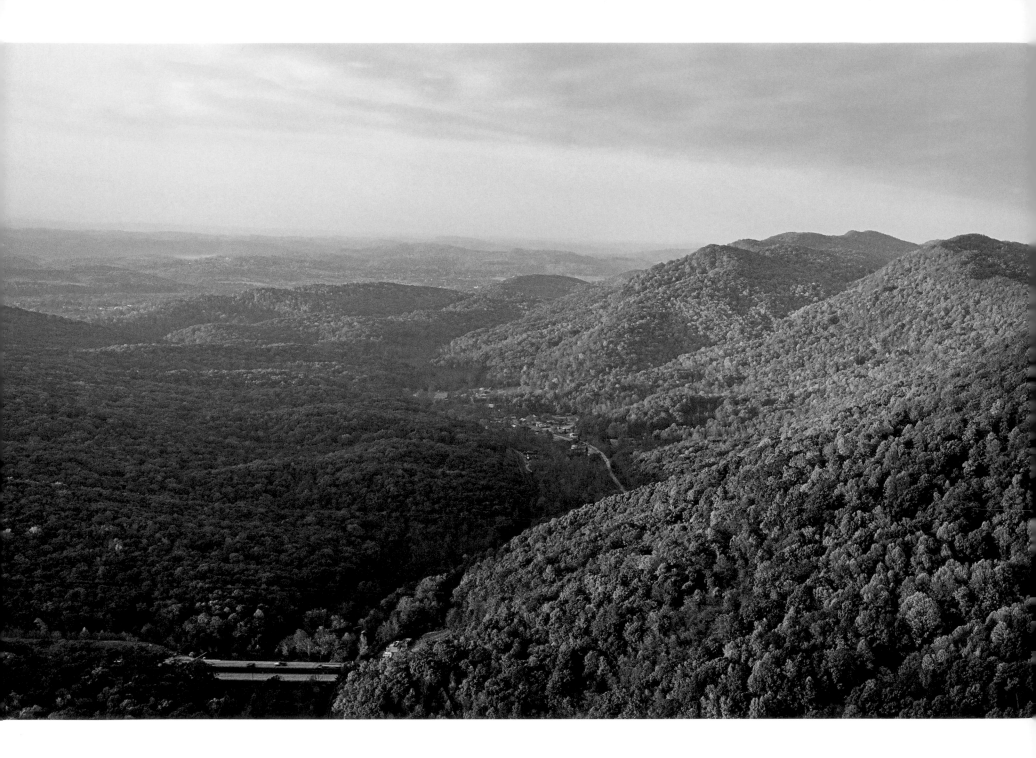

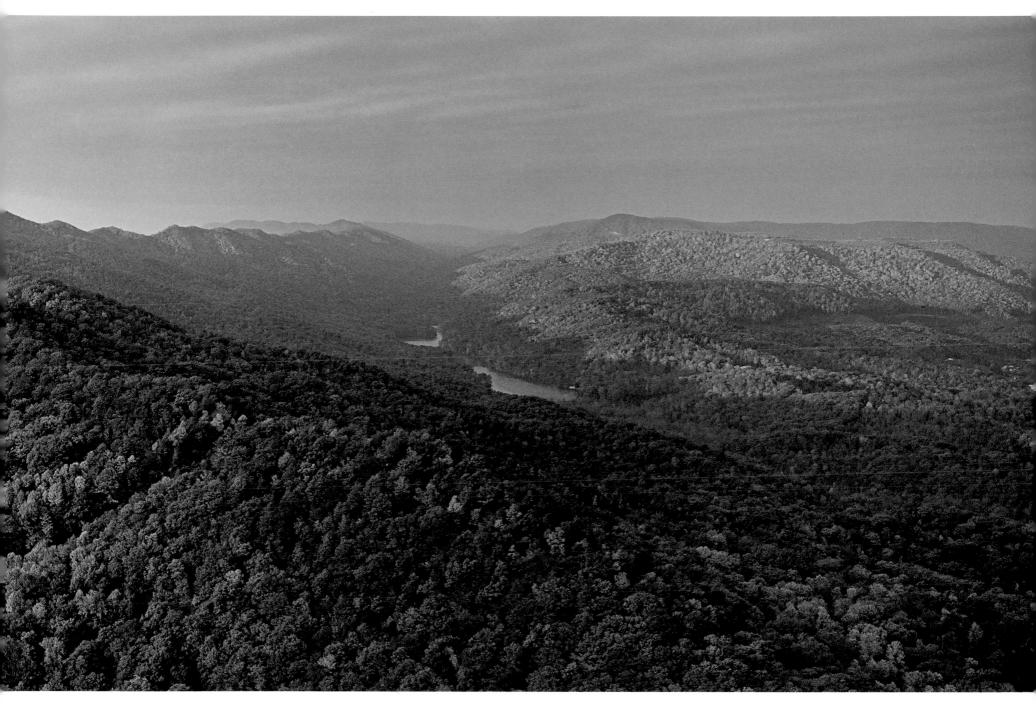

Cumberland Gap • Bell County

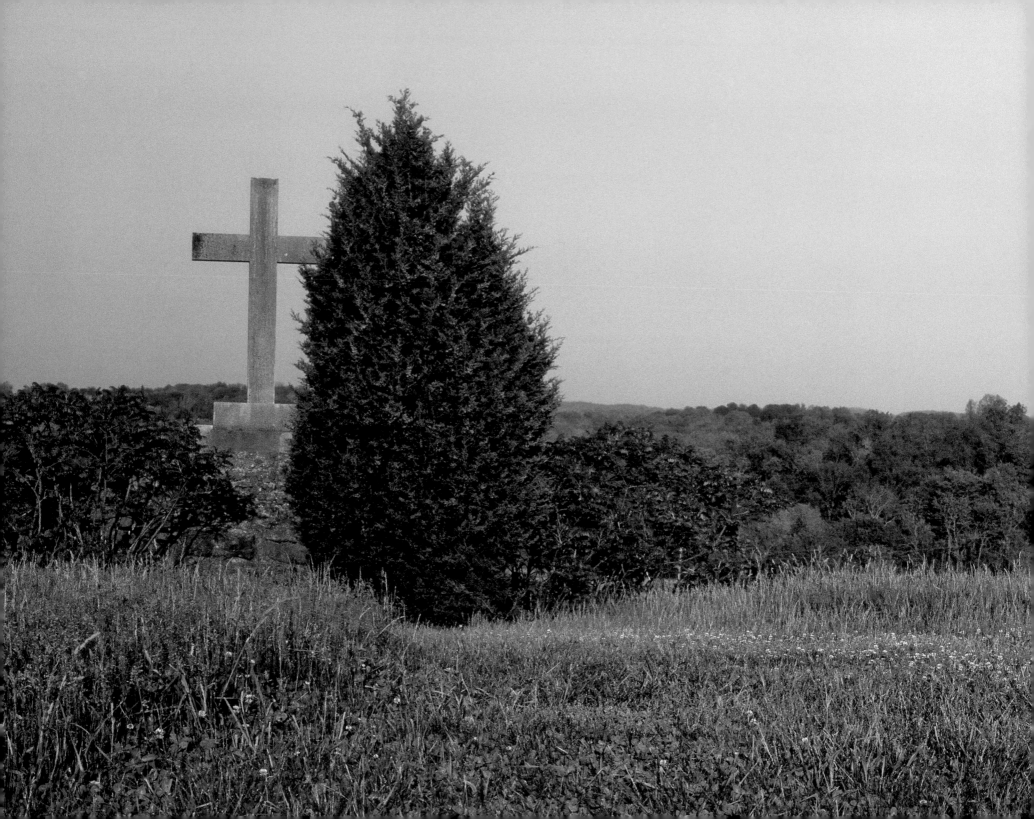

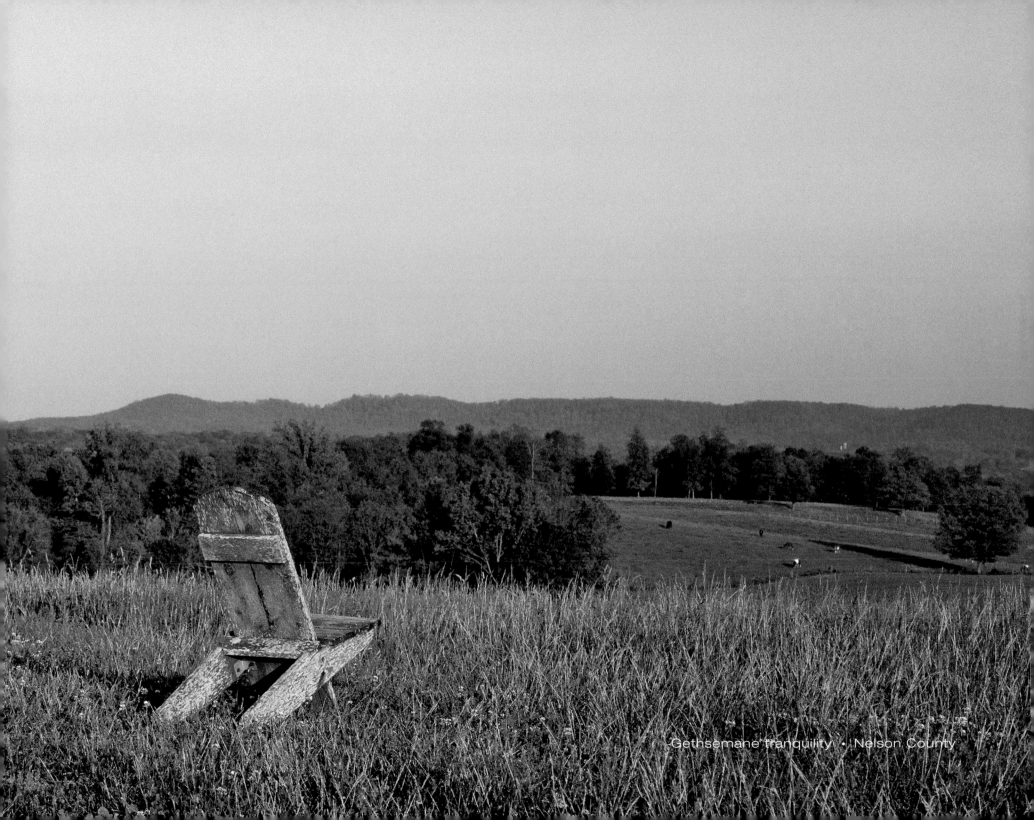

Gethsemane tranquility · Nelson County

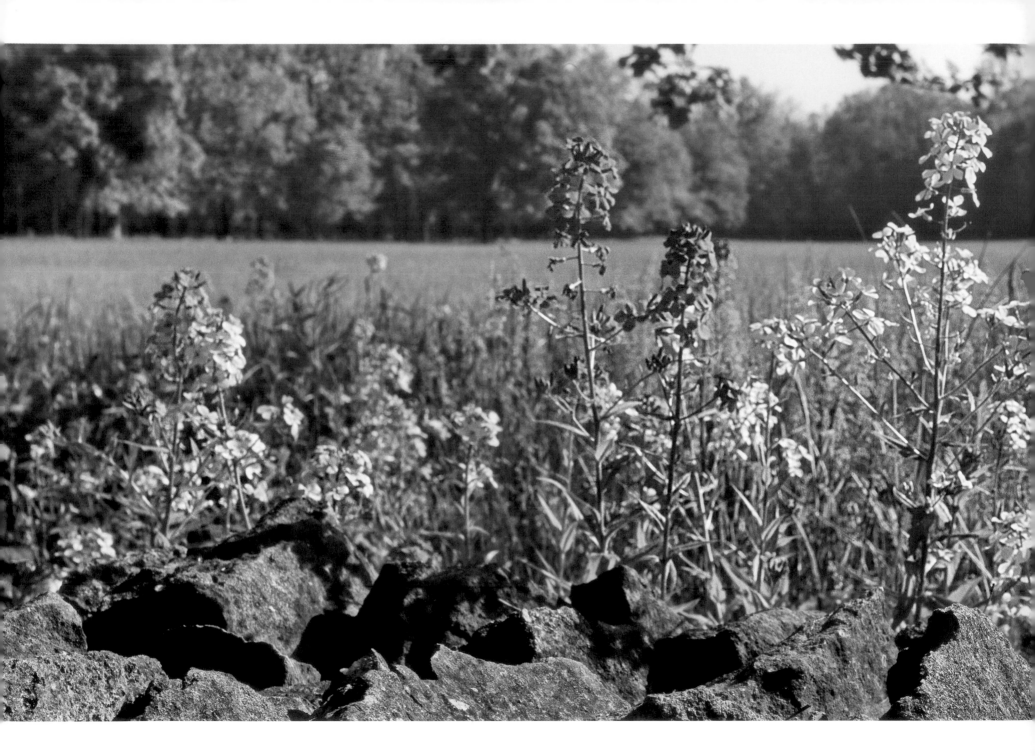

Spring wildflowers and rock wall • Fayette County

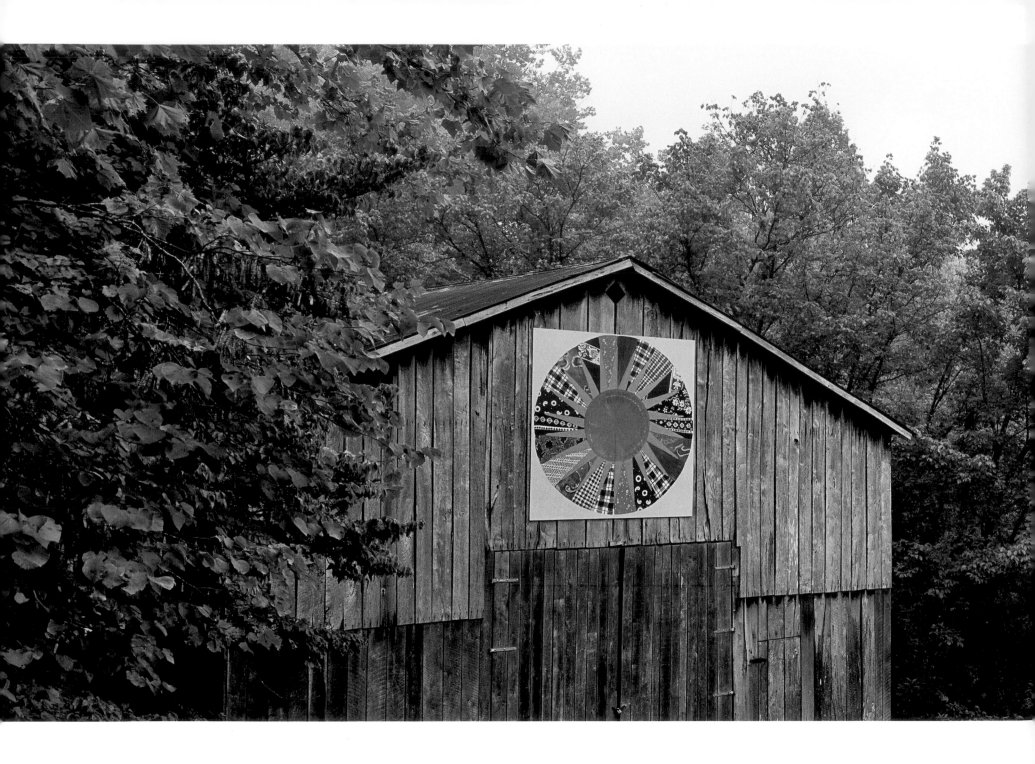

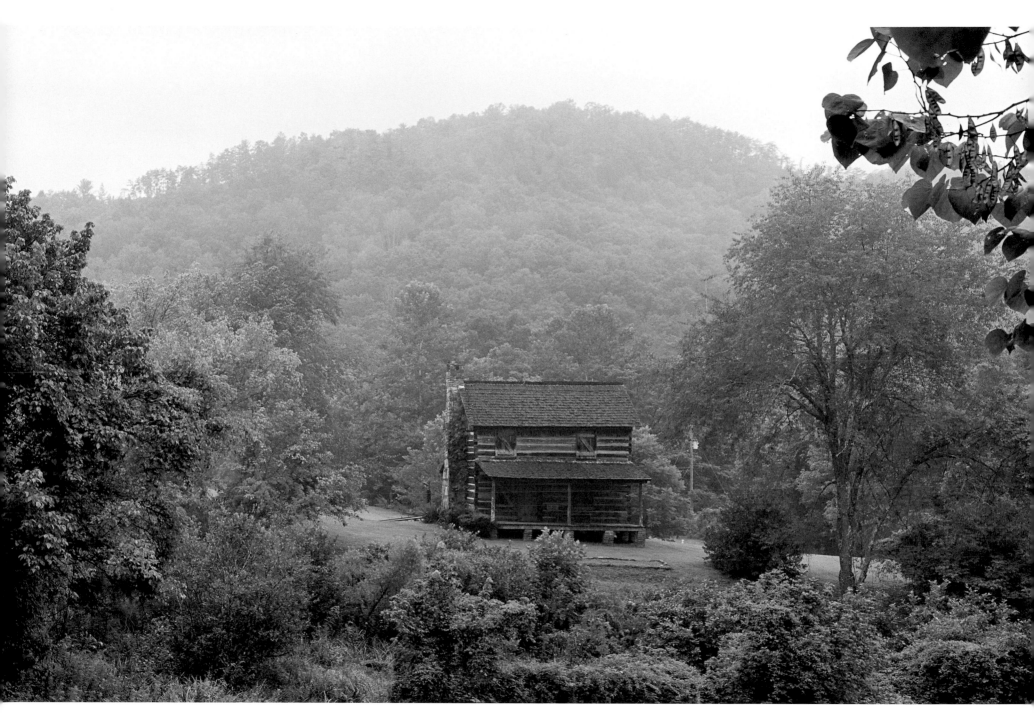

Gladie Creek Historic Site • Menifee County

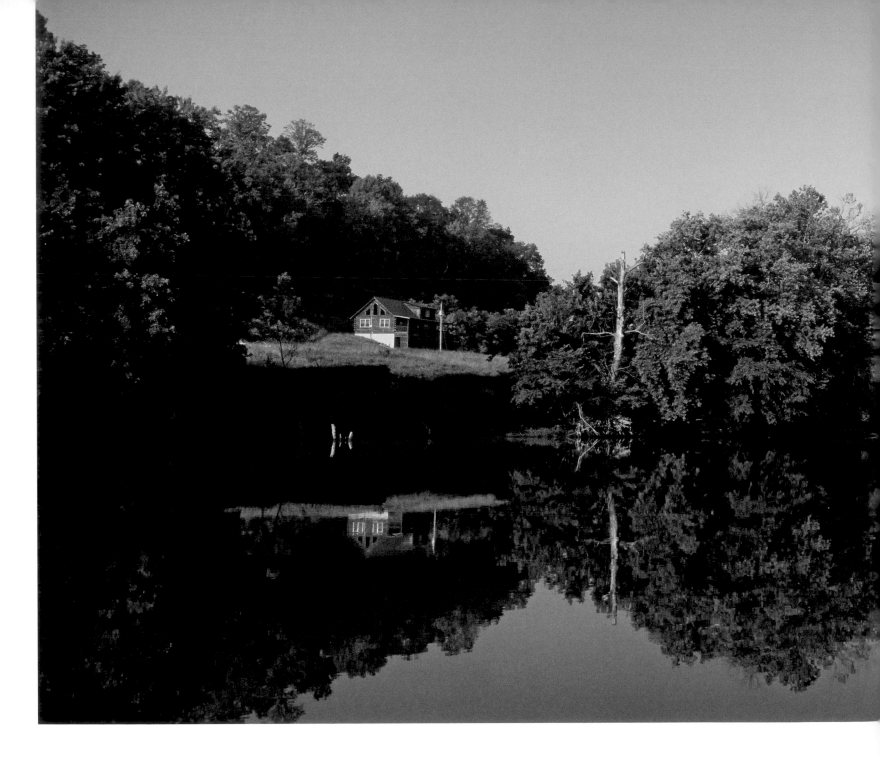

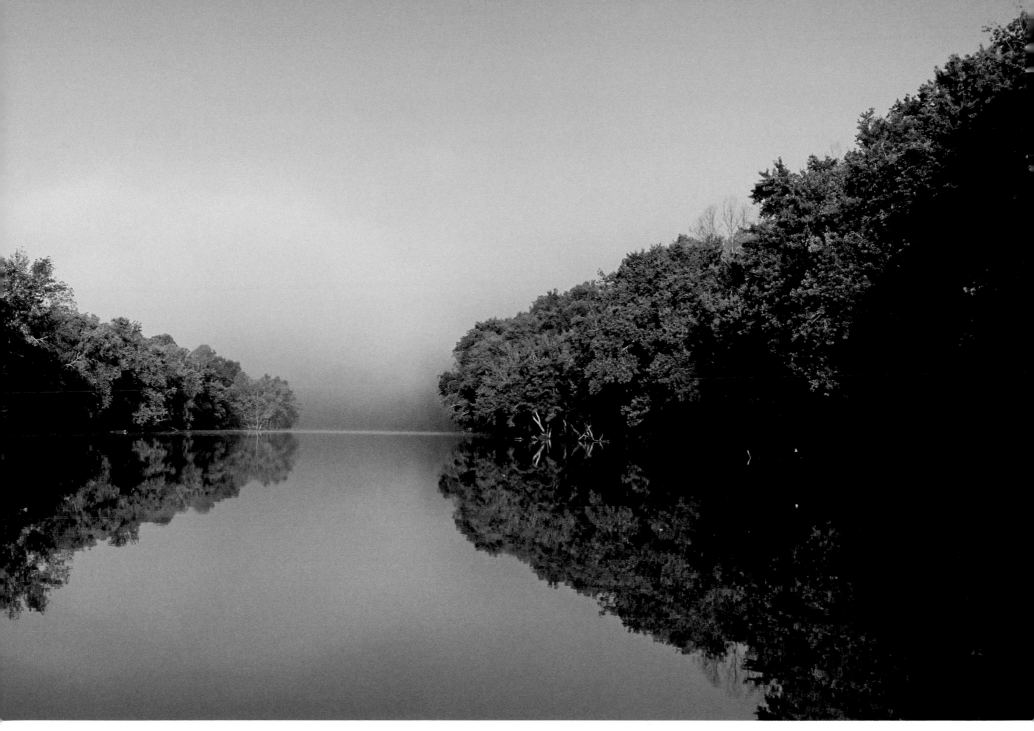

Early morning on Kentucky River • Madison County

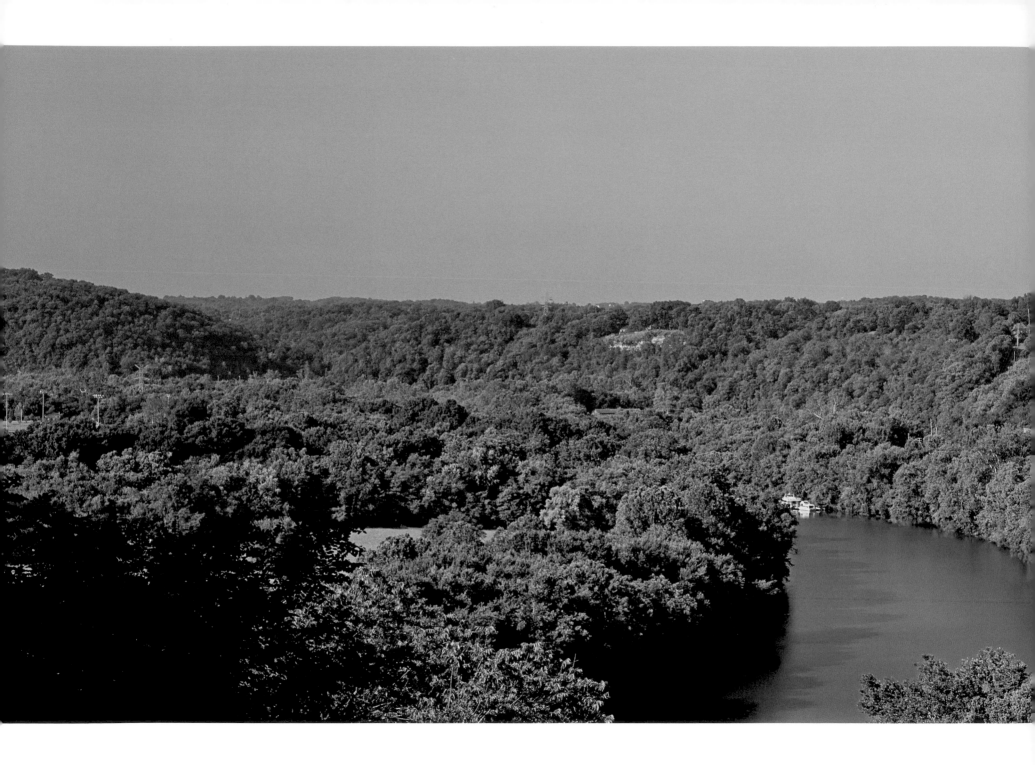

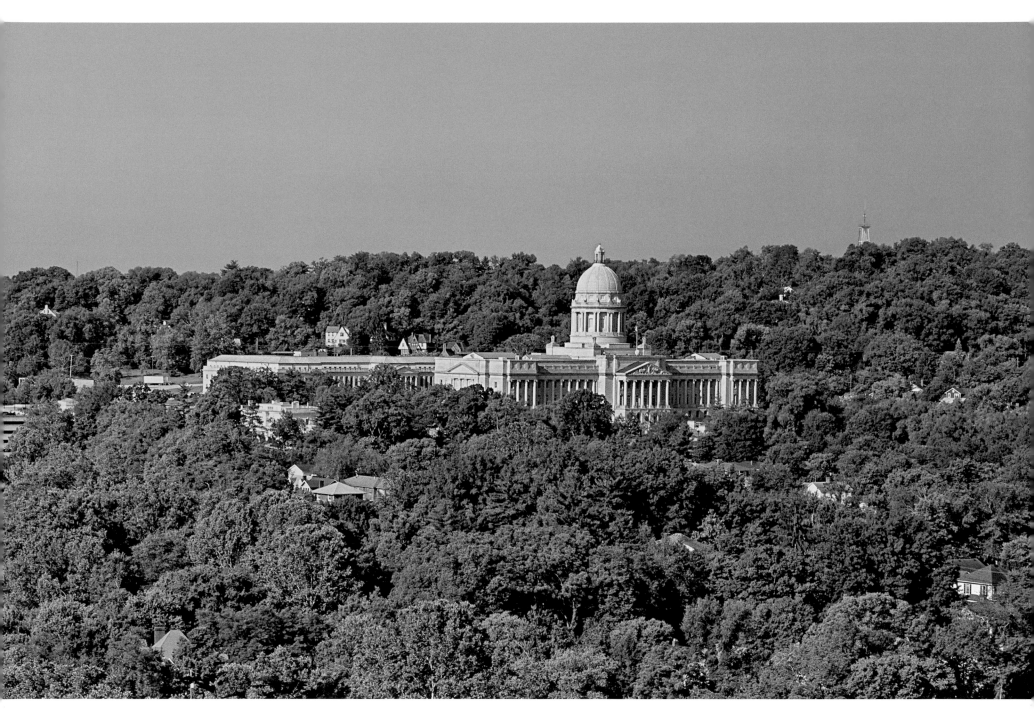

State Capitol by Kentucky River • Franklin County

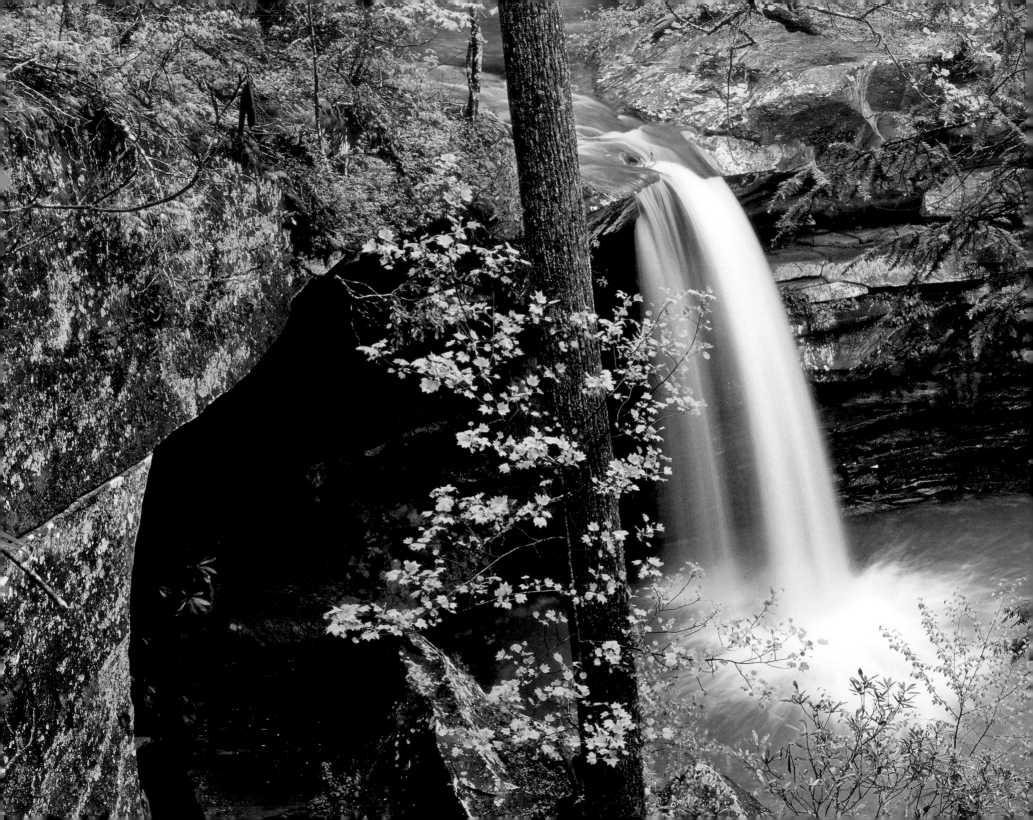

Flat Lick Falls •
Jackson County

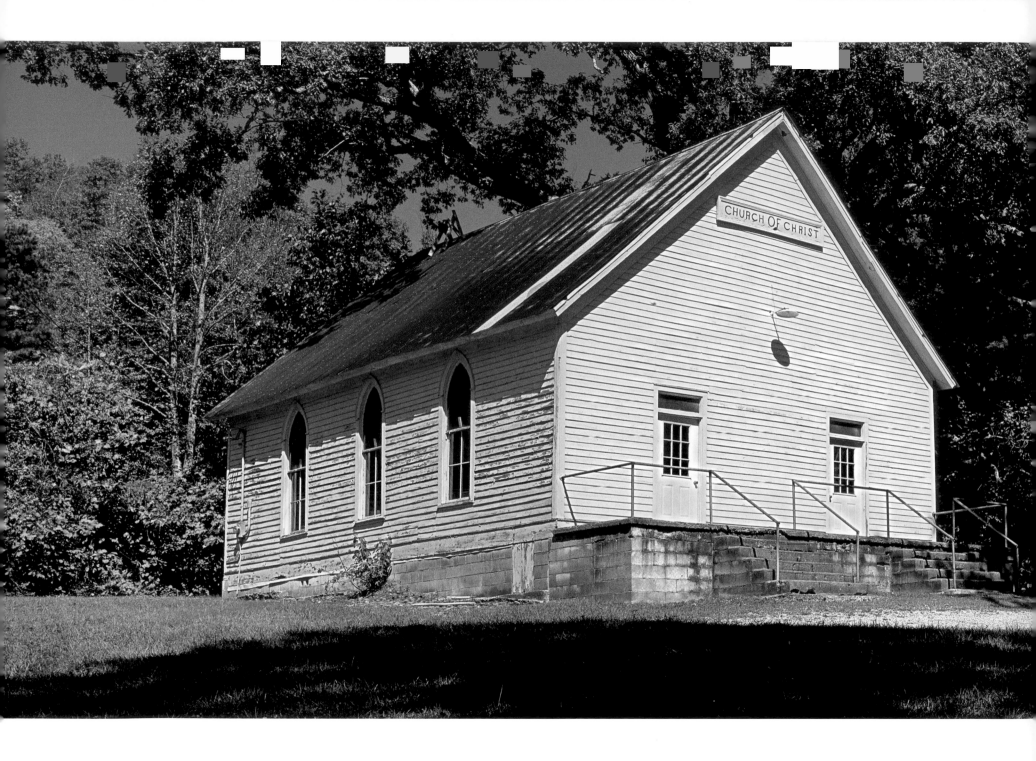

Country church • Southern Kentucky

Reelfoot National Wildlife Refuge • Fulton County

My Old Kentucky Home • Nelson County

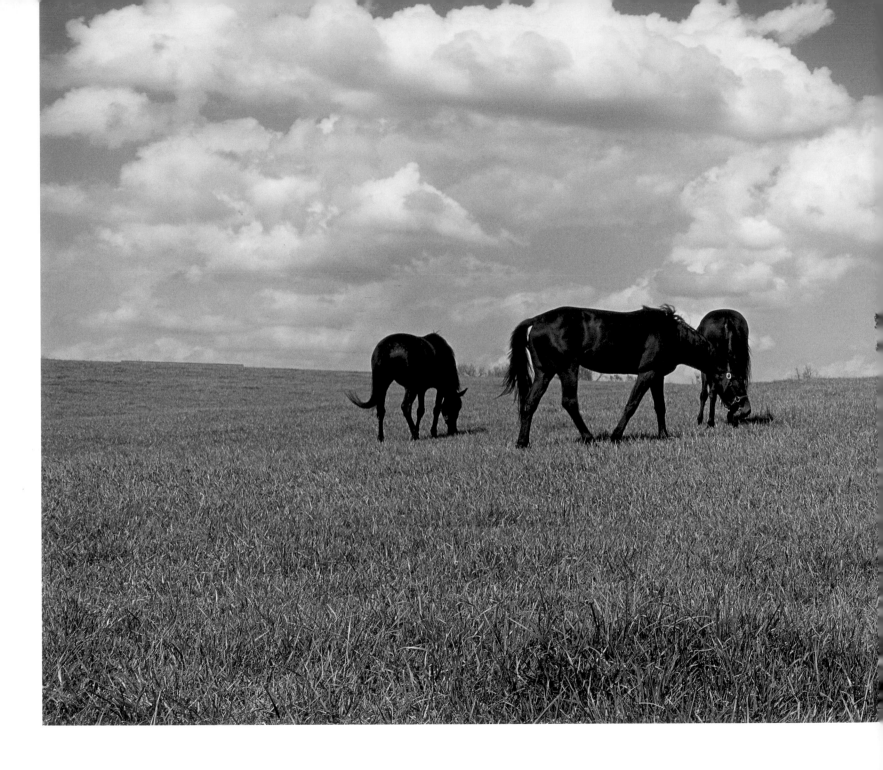

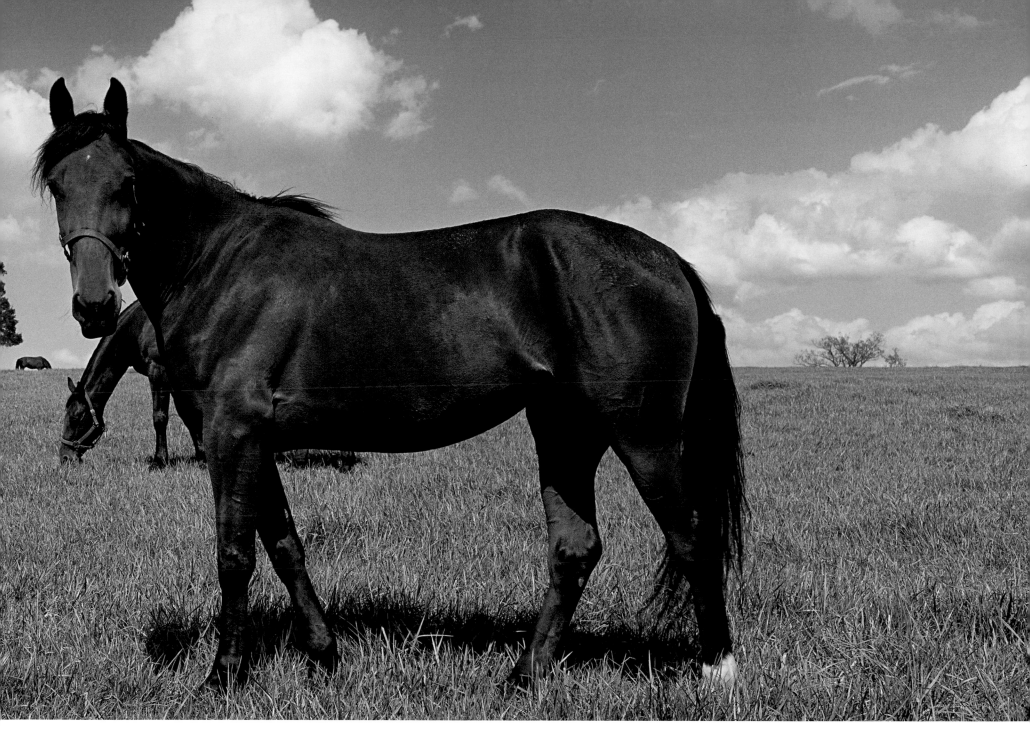

Horses at Pisgah Pike • Woodford County

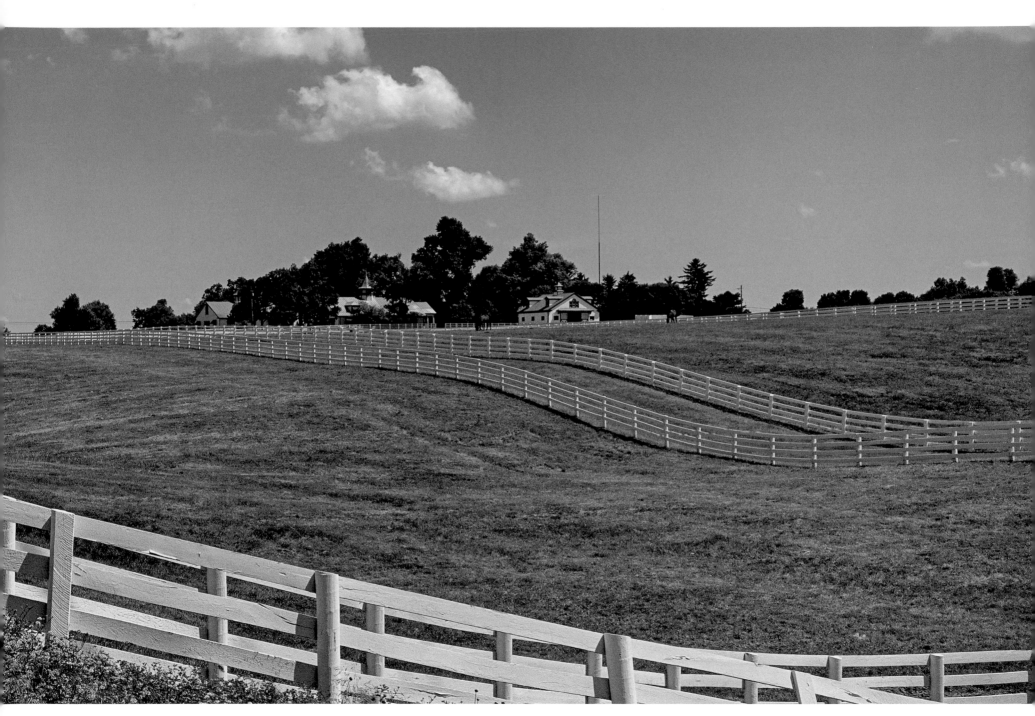

Pleasant boundaries • Fayette County

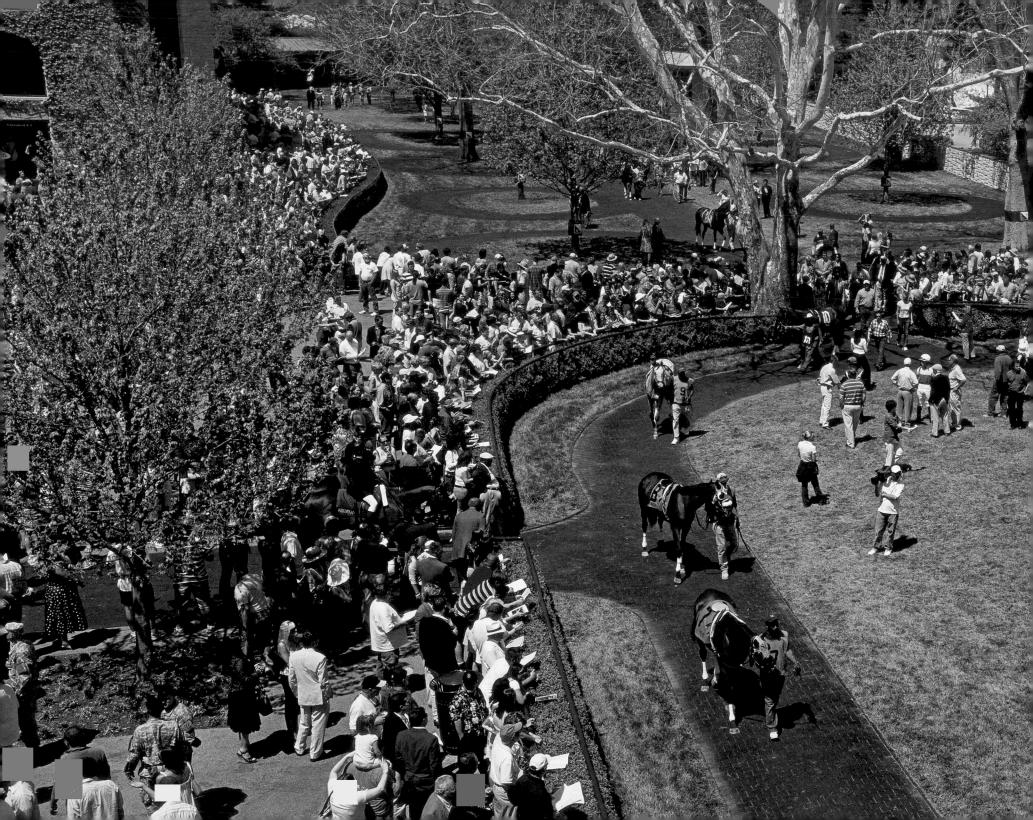

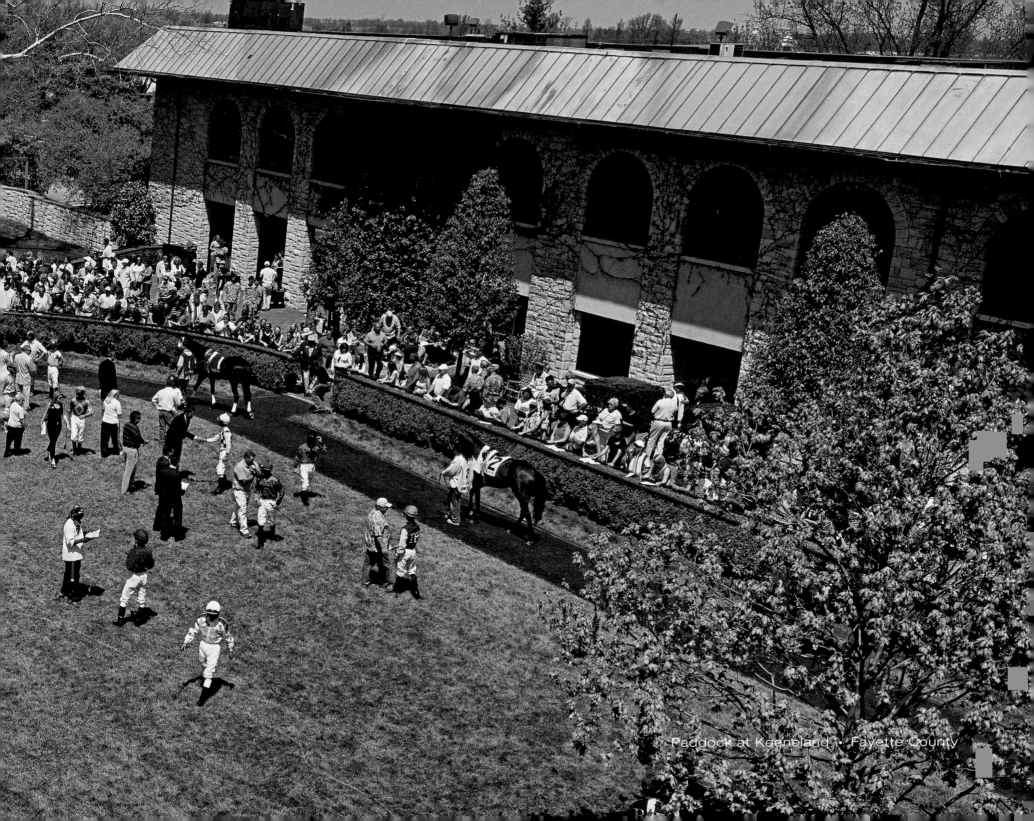

Paddock at Keeneland · Fayette County

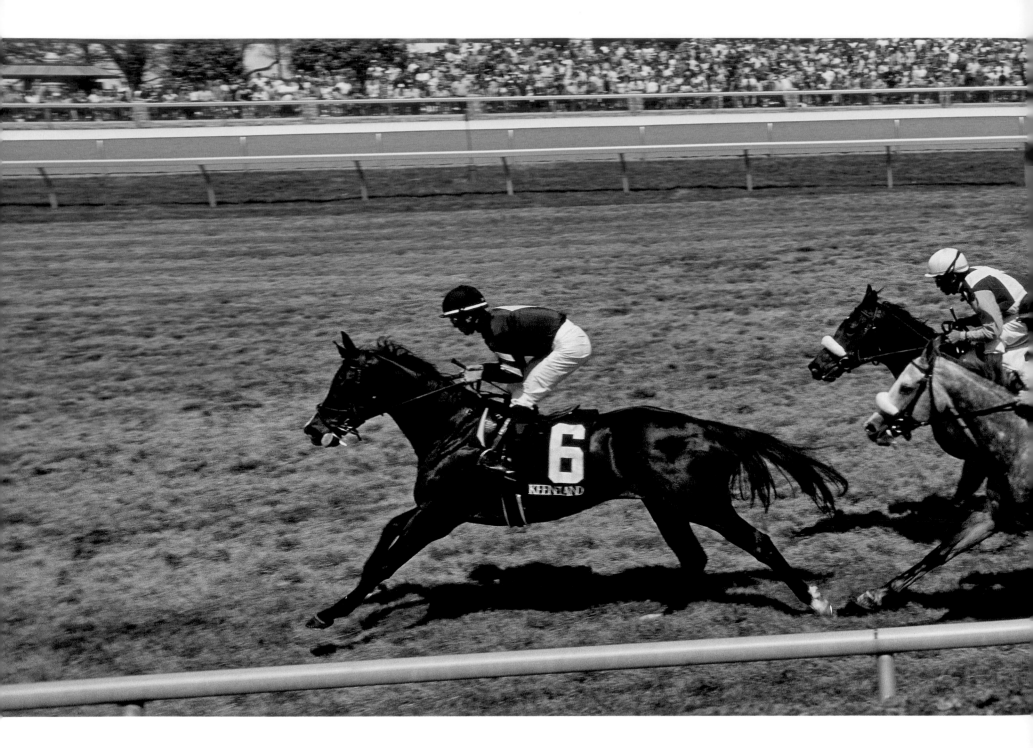

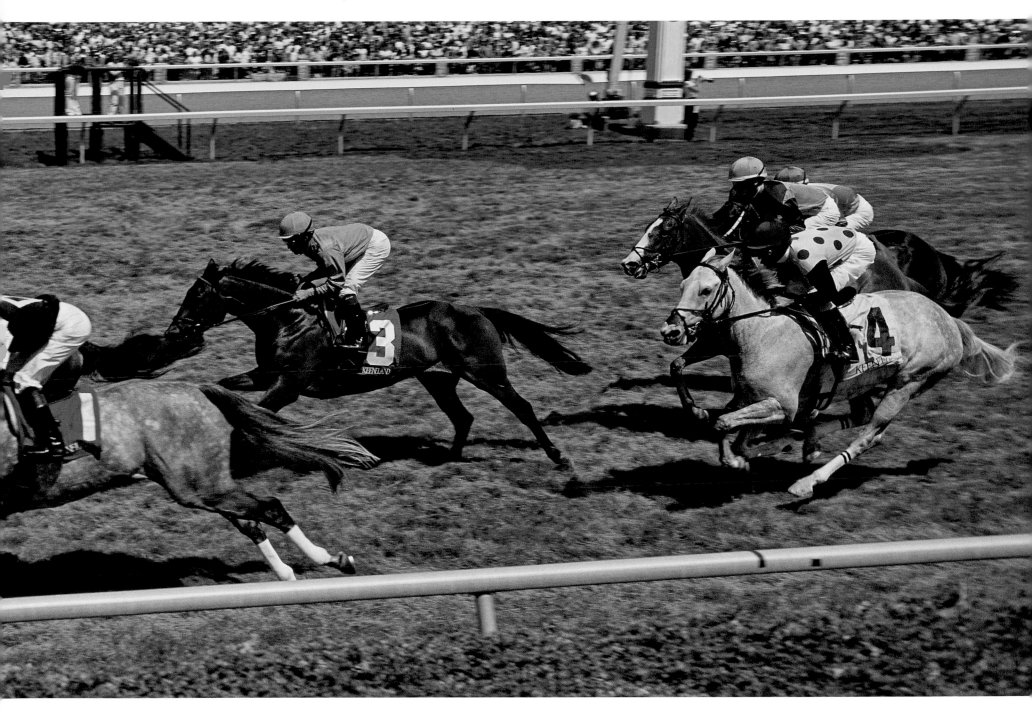

Turf racing at Keeneland • Fayette County

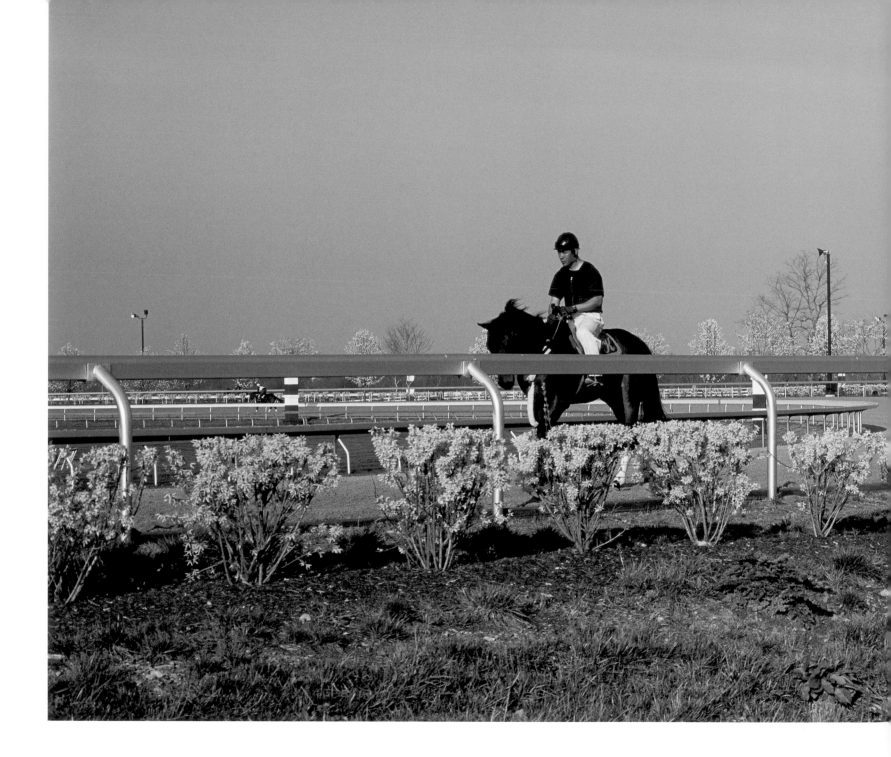

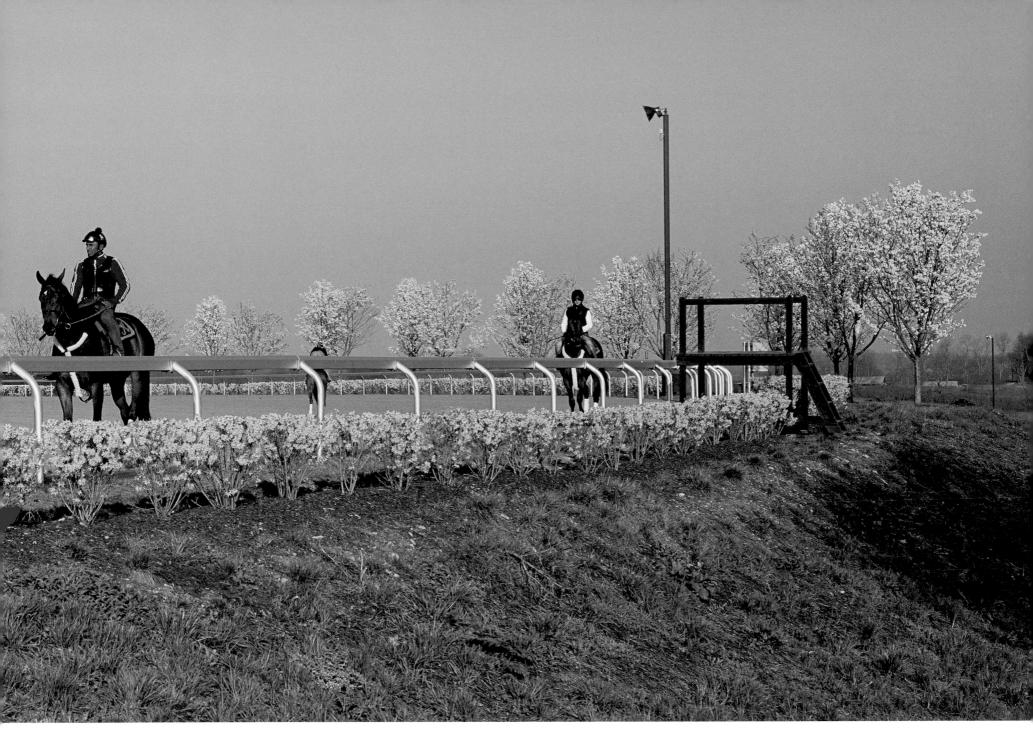

Morning workout at Keeneland • Fayette County

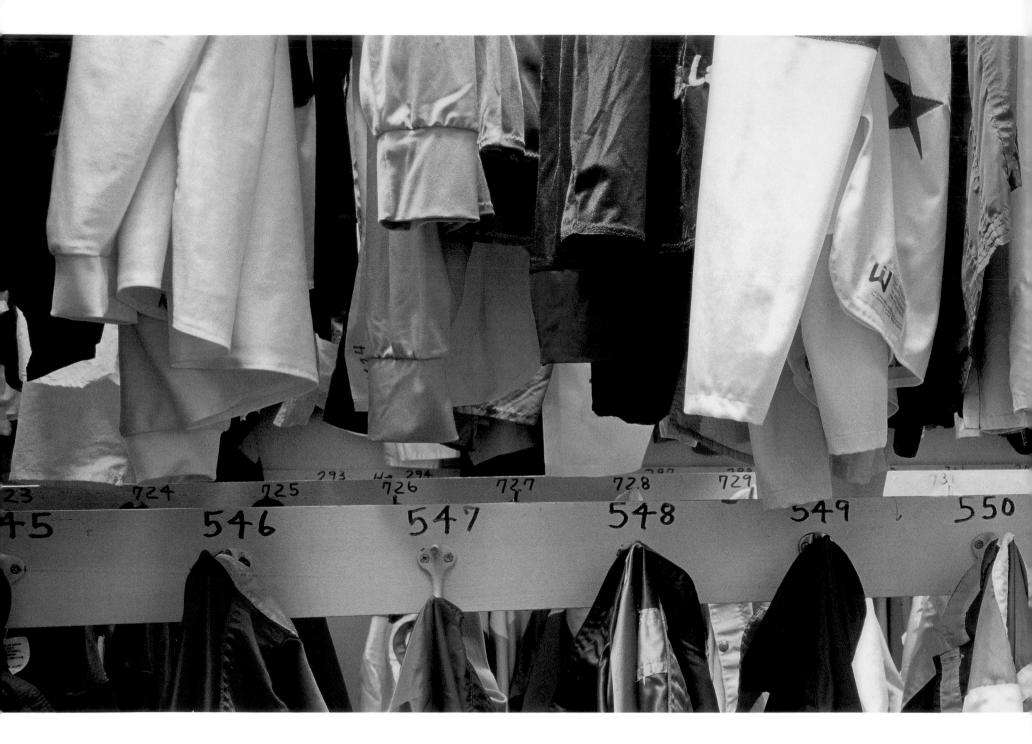

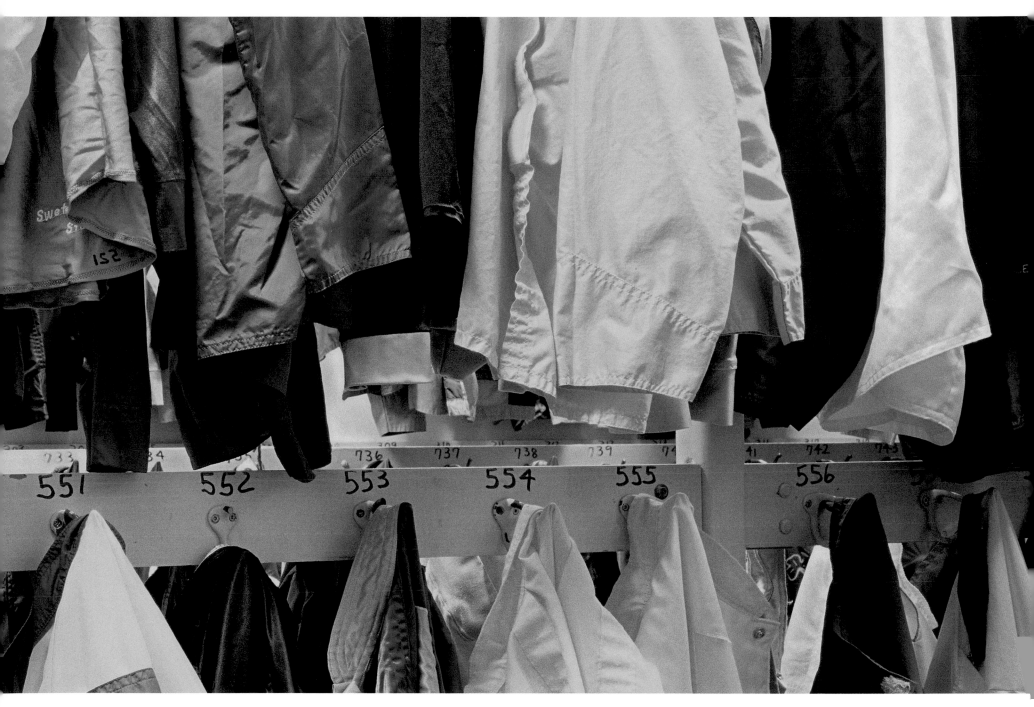

Jockey silk room at Keeneland • Fayette County

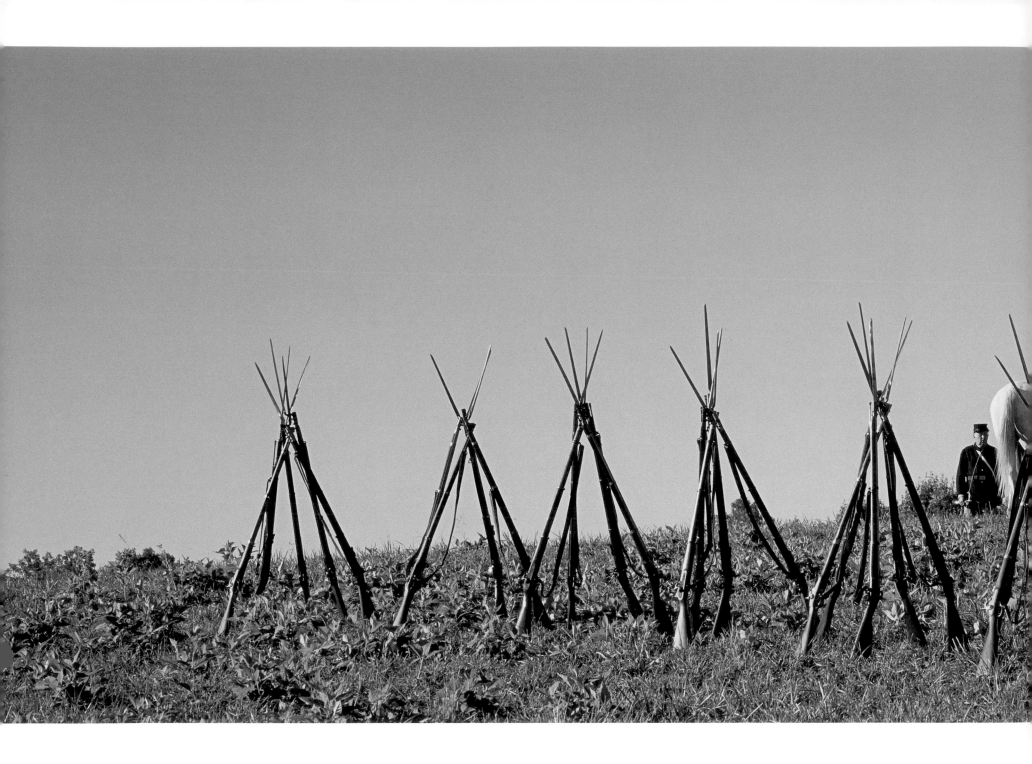

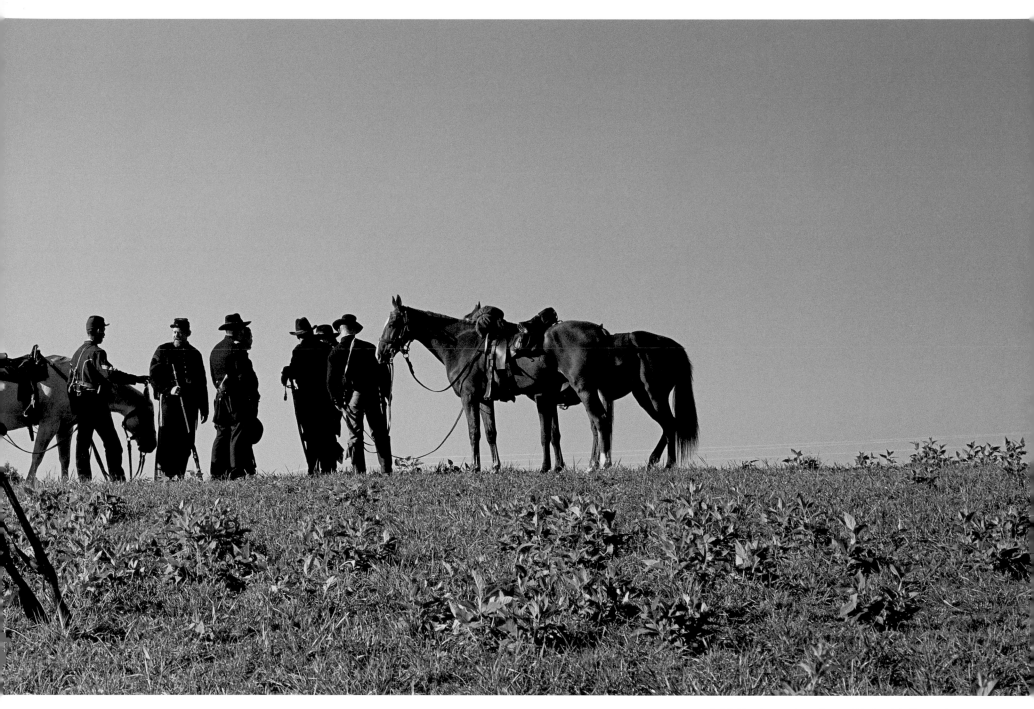

Mill Springs battle · Pulaski County

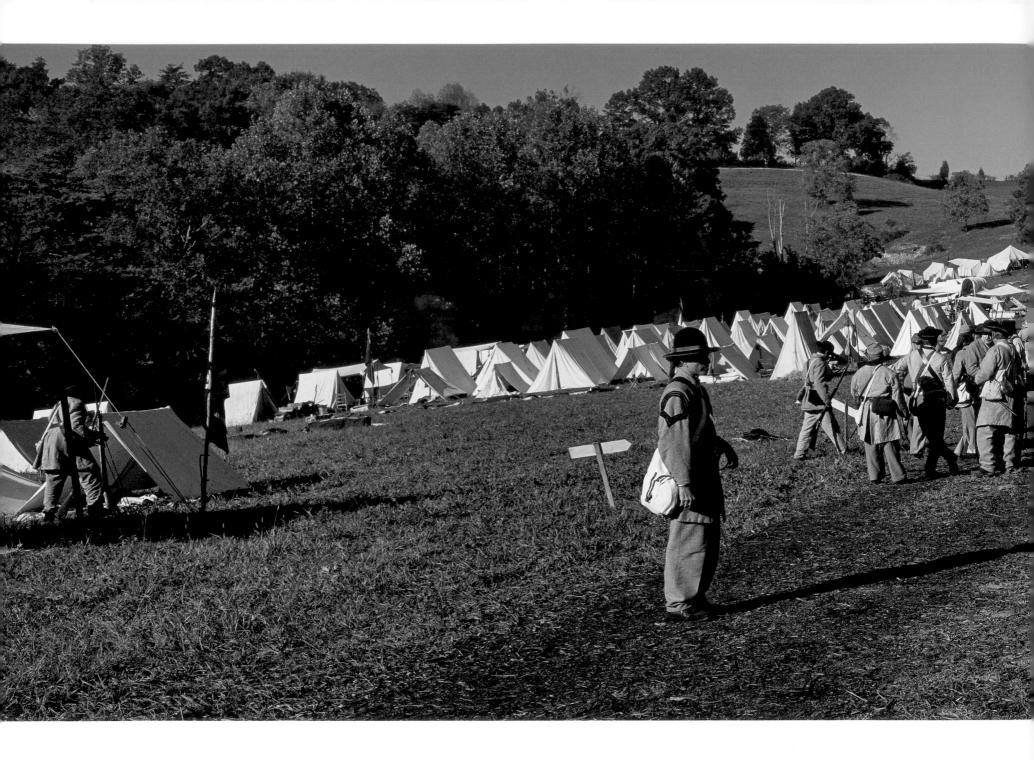

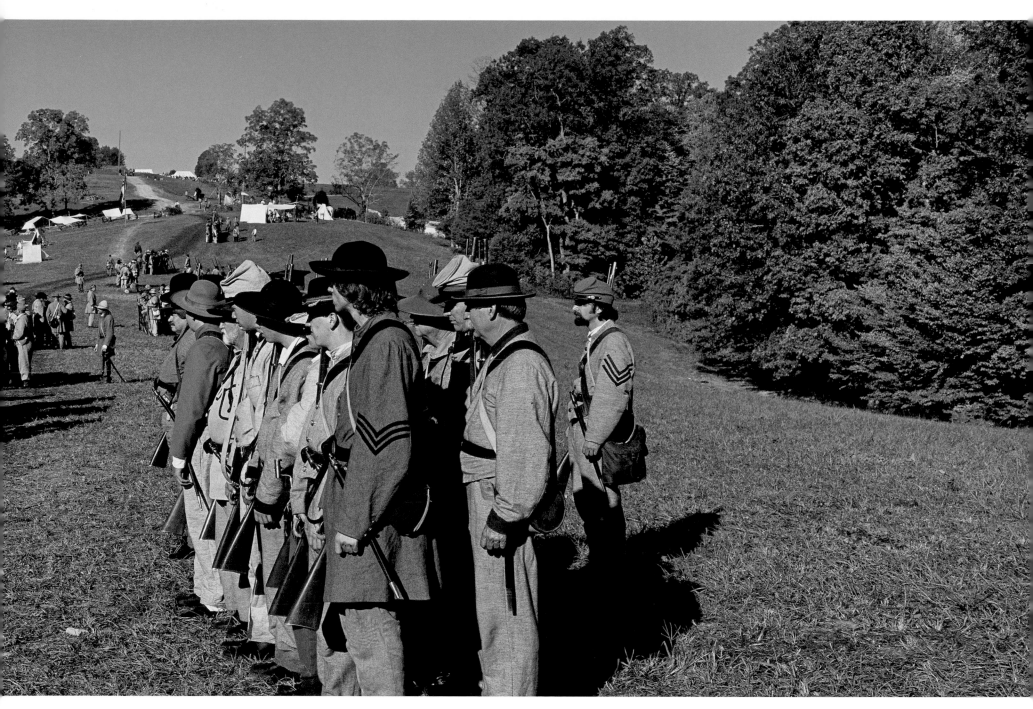

Mill Springs formation • Pulaski County

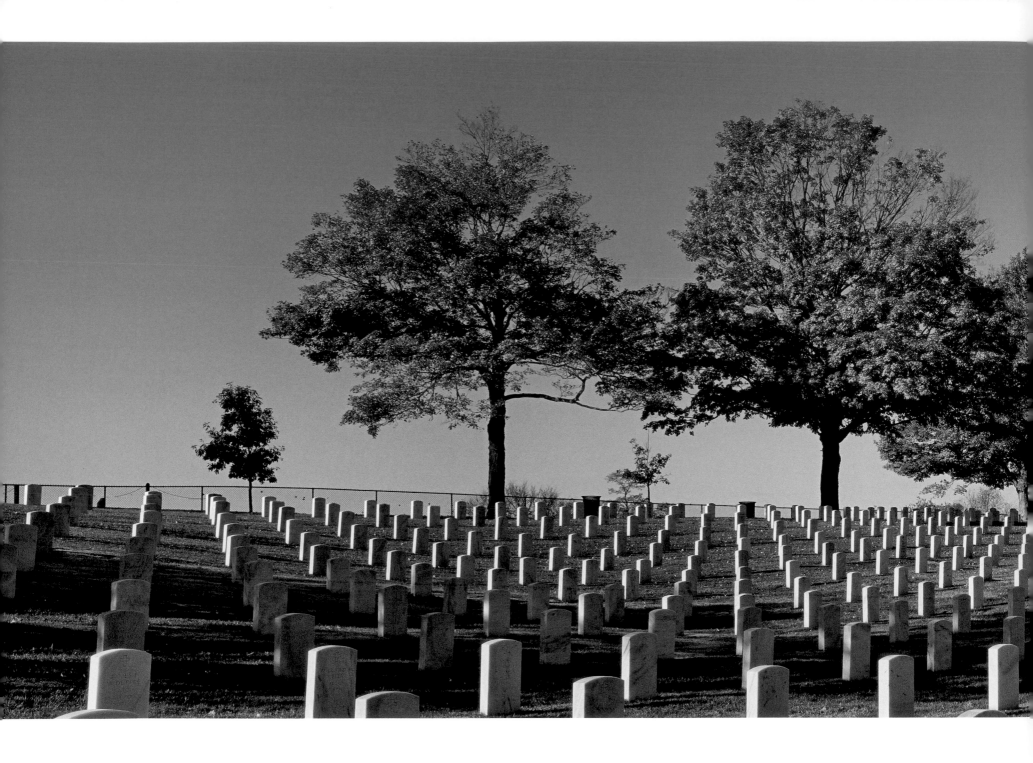

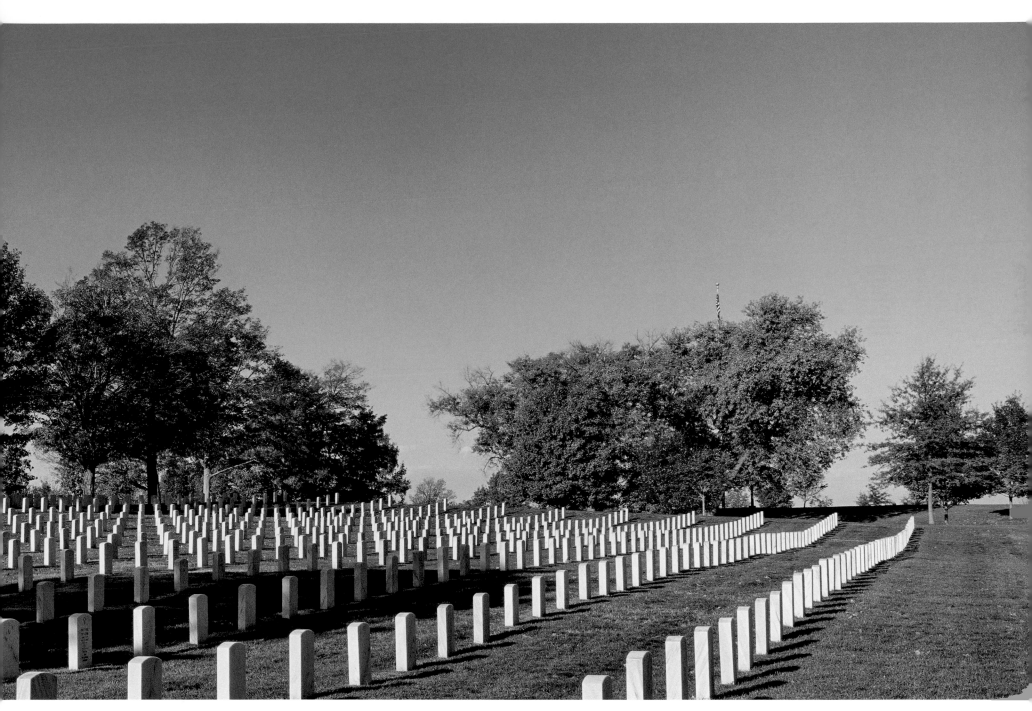

Camp Nelson National Cemetery • Jessamine County

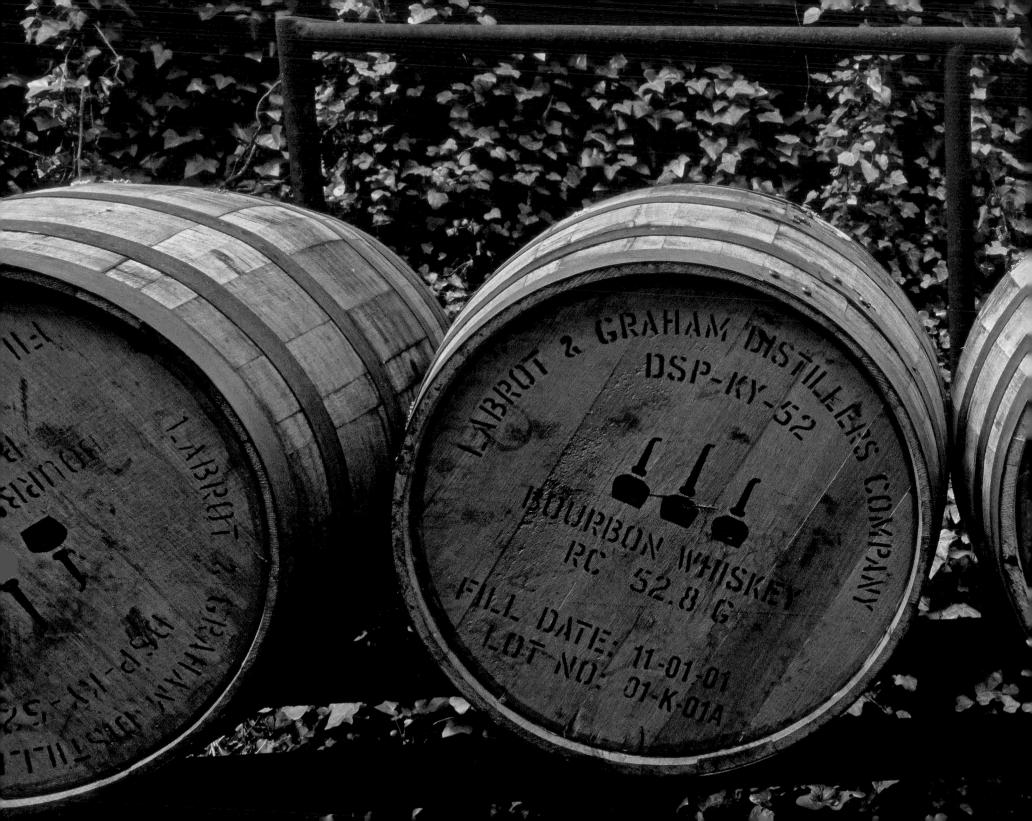

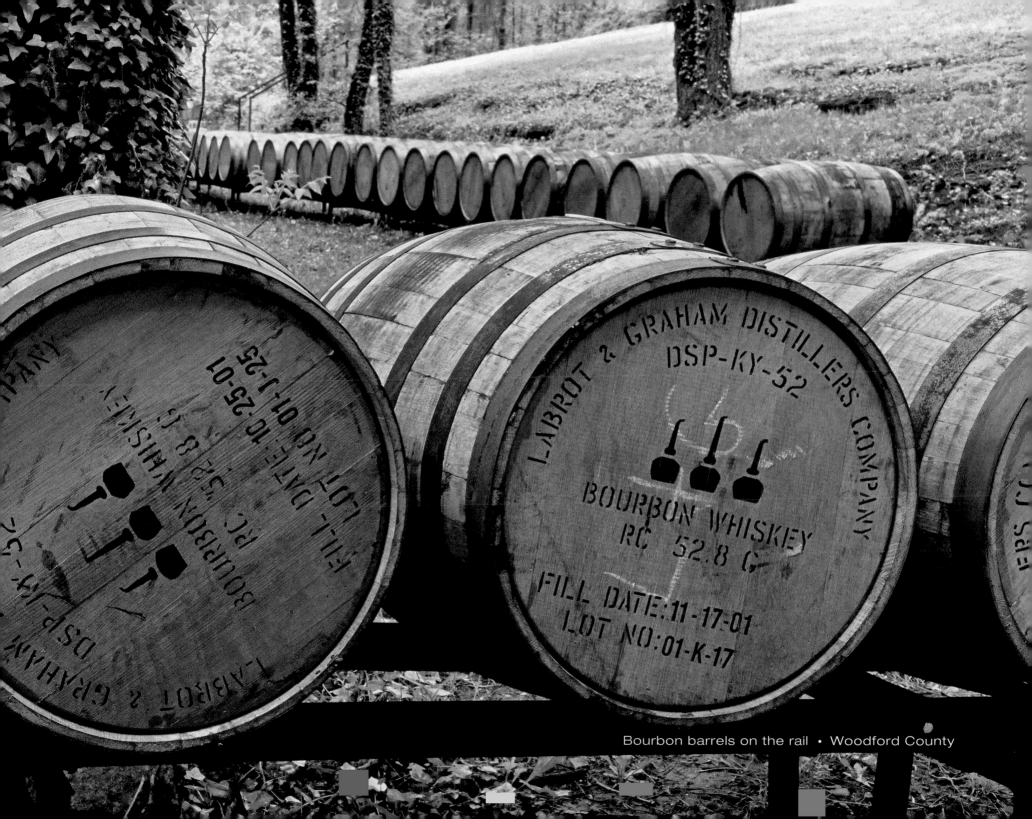

LABROT & GRAHAM DISTILLERS COMPANY

DSP-KY-52

BOURBON WHISKEY
RC 52.8 G

FILL DATE: 11-17-01
LOT NO: 01-K-17

Bourbon barrels on the rail • Woodford County

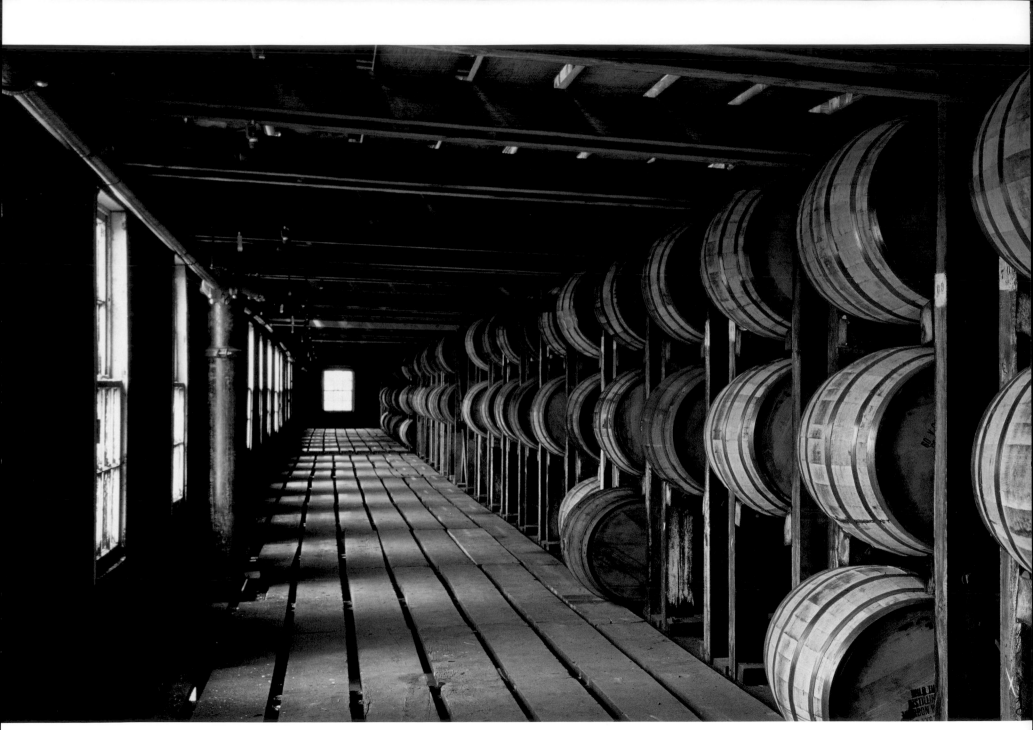

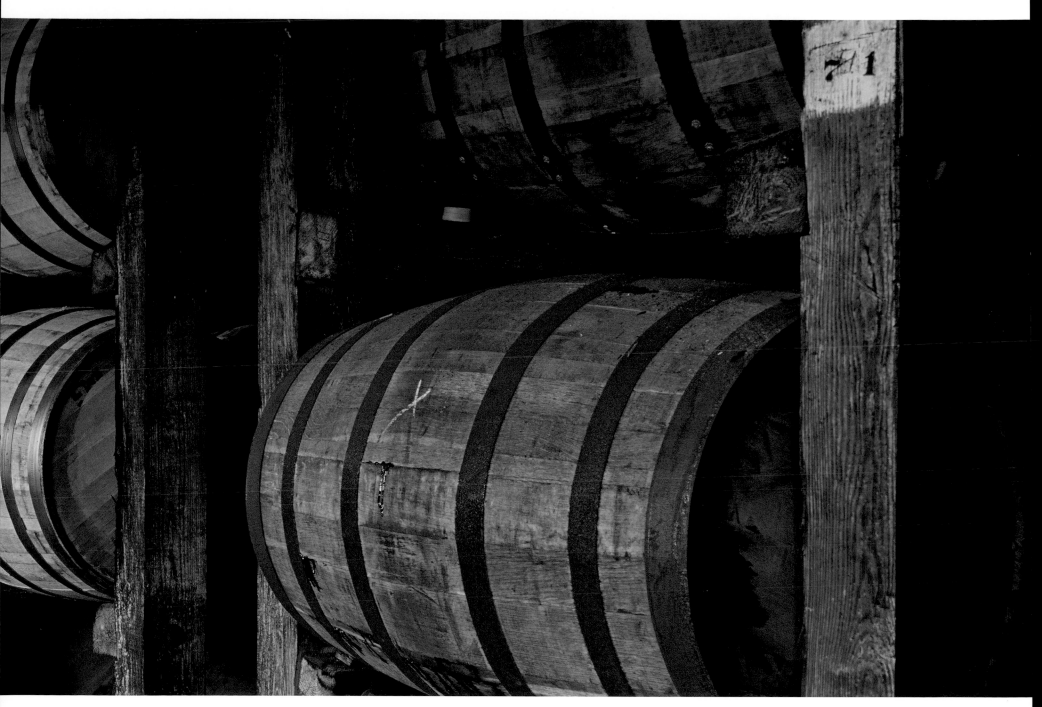

Bourbon warehouse • Anderson County

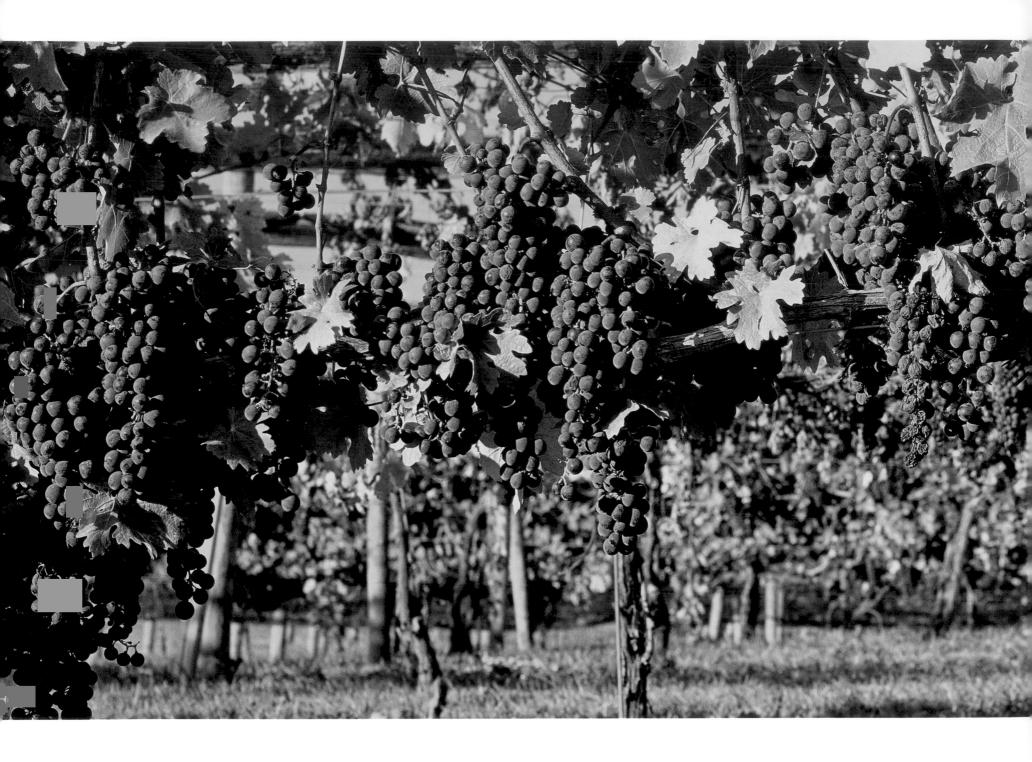

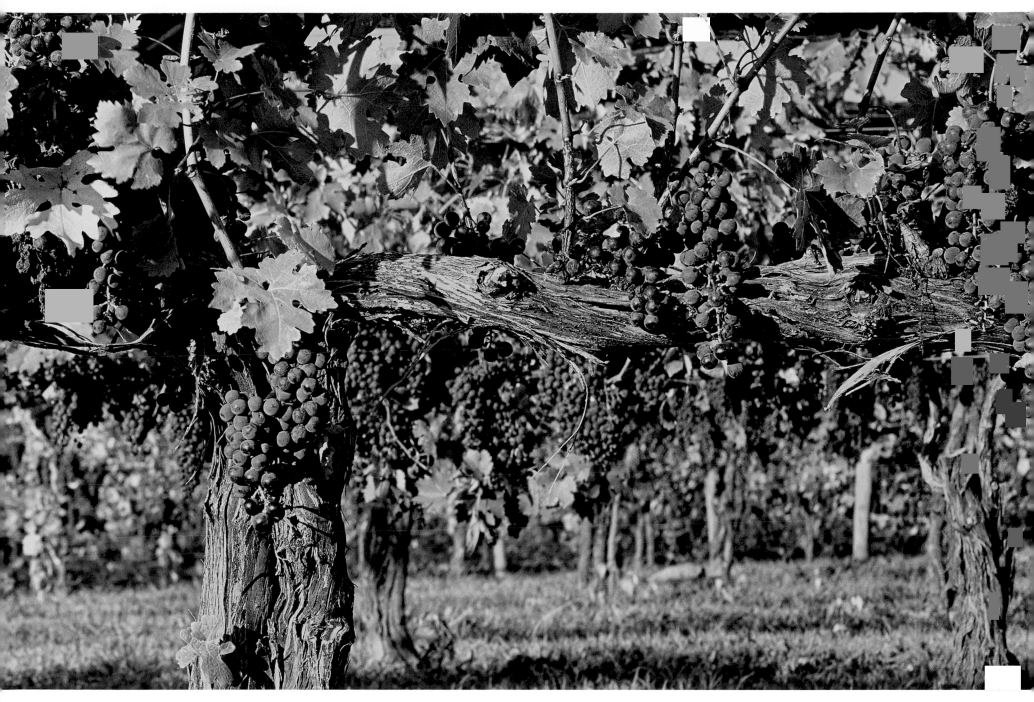

Lover's Leap Winery • Anderson County

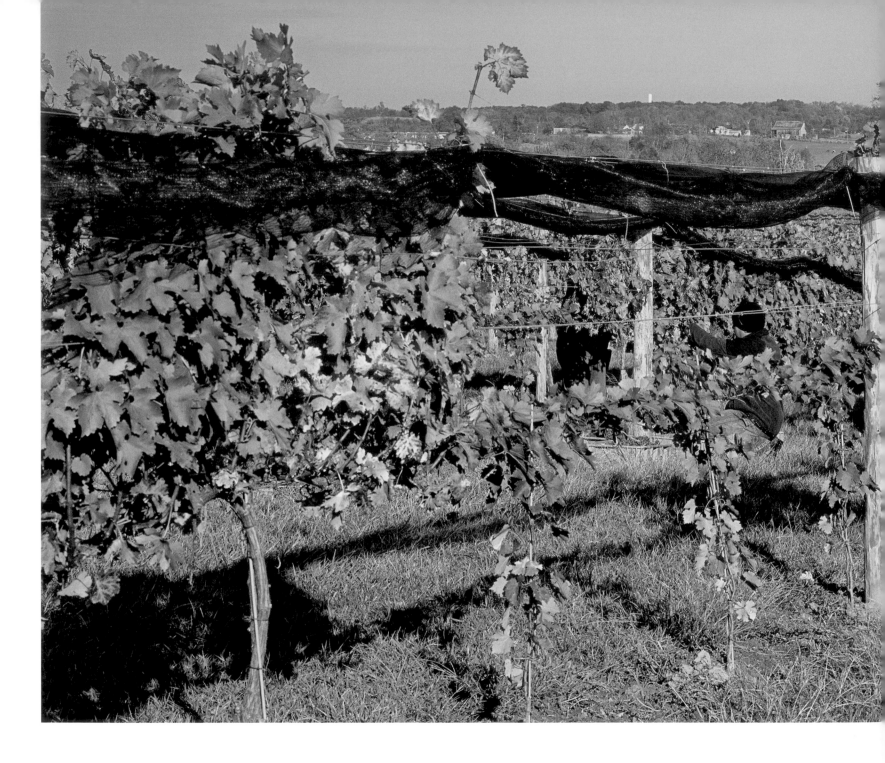

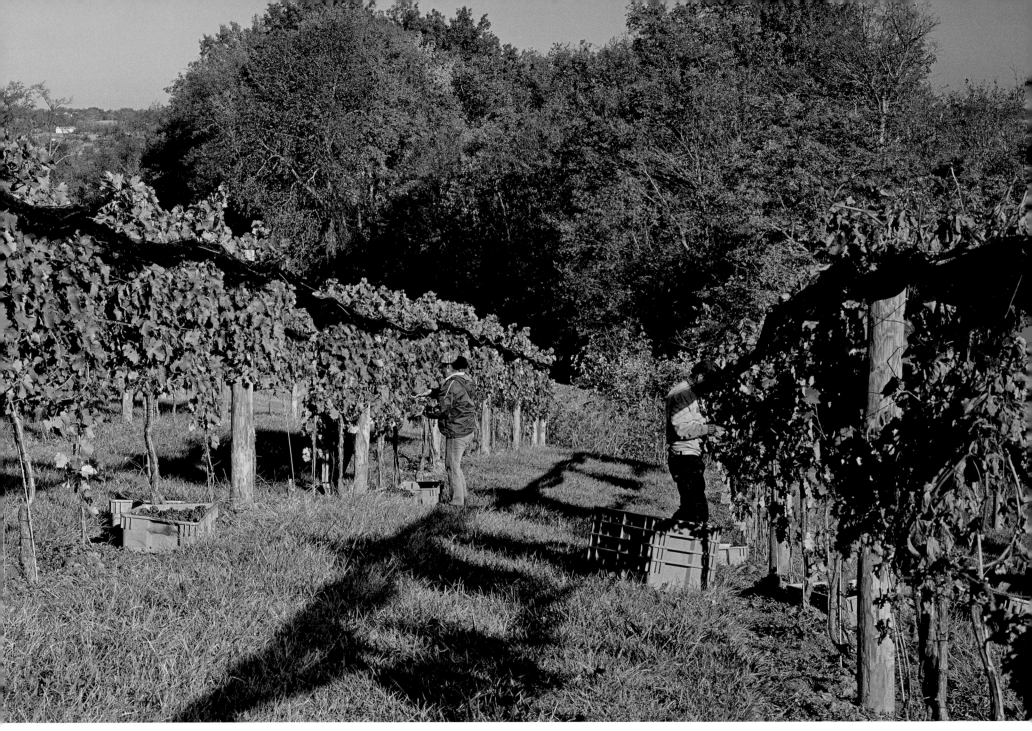

Harvest at Lover's Leap Winery • Anderson County

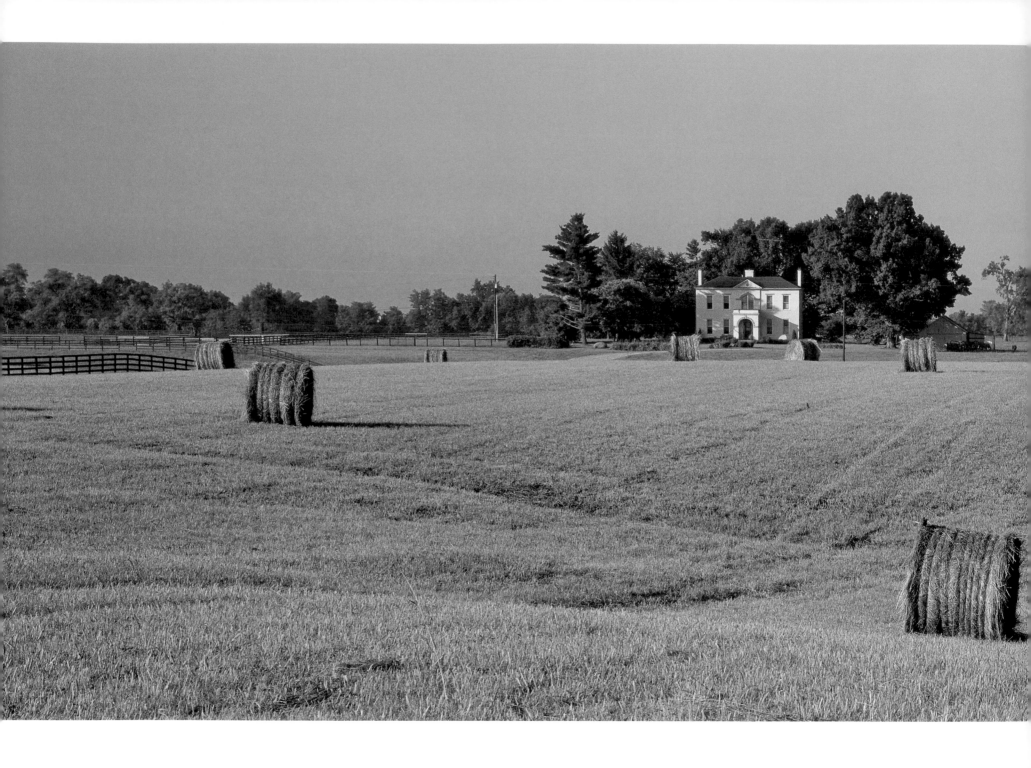

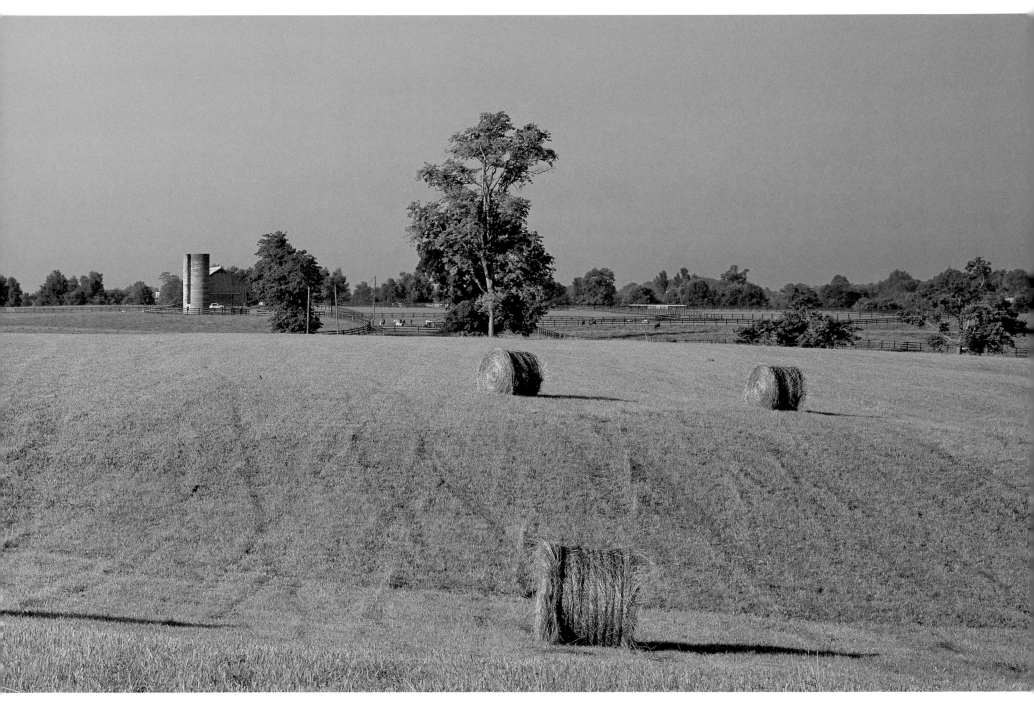

Summer cutting • Franklin County

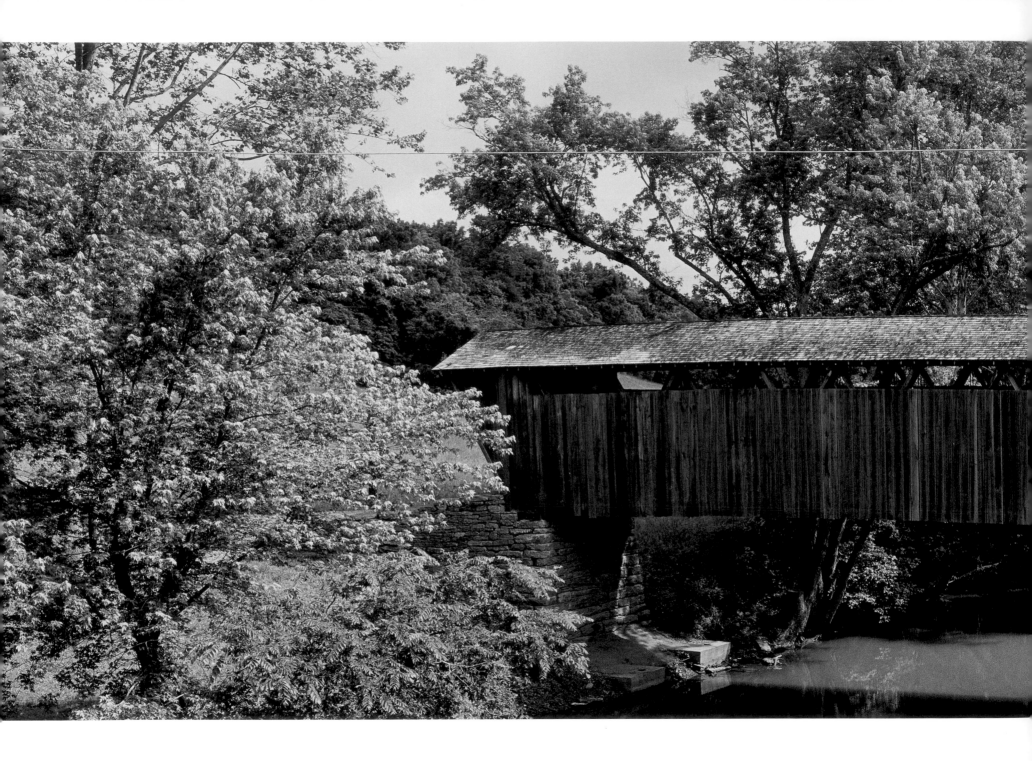

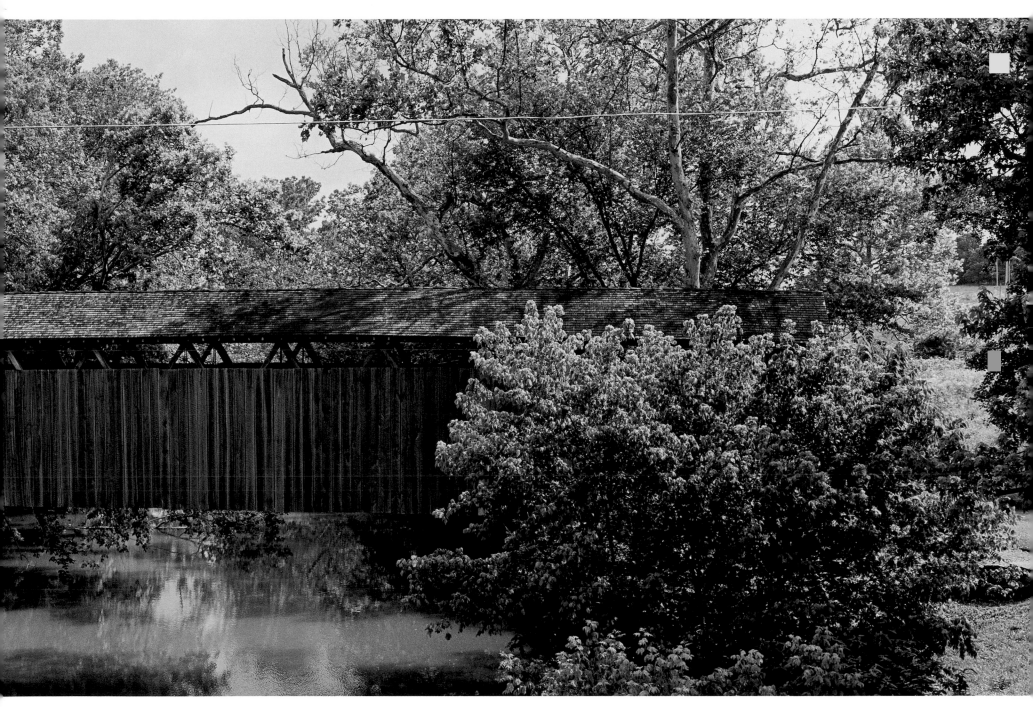

Switzer Covered Bridge • Franklin County

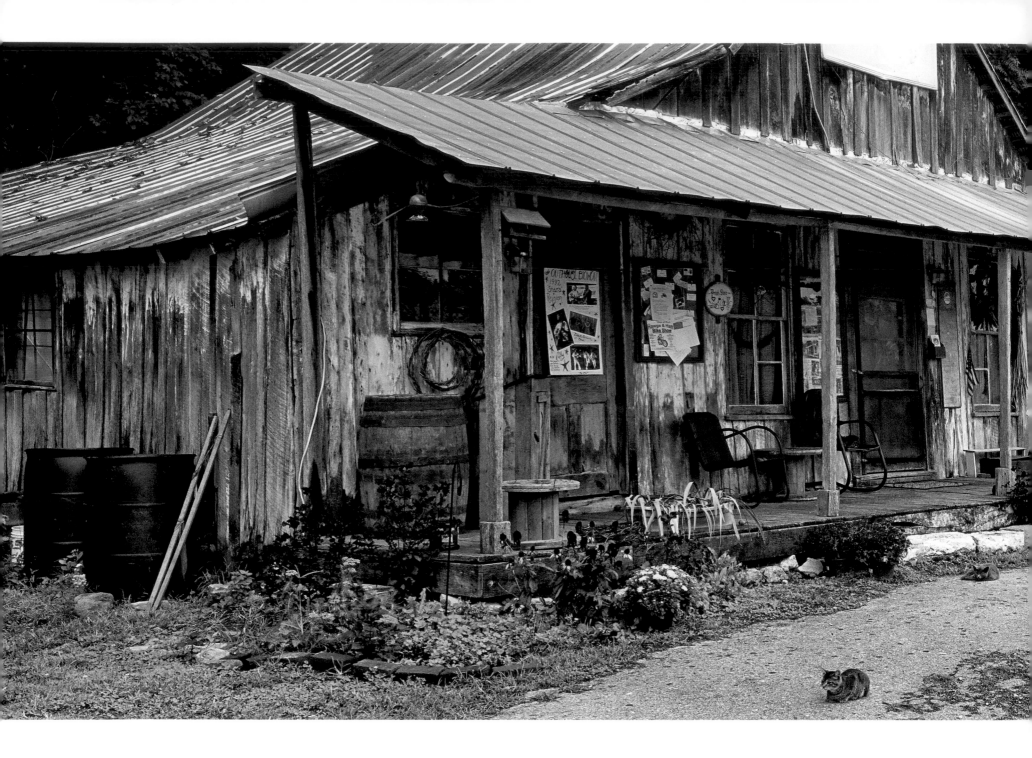

Penn's Store at Gravel Switch • Marion County

Colors of summer • Boyle County

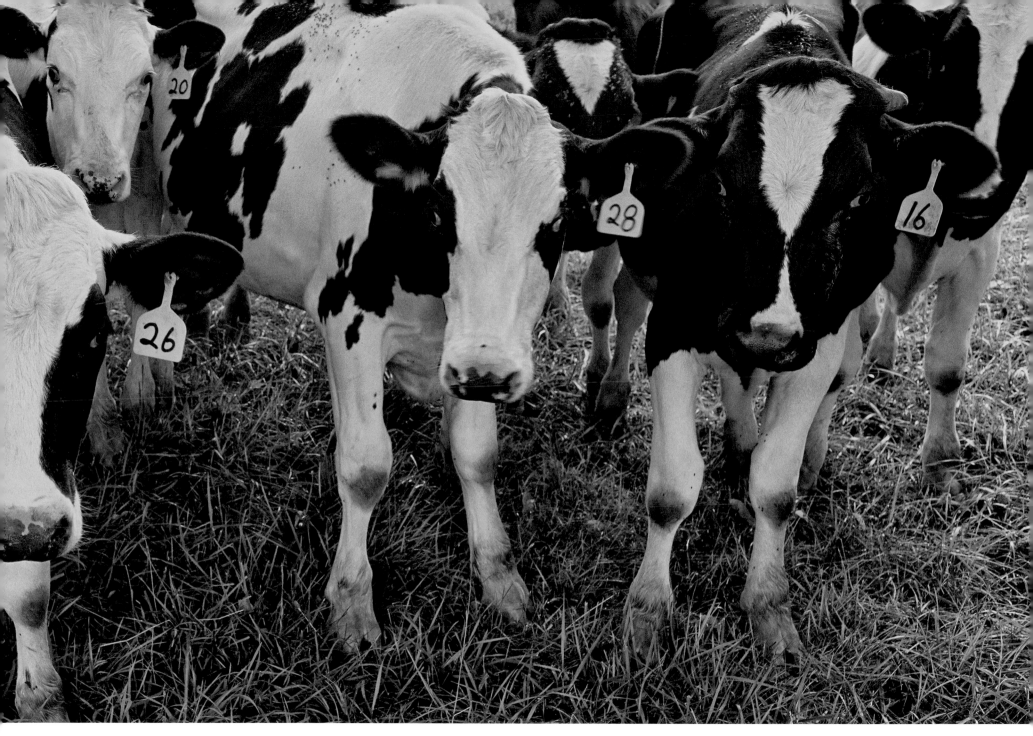

Curious cows • Garrard County

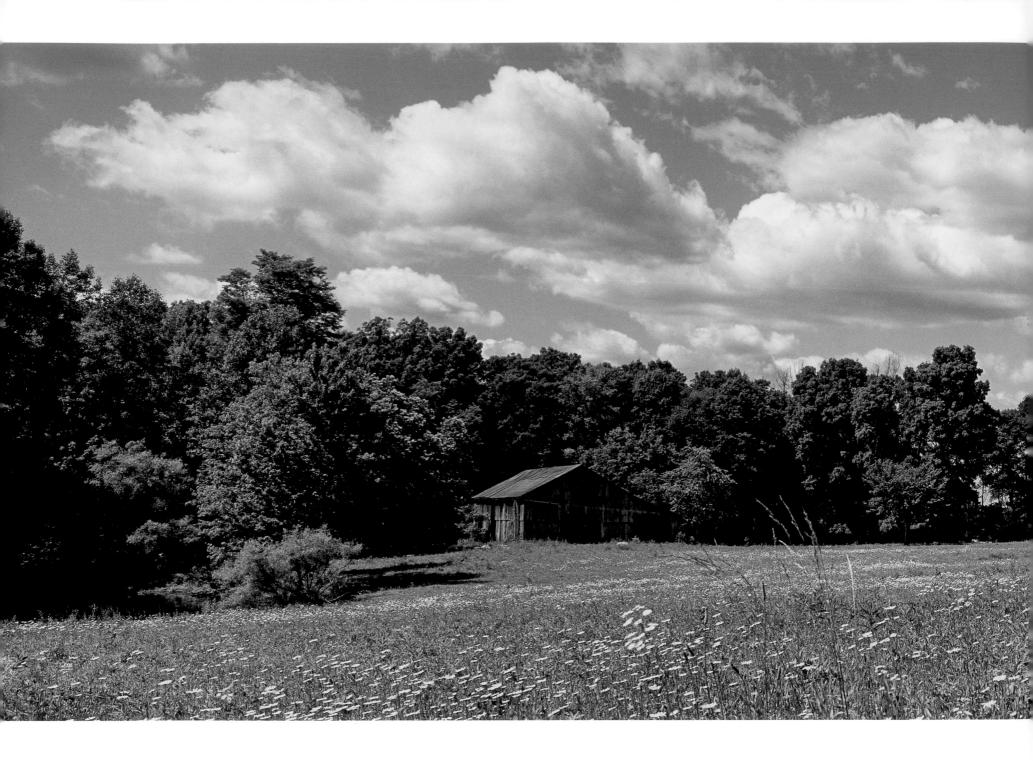

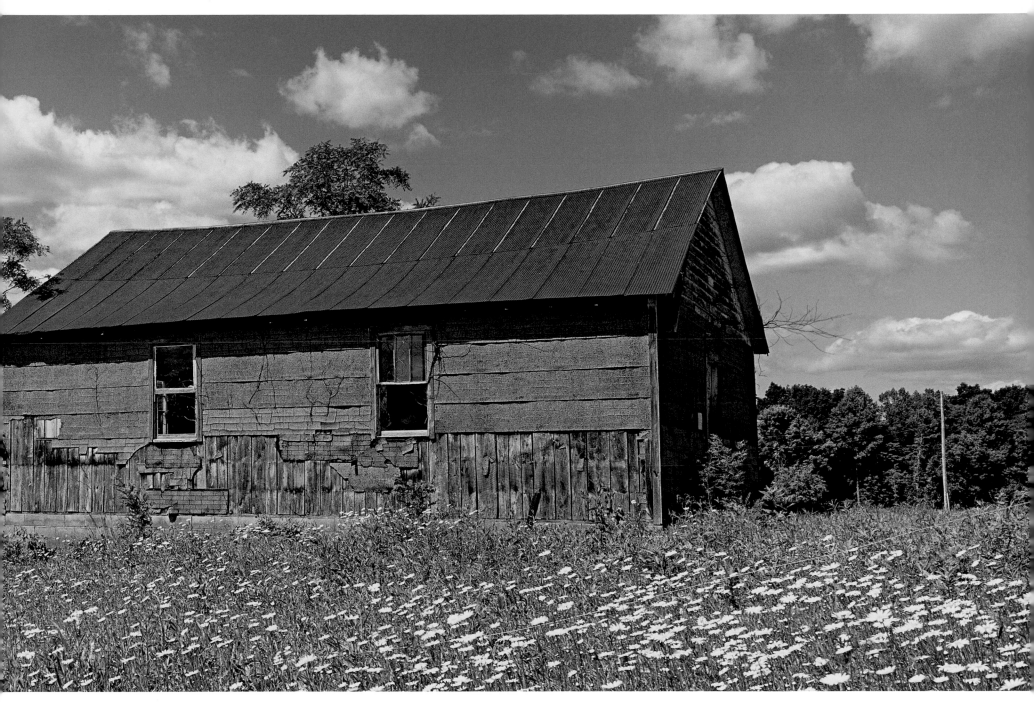

Old homestead · Pulaski County

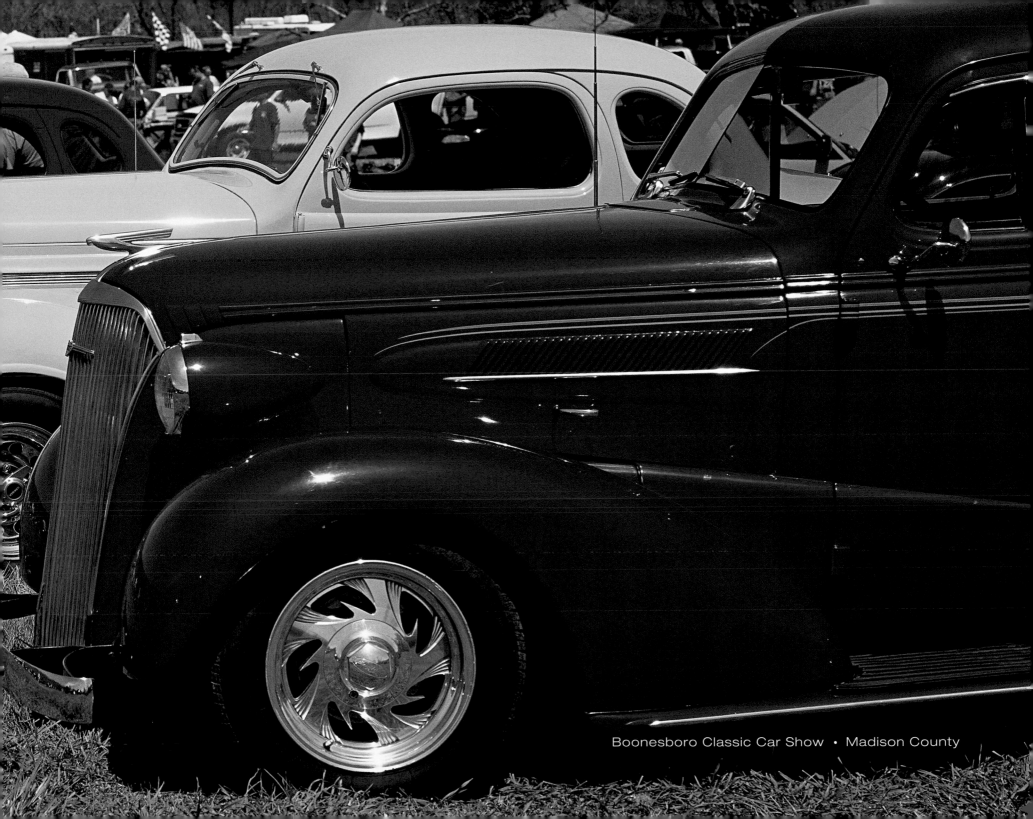

Boonesboro Classic Car Show • Madison County

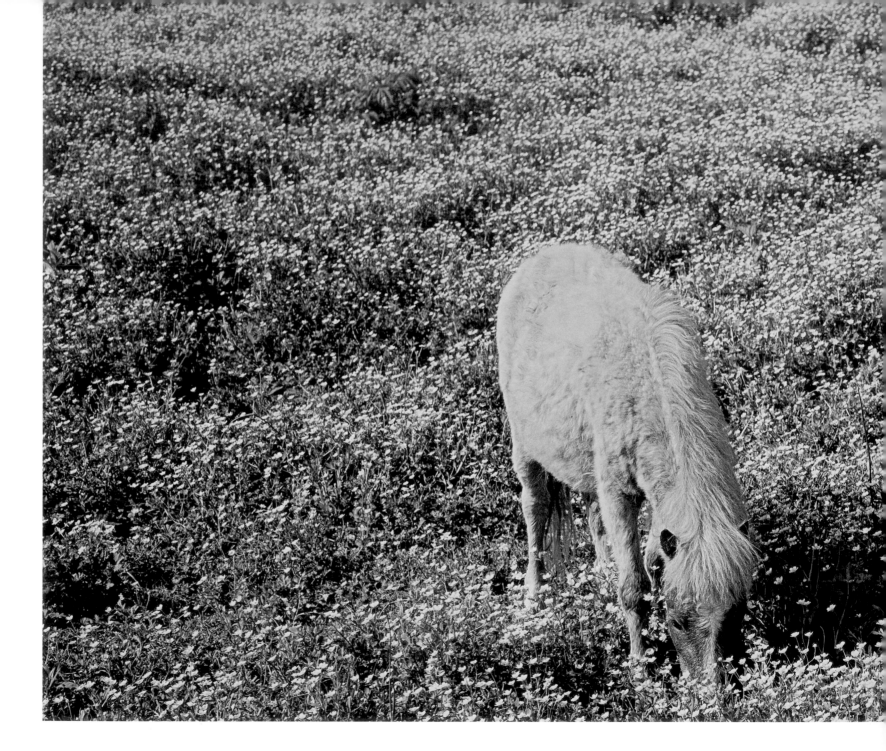

Miniature horses grazing • Fayette County

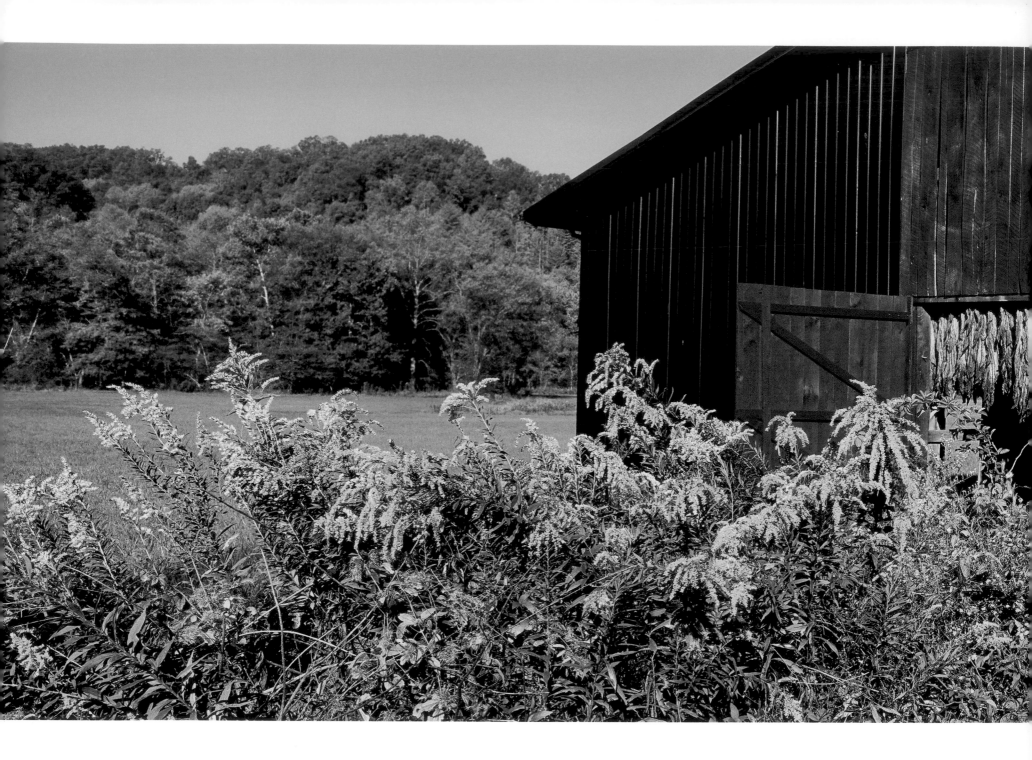

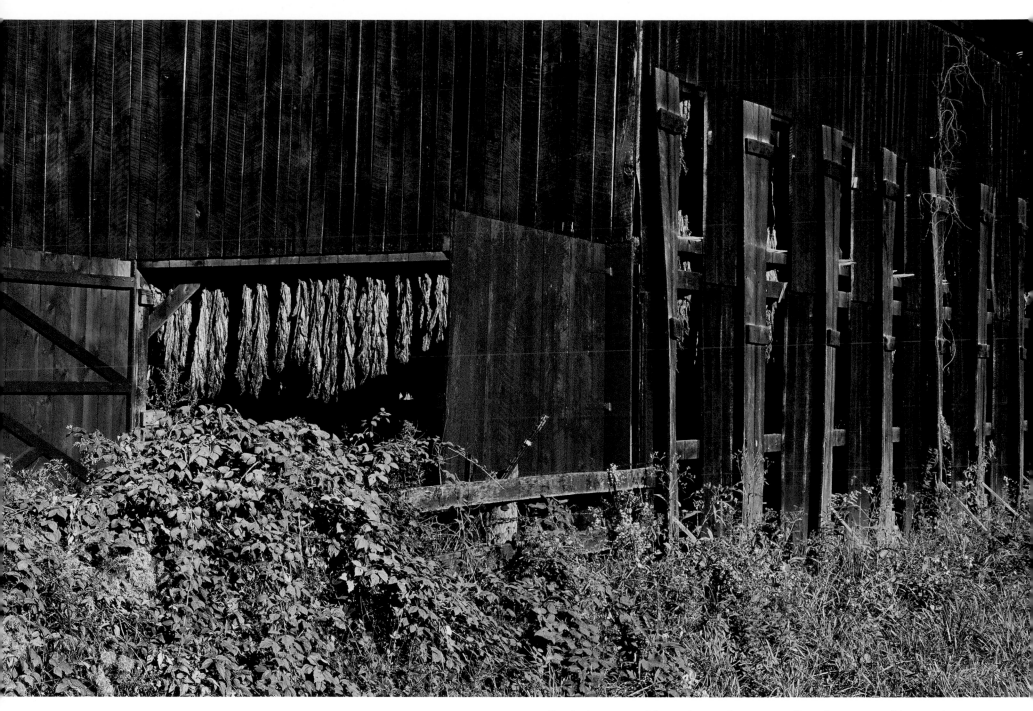

Red doors and hanging tobacco • Southeastern Kentucky

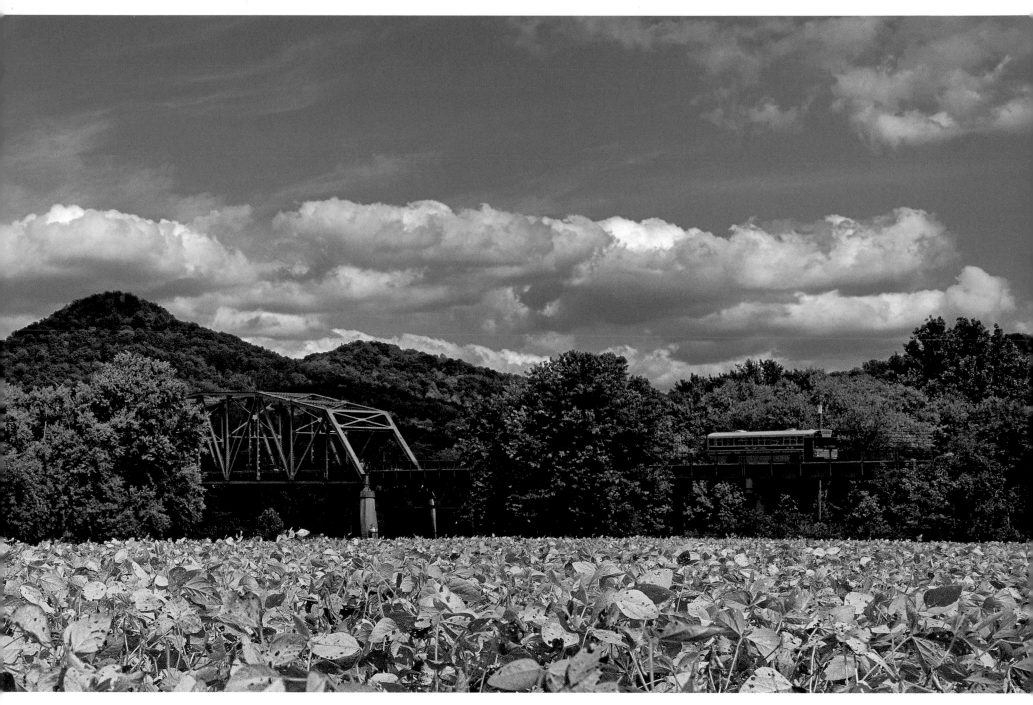

Soybean field • Estill County

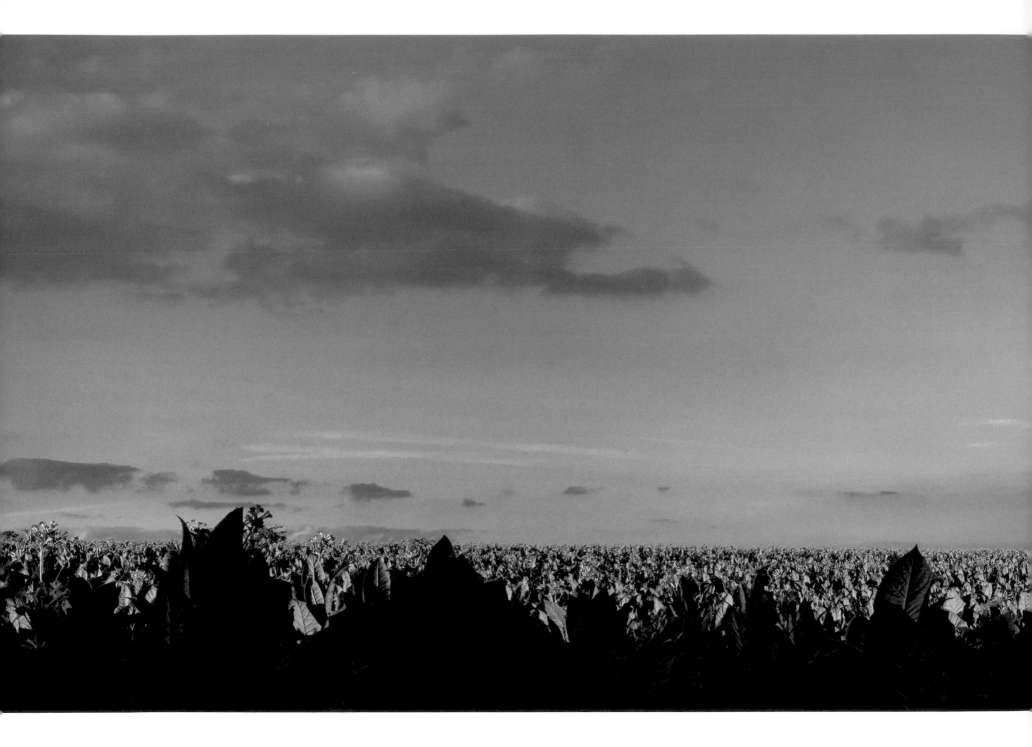

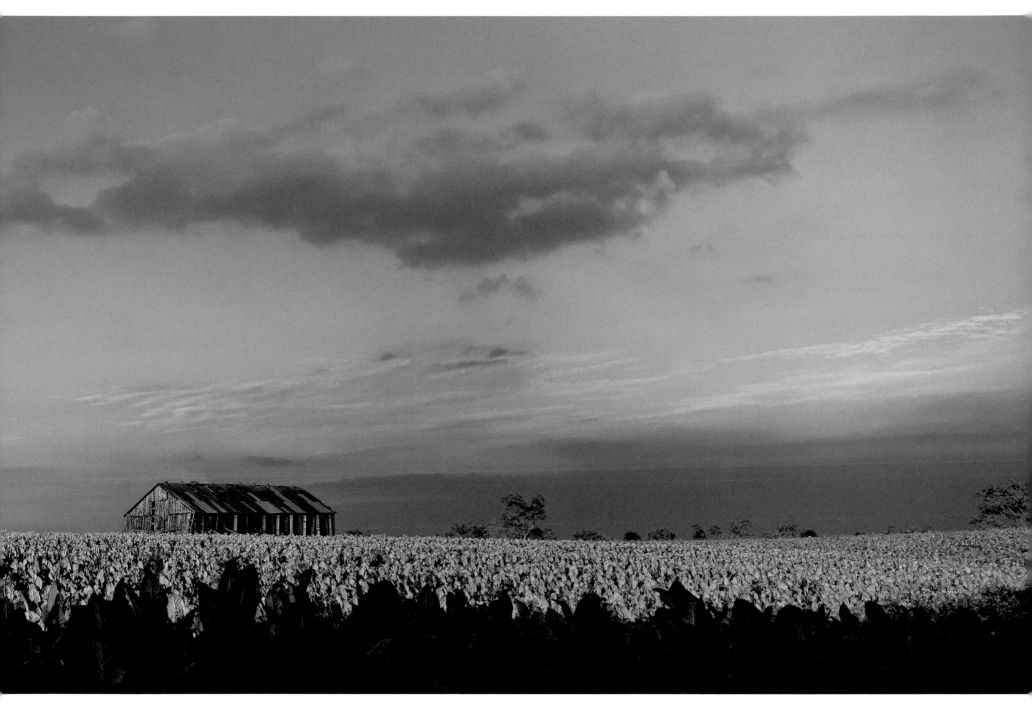

Tobacco field • Fayette County

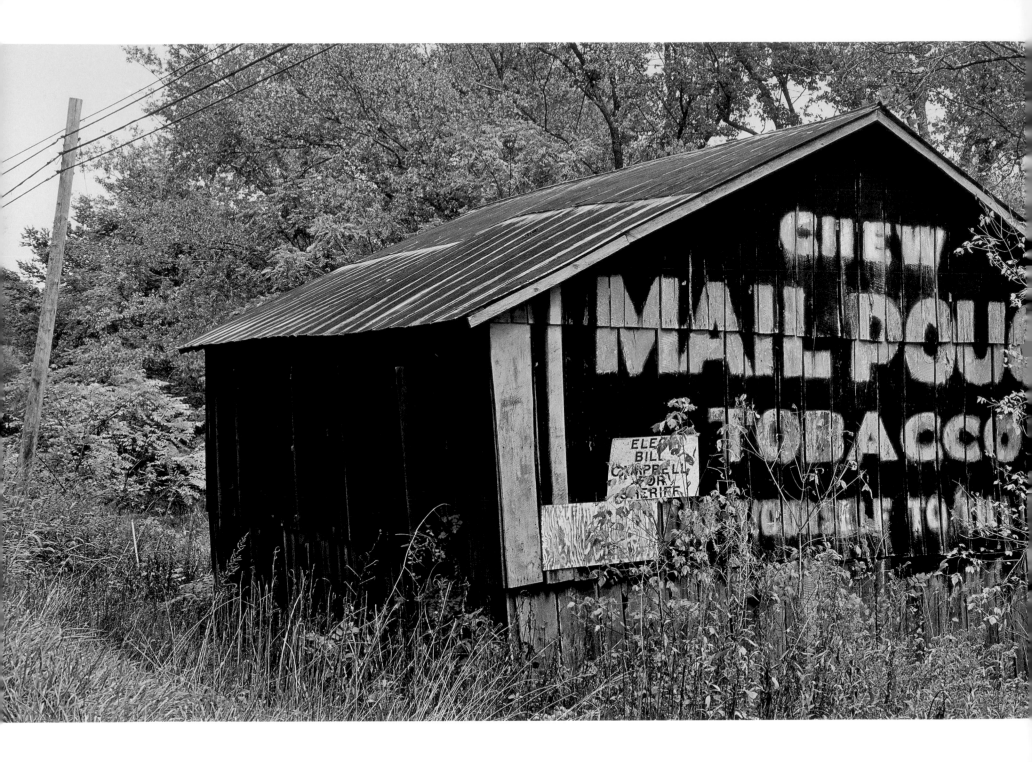

Mail Pouch barn • Owsley County

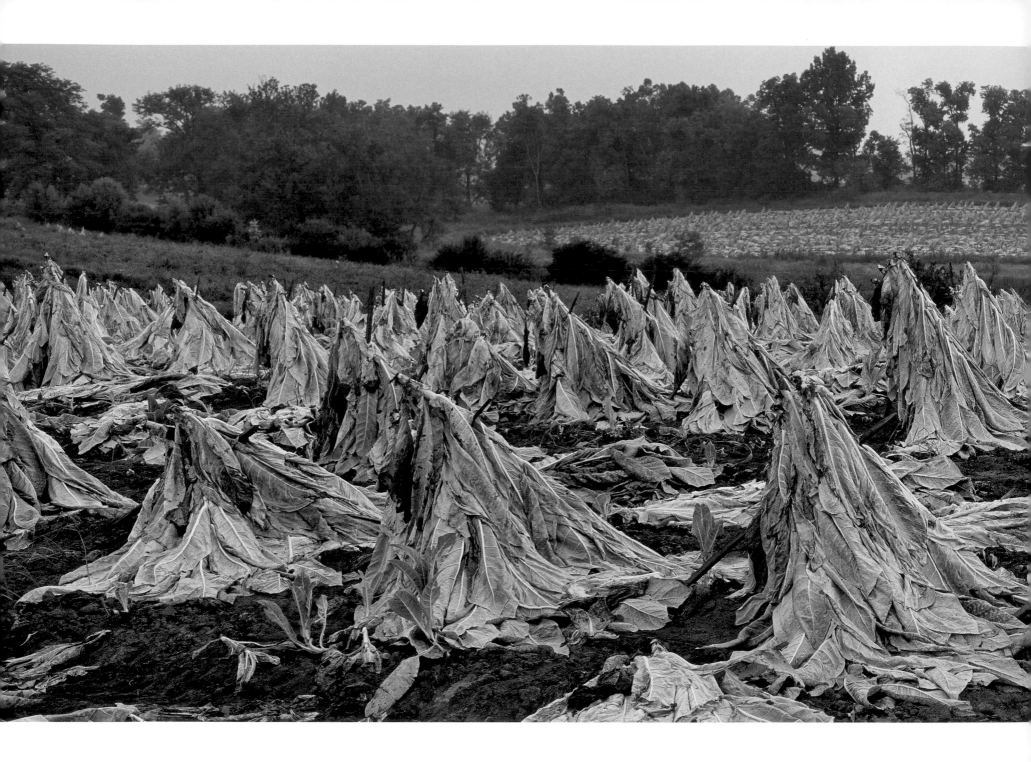

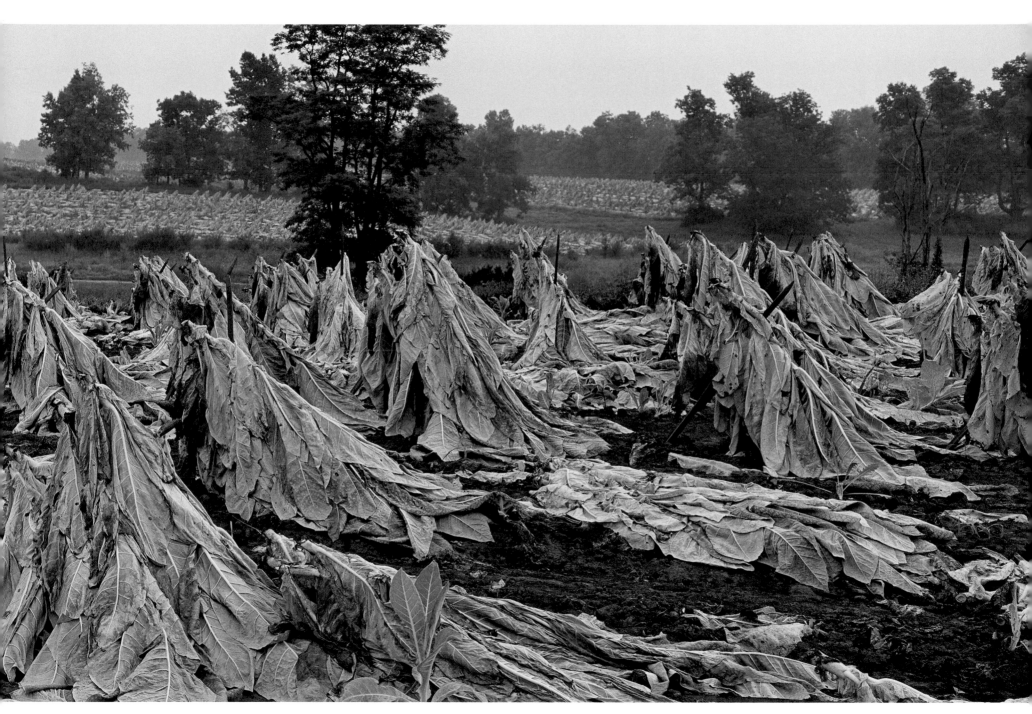

Tobacco, after the cutting • Fayette County

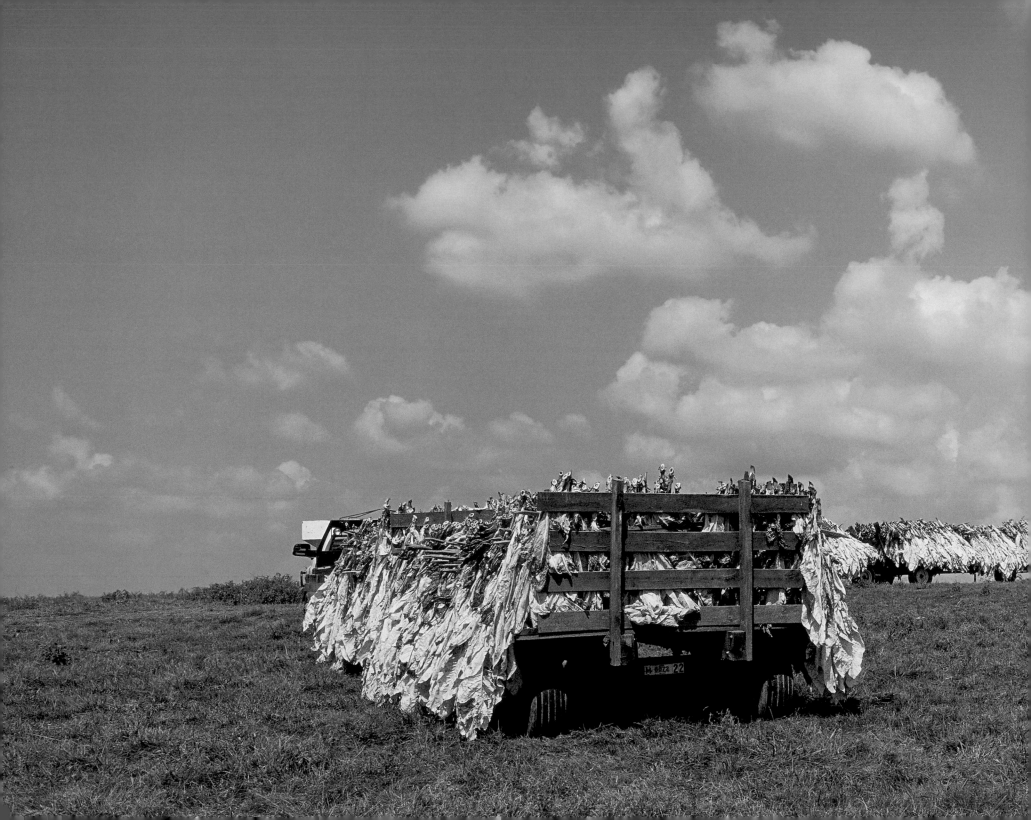

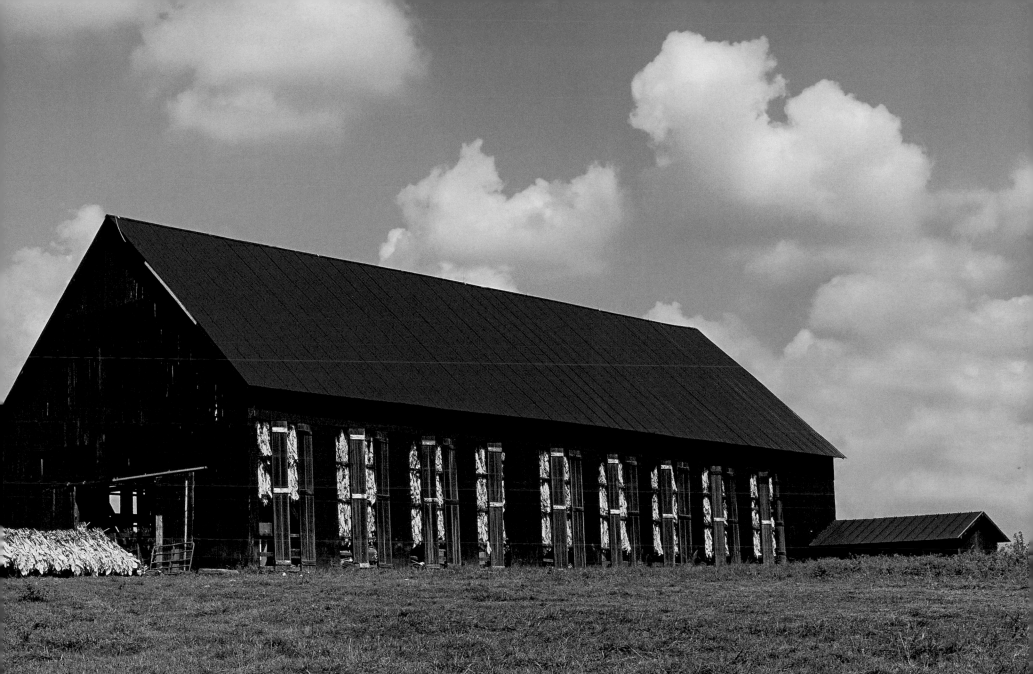

Tobacco housing • Fayette County

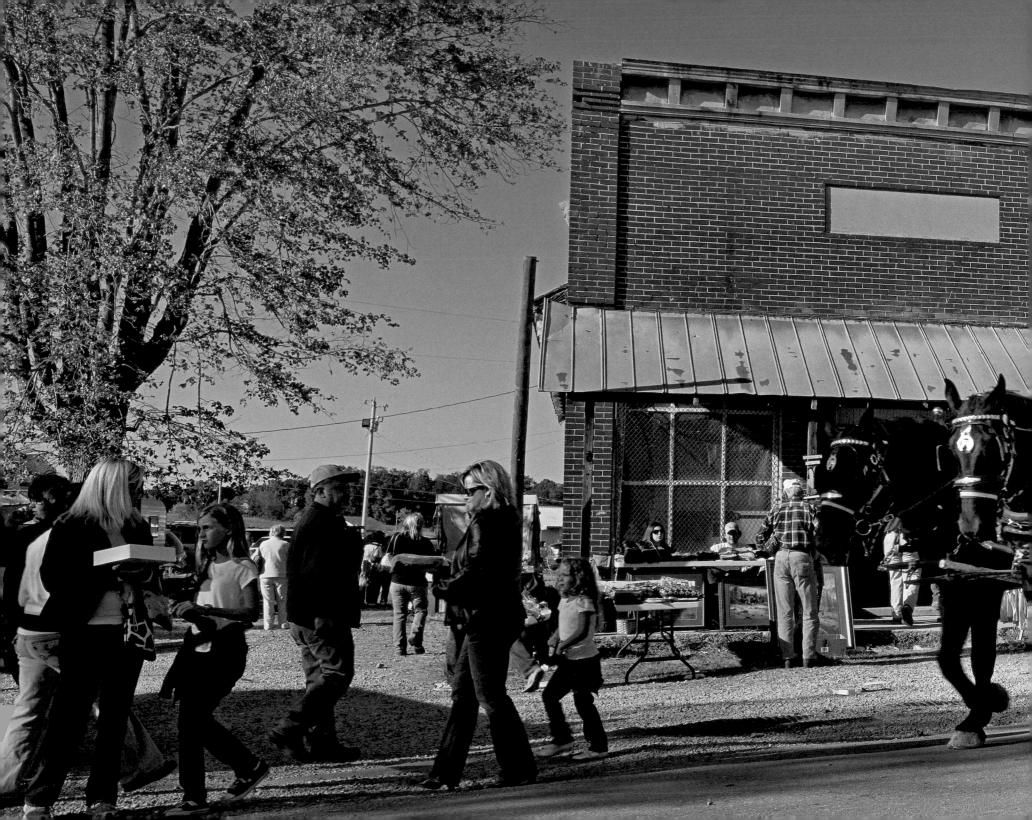

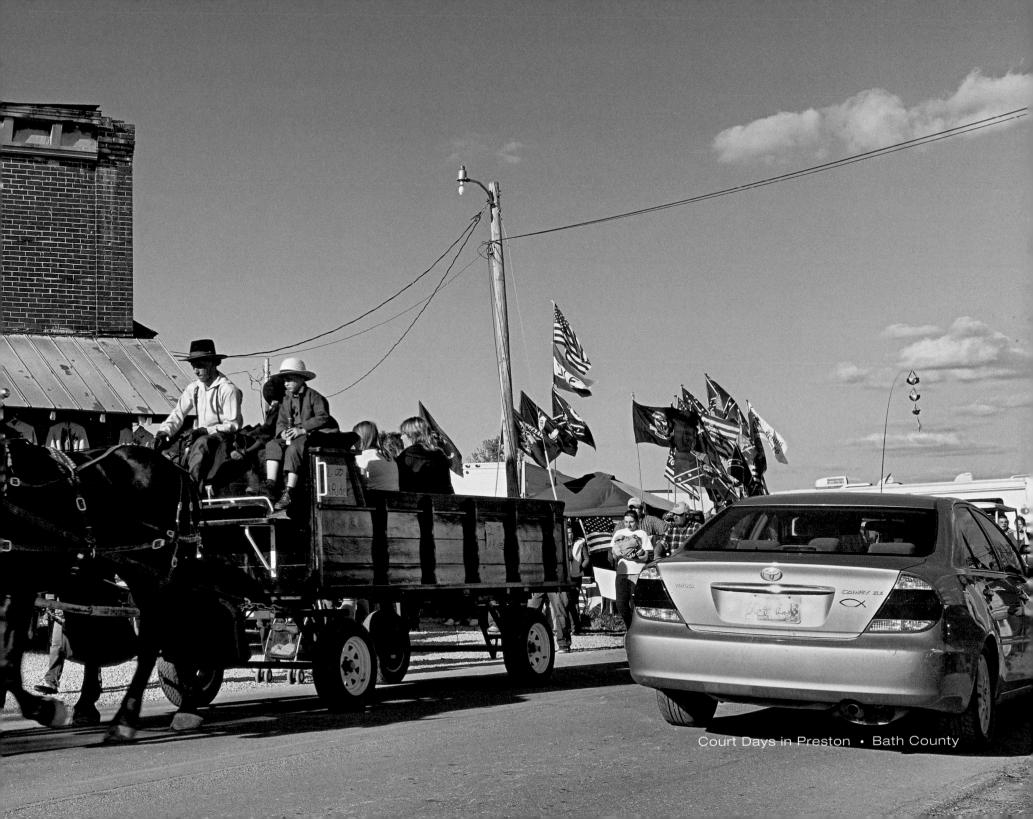

Court Days in Preston • Bath County

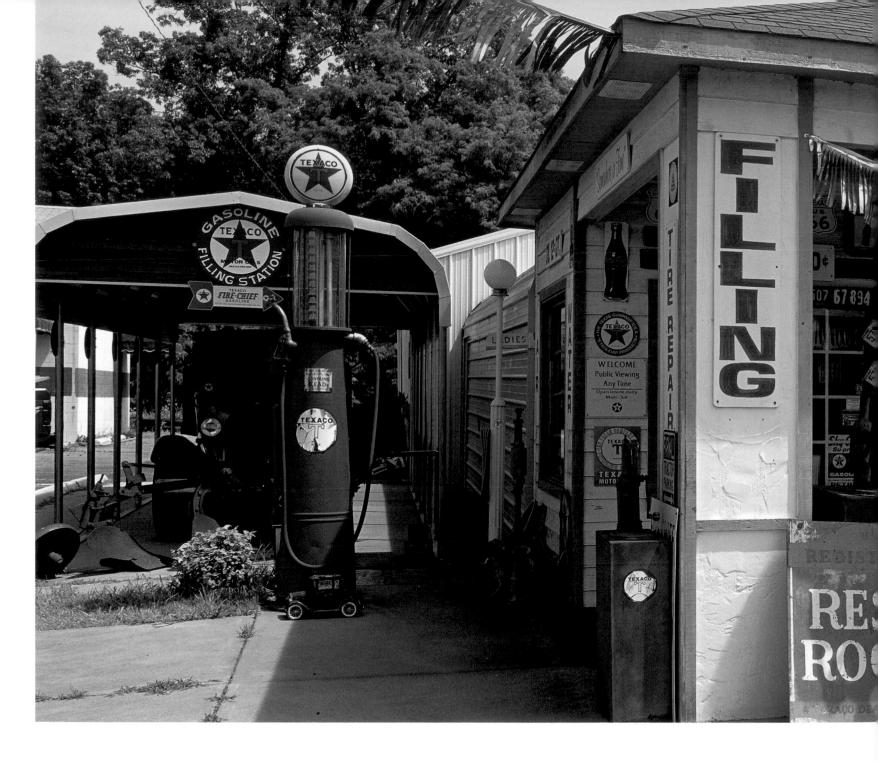

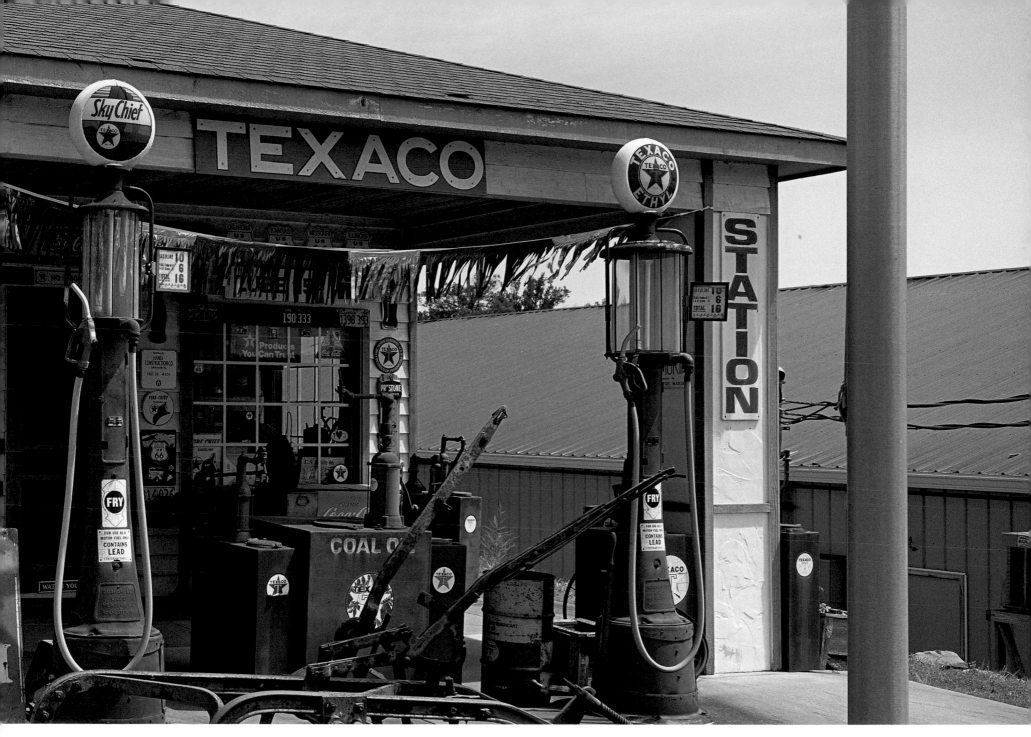

Texaco filling station • Western Kentucky

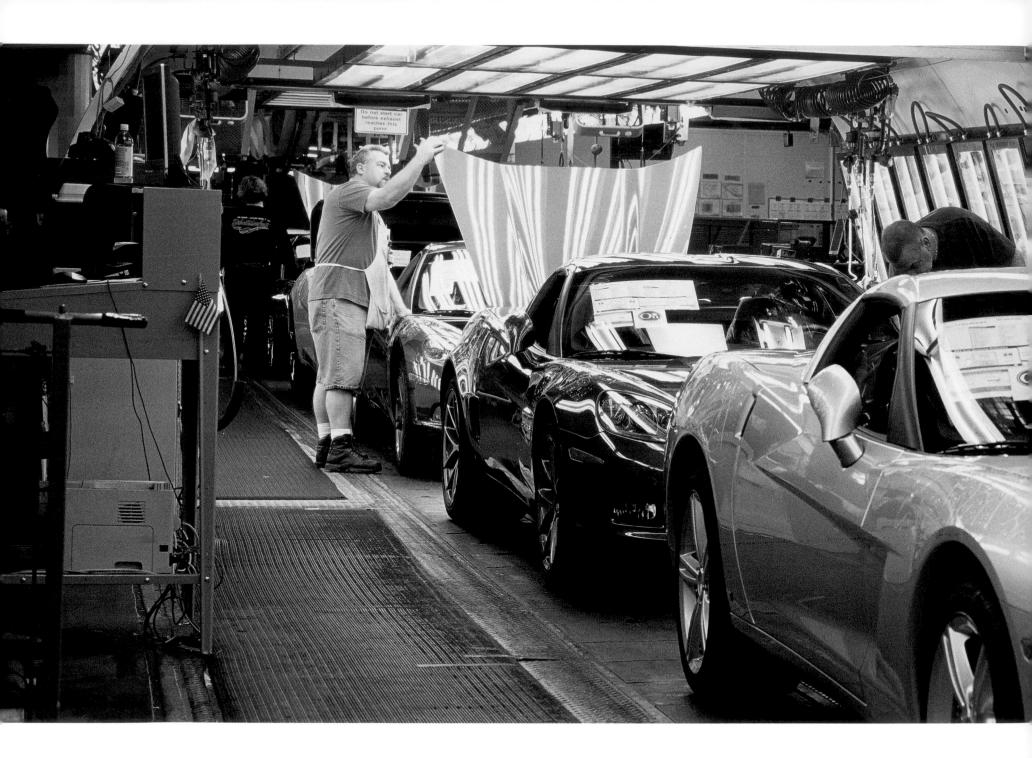

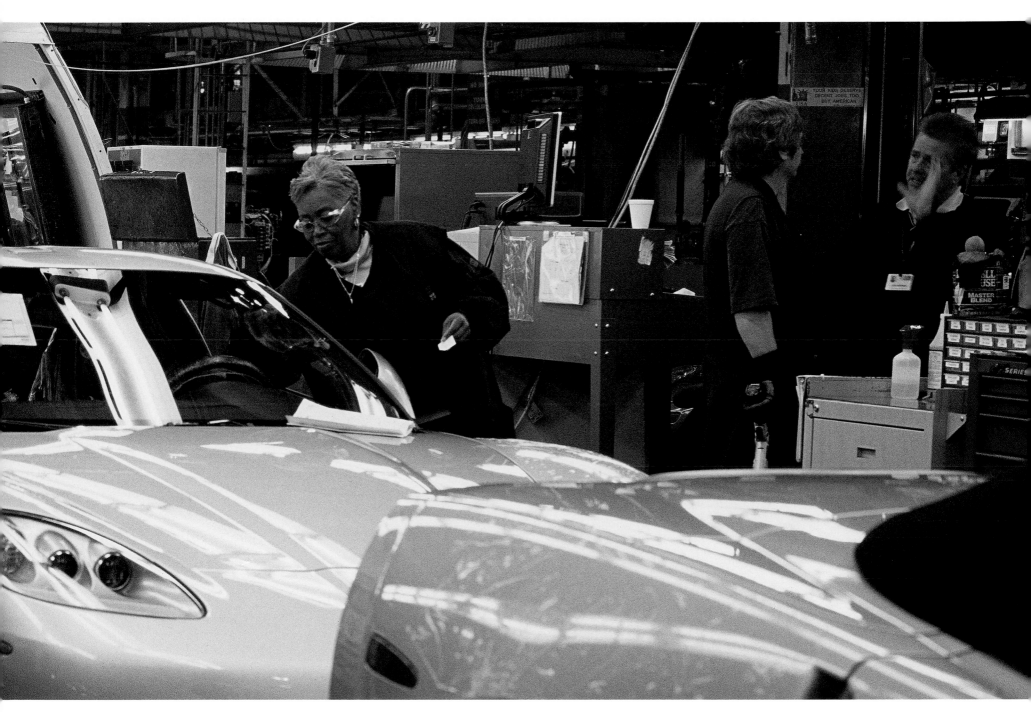

Chevrolet Corvette assembly • Warren County

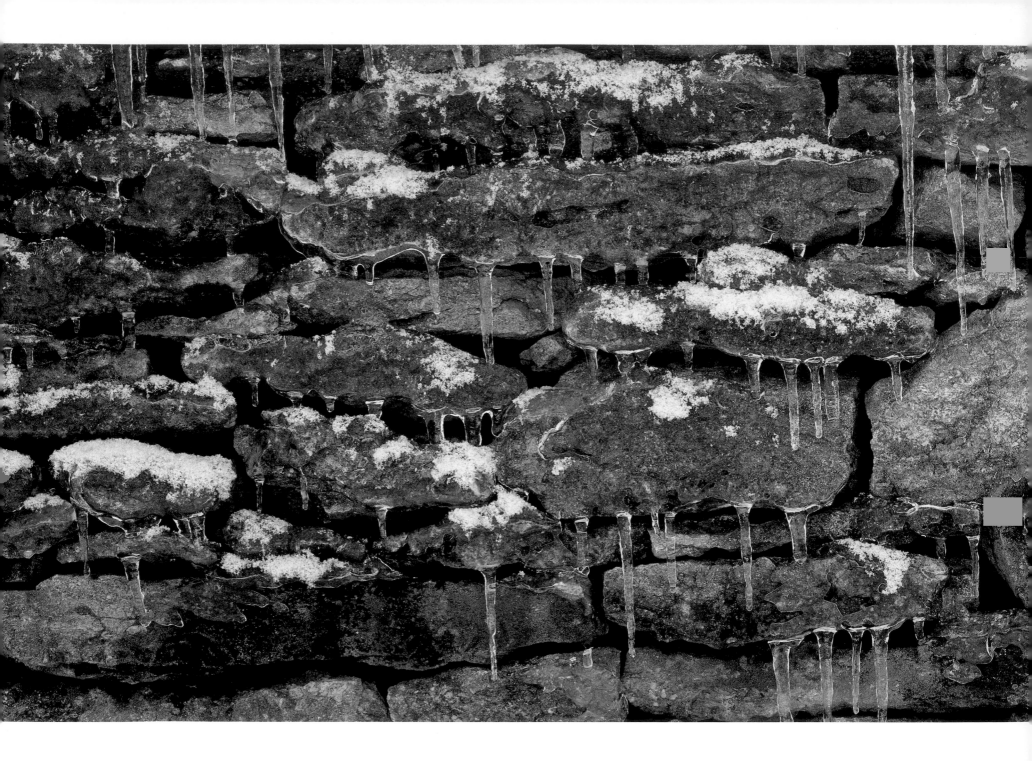

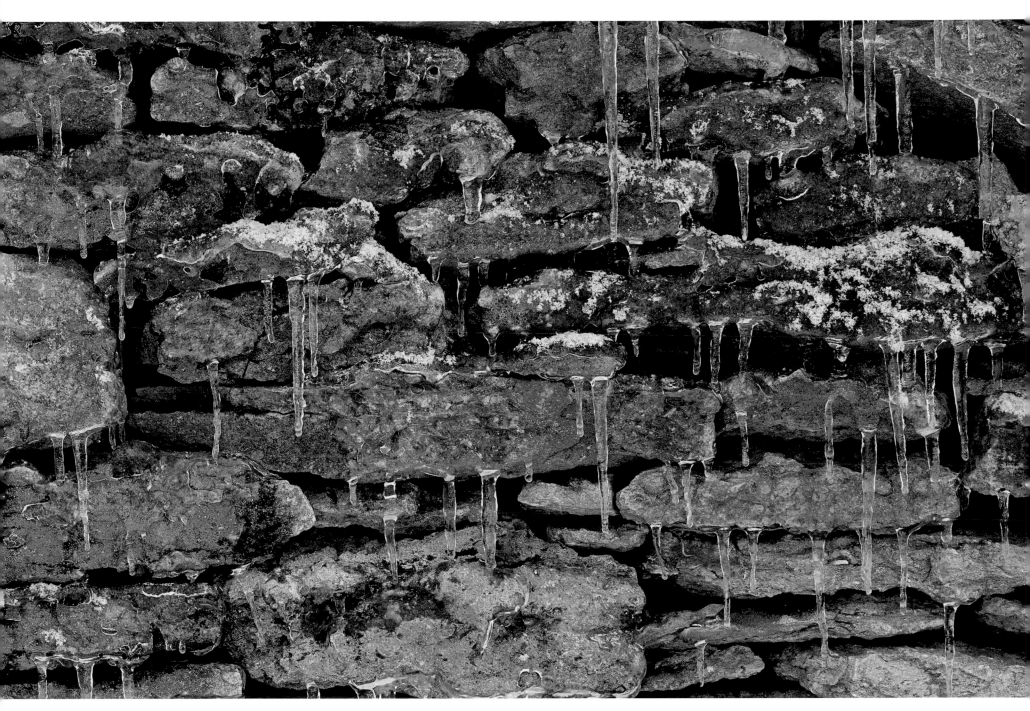

Shaker rock wall in winter • Mercer County

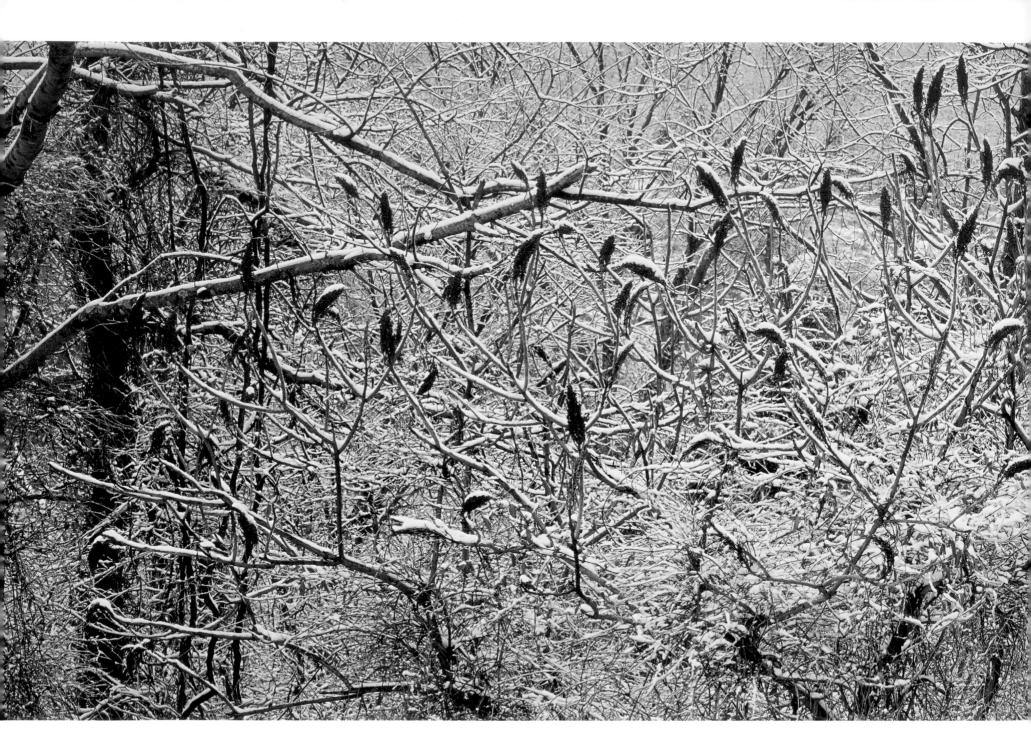

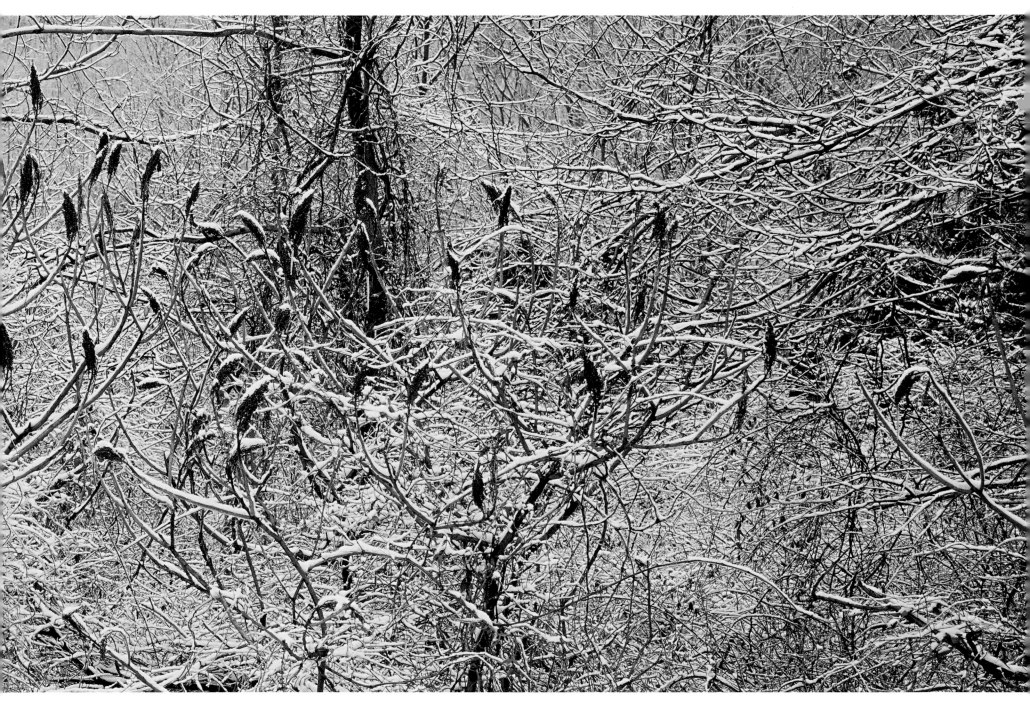

Winter storm • Grant County

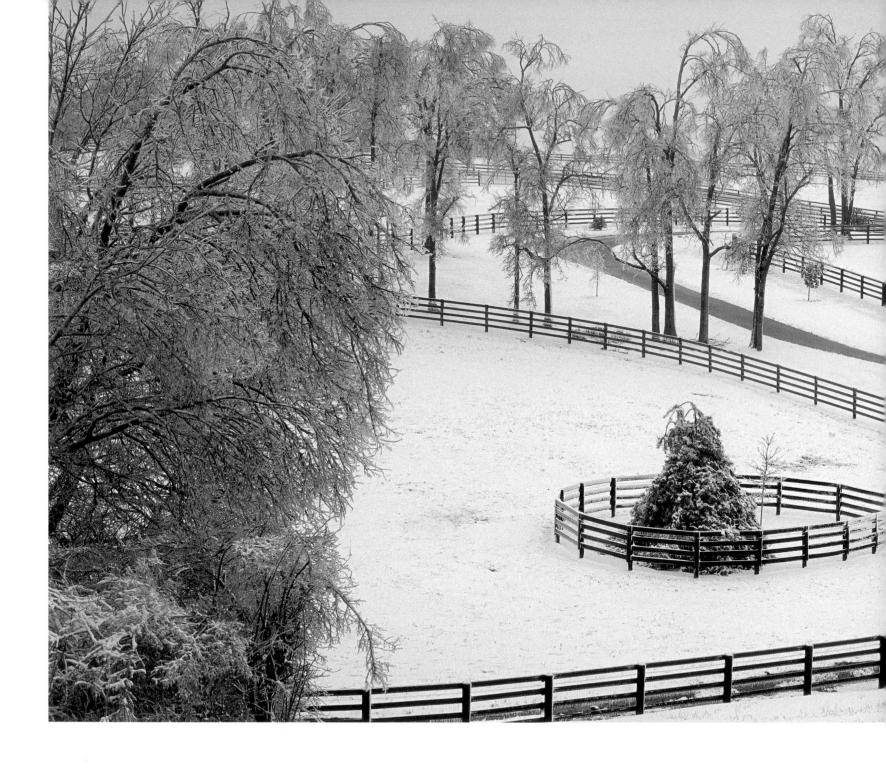

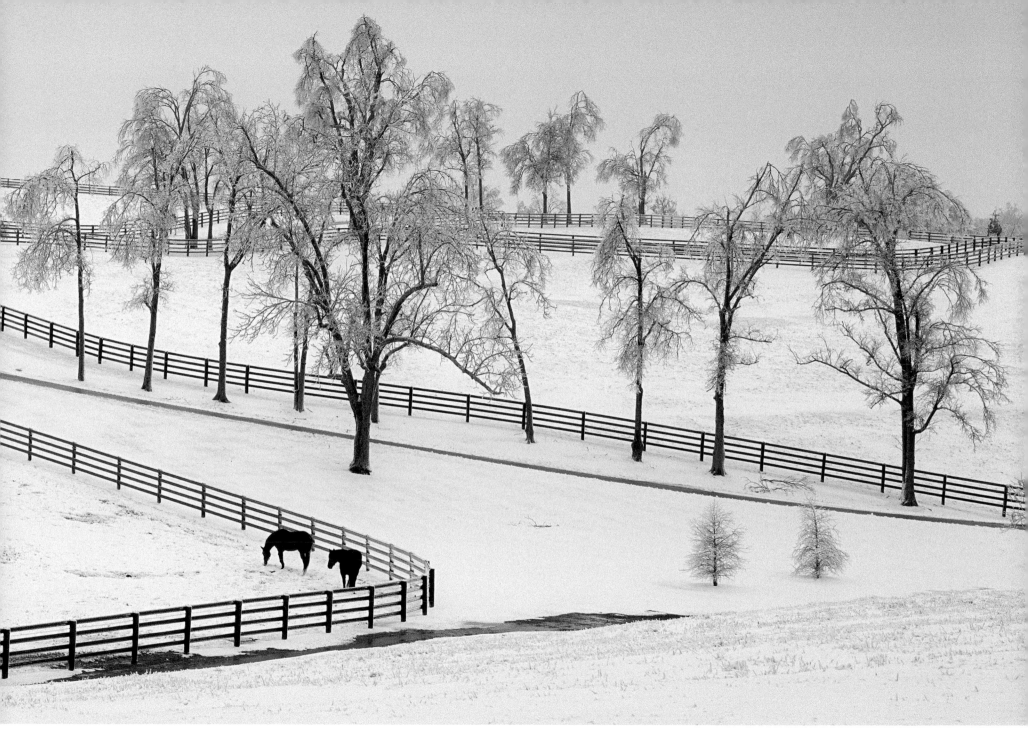

Winter solace • Fayette County

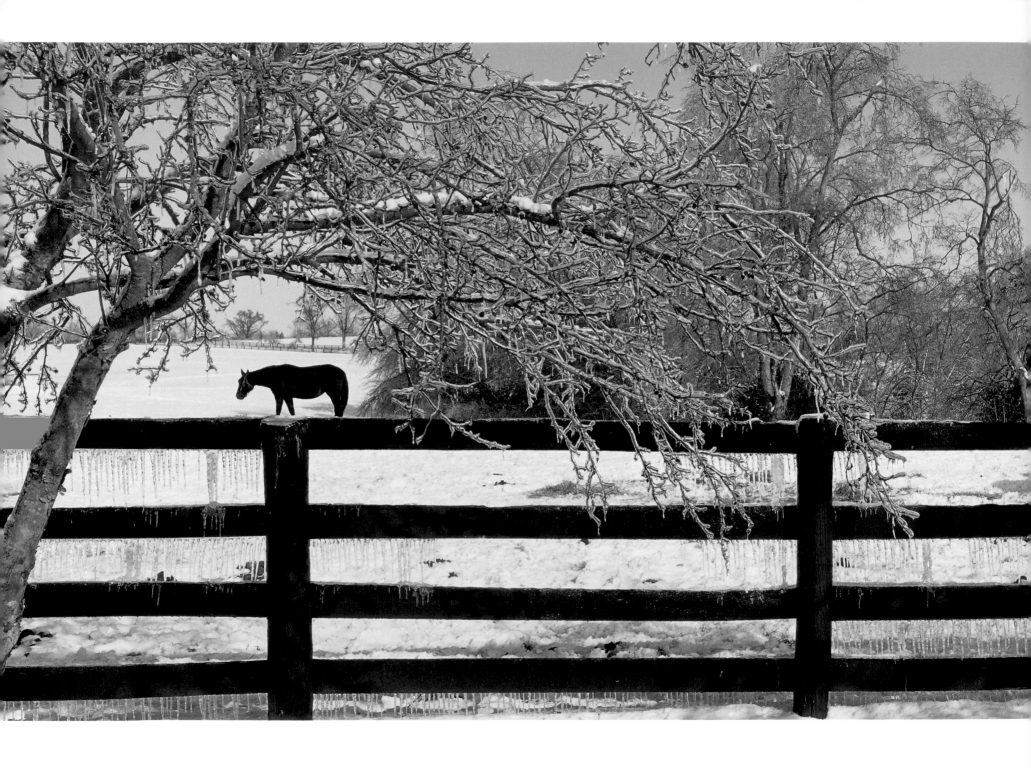

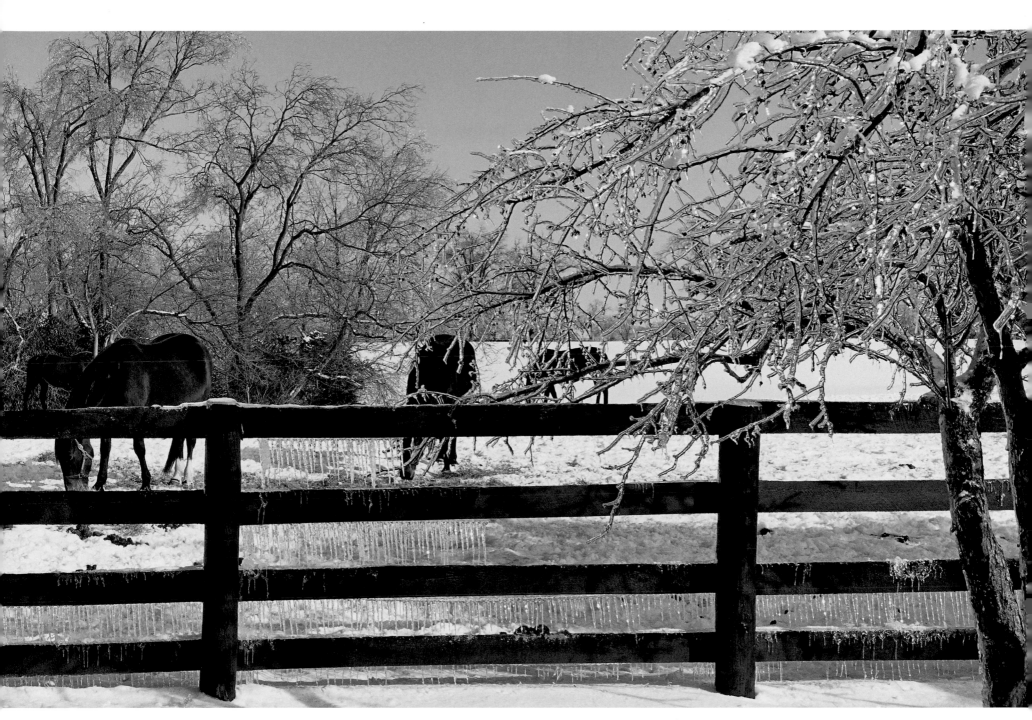

Ice storm and horses • Bourbon County

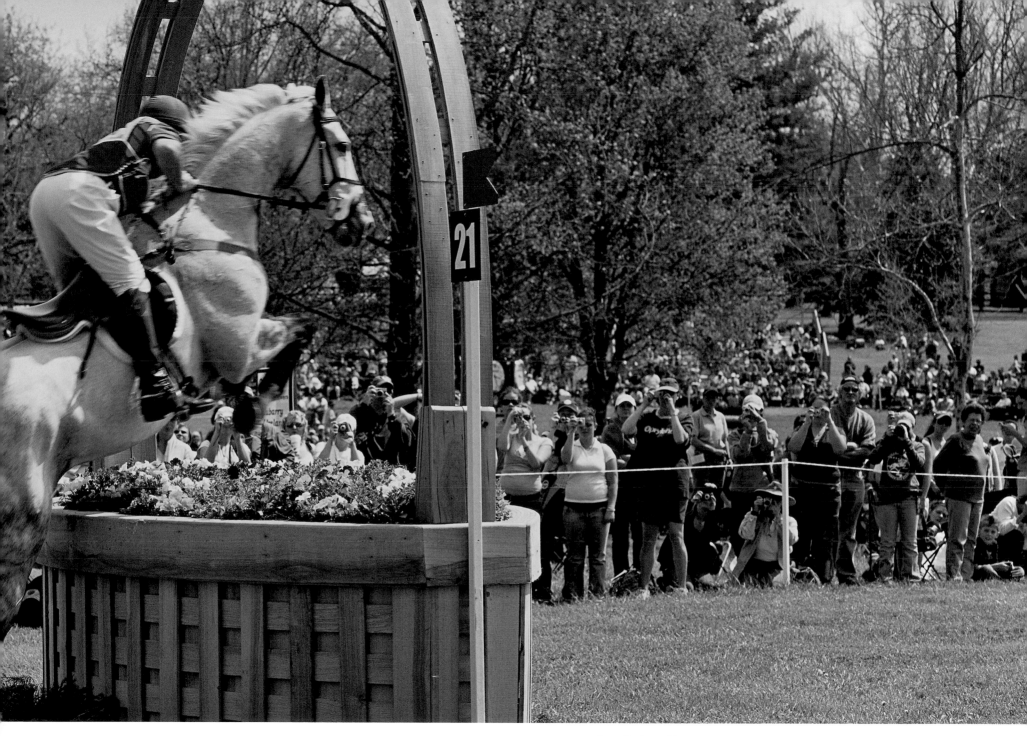

Rolex Three Day Event, 2008 • Fayette County

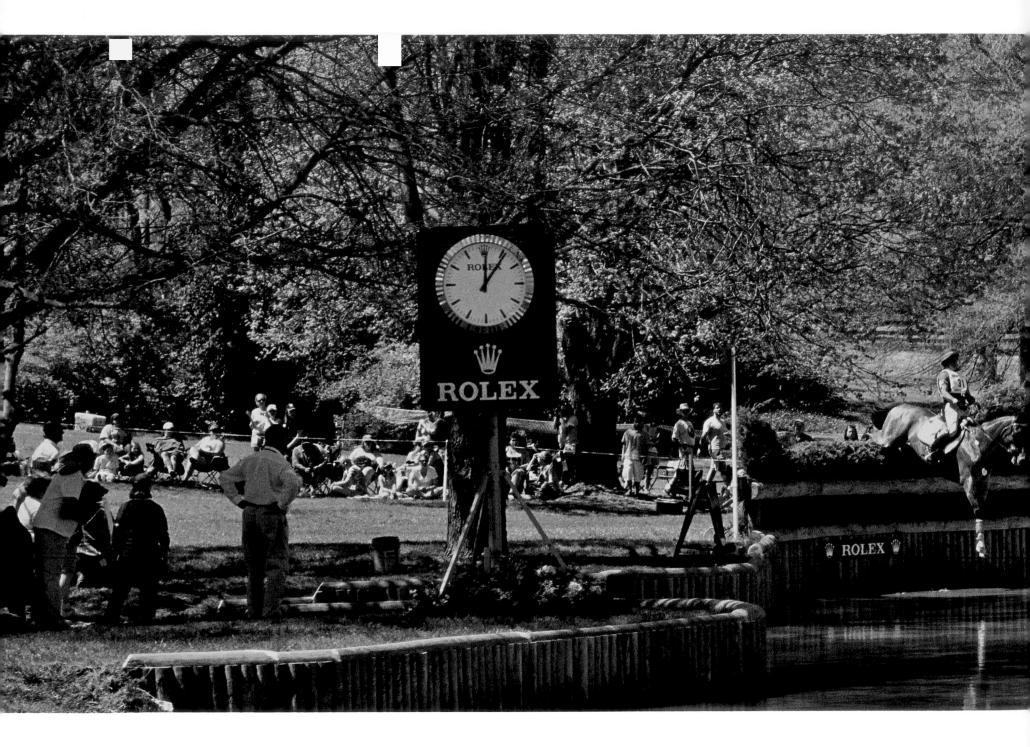

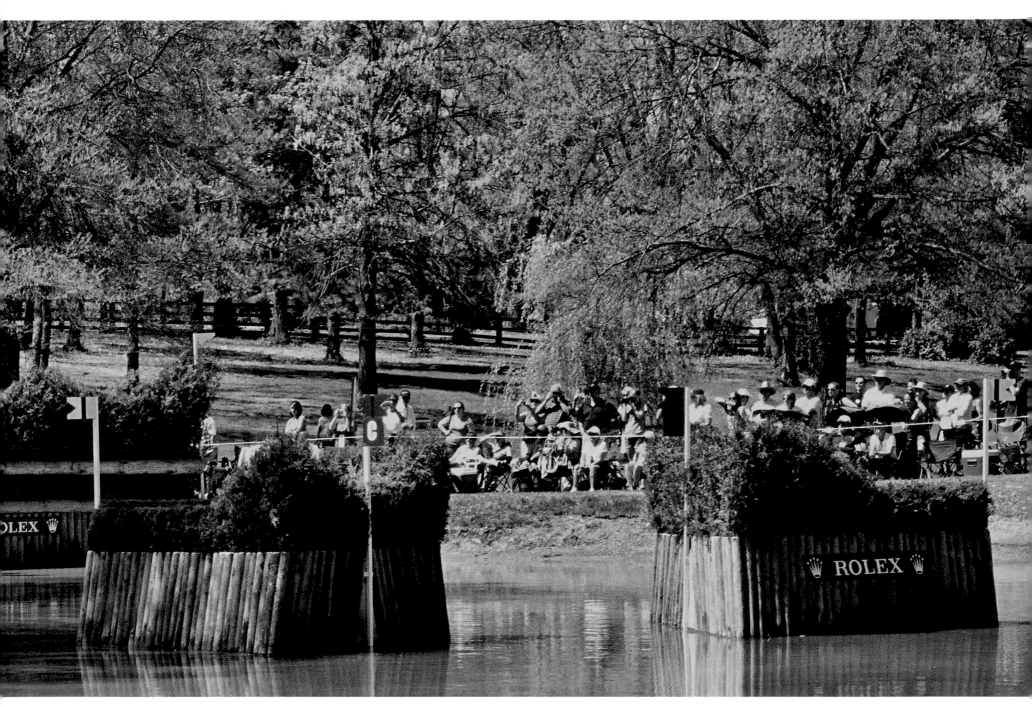

Rolex Three Day Event, 2009 • Fayette County

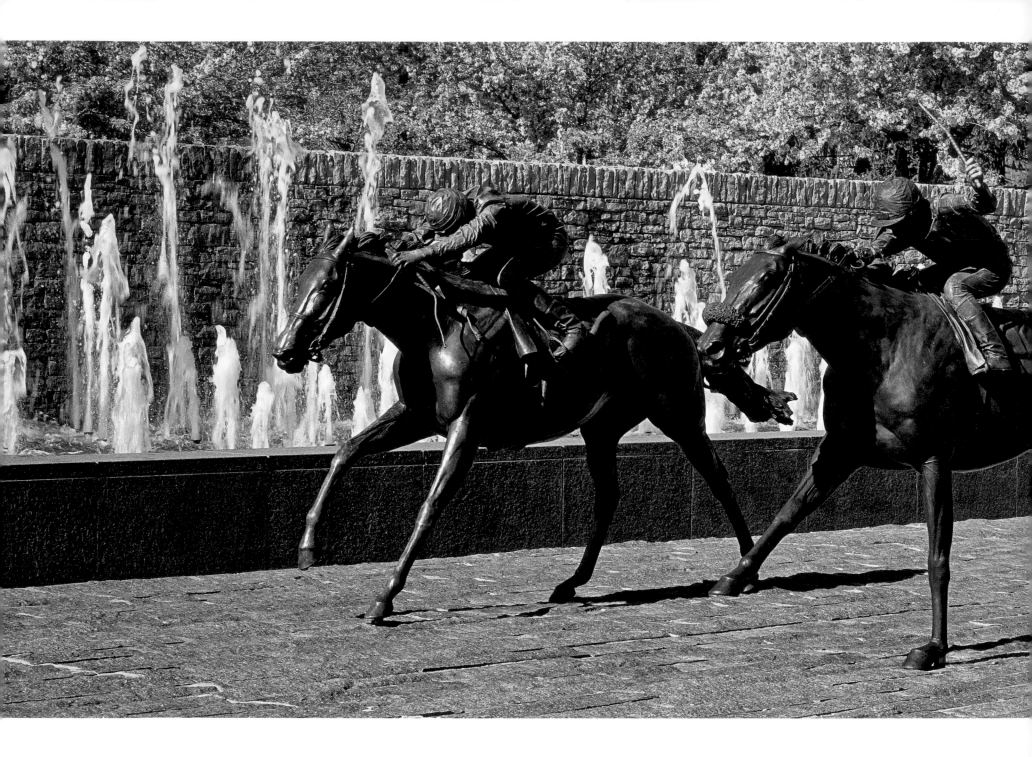

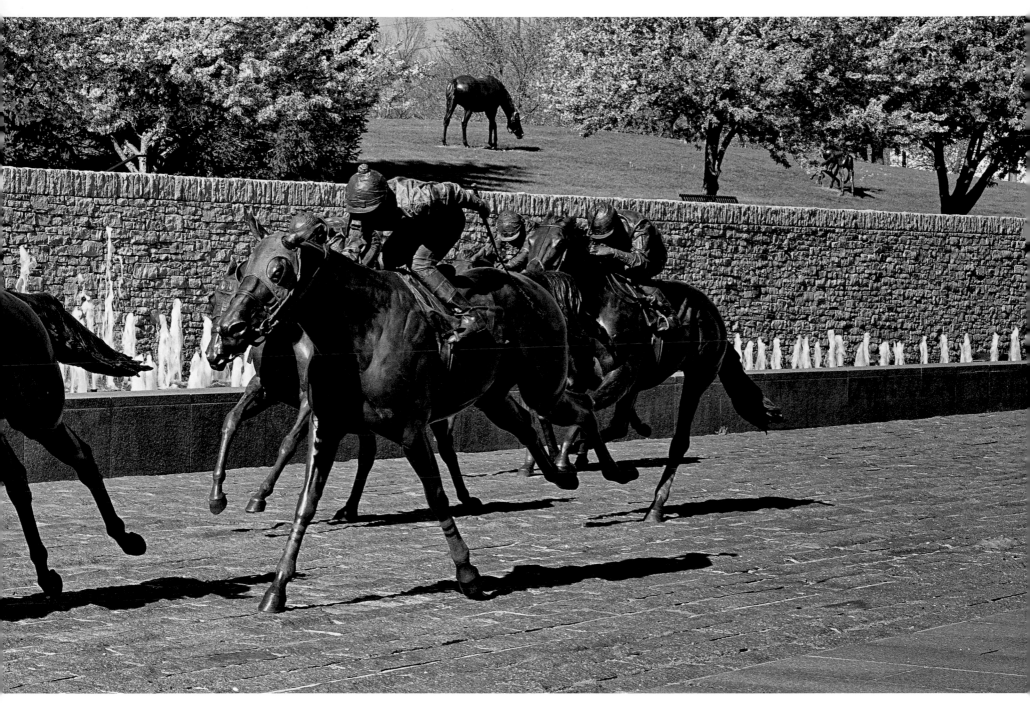

Thoroughbred Park • Fayette County

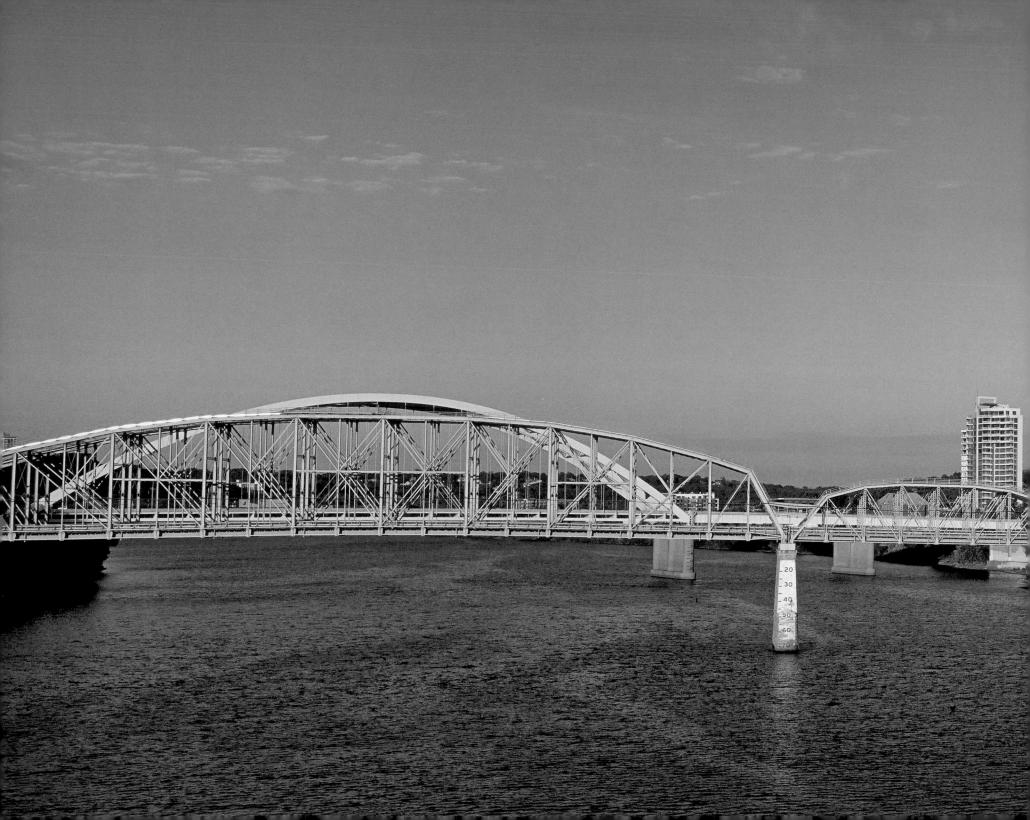

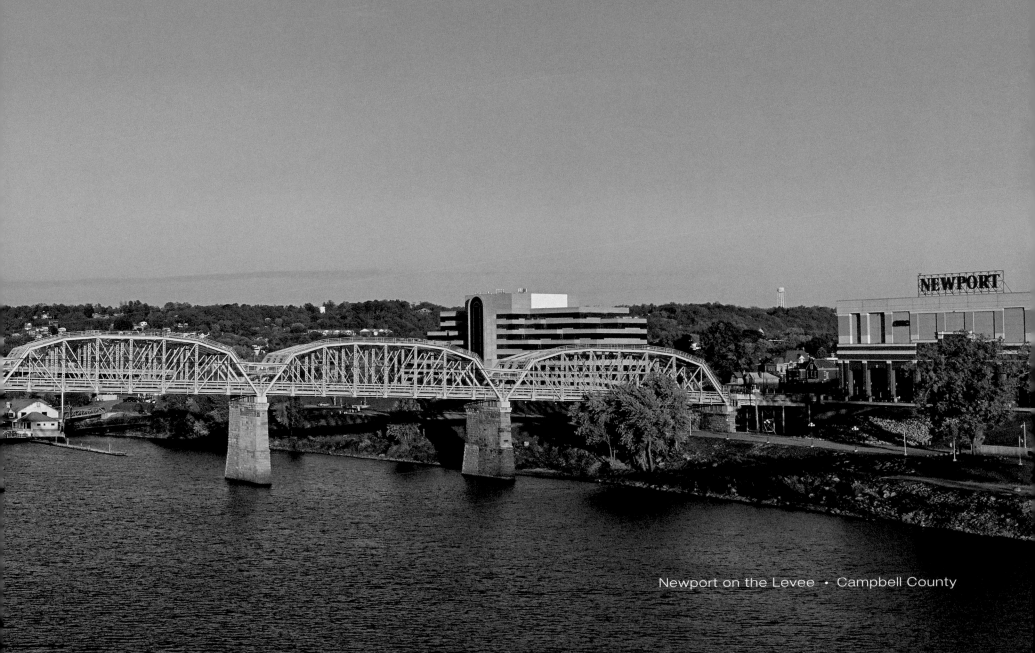

Newport on the Levee • Campbell County

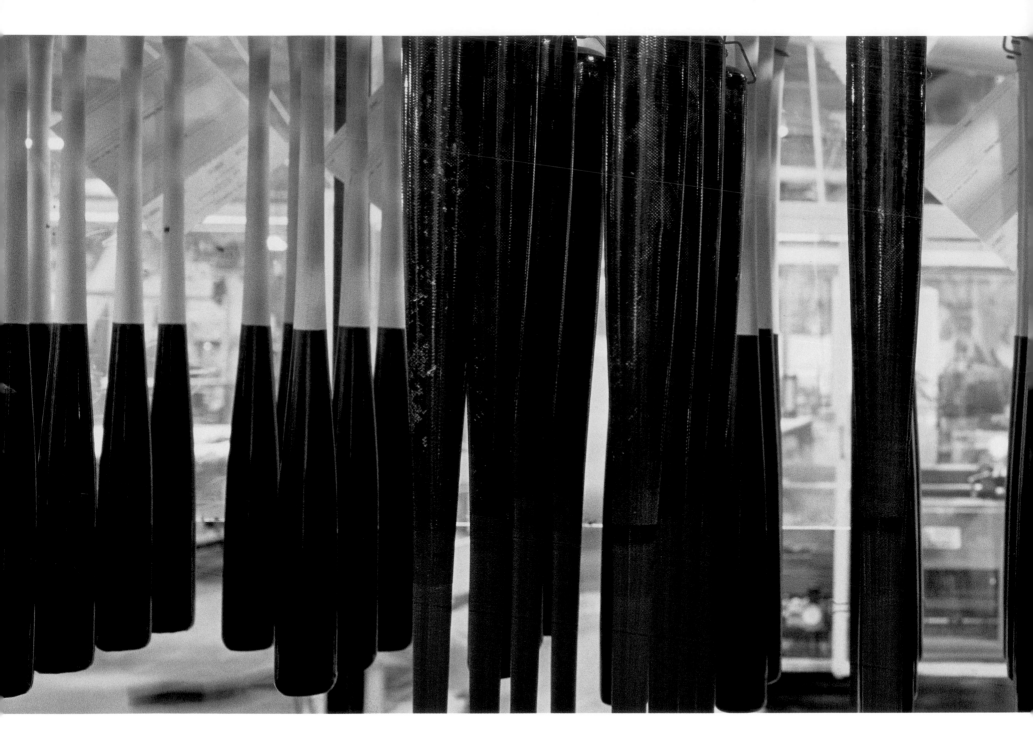

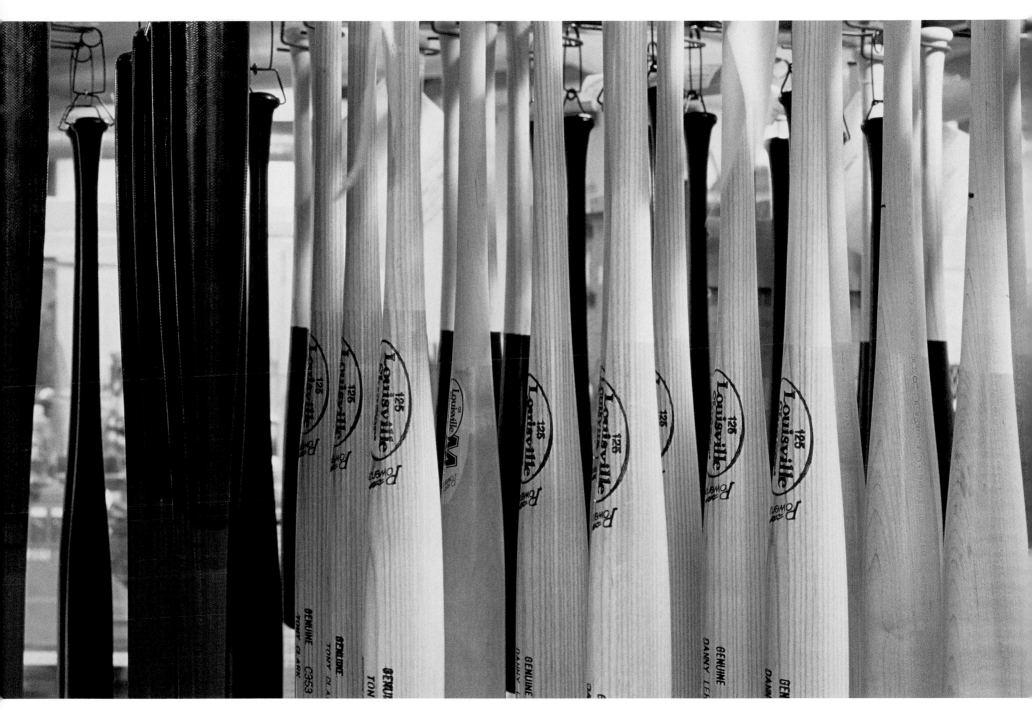

Louisville Slugger wood bats • Jefferson County

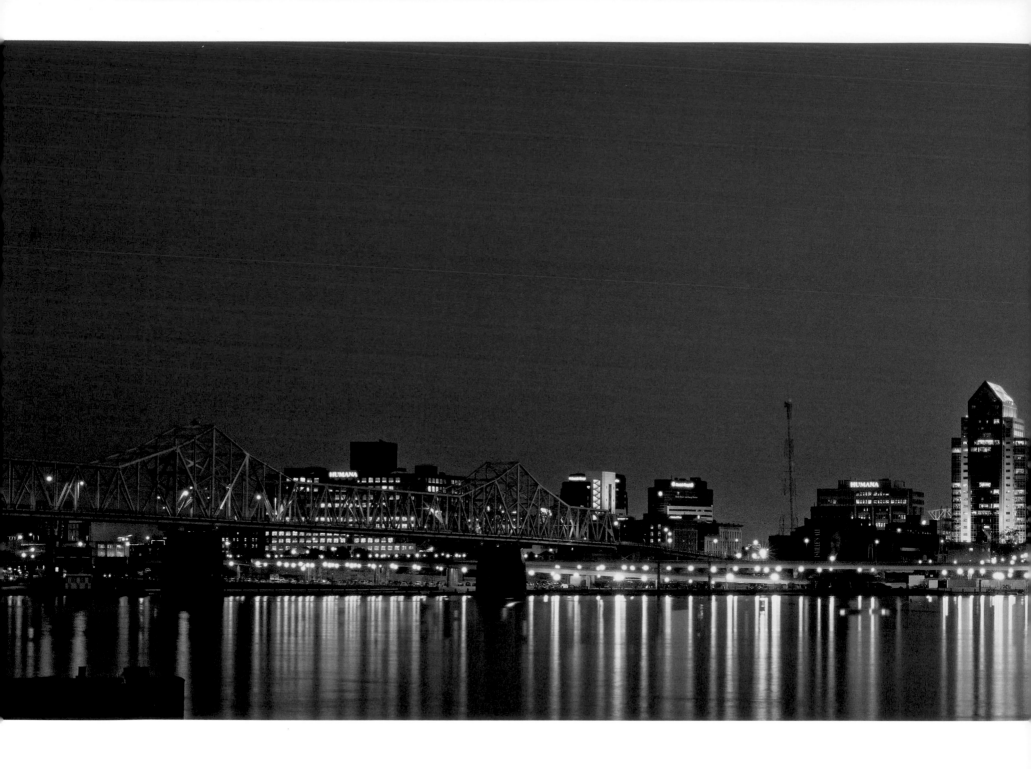

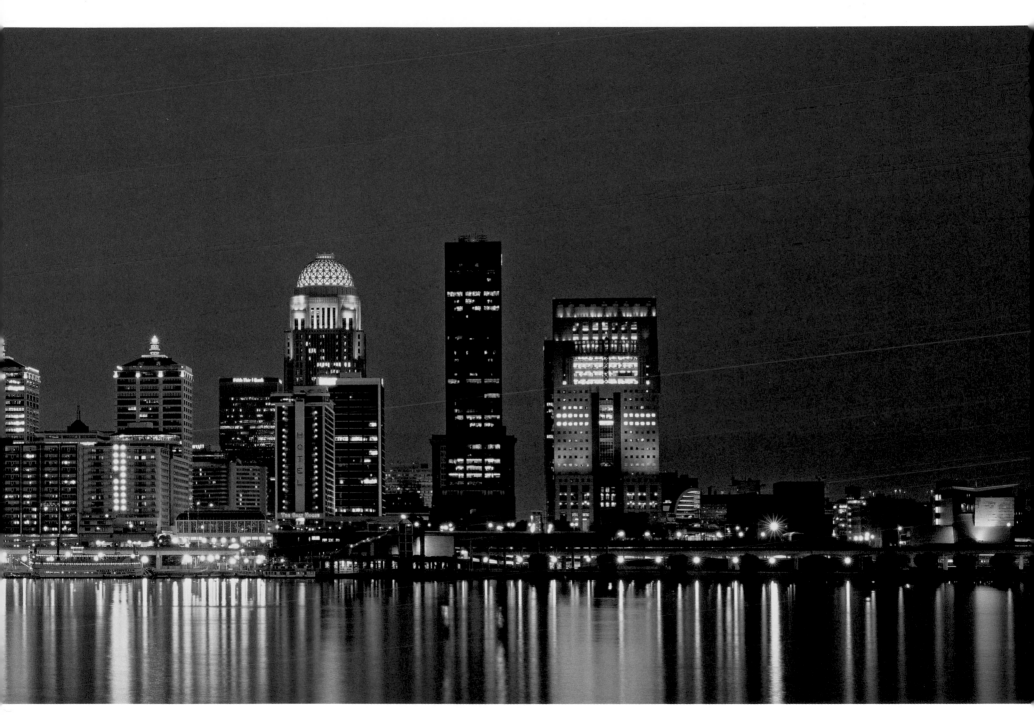

Louisville skyline at night • Jefferson County

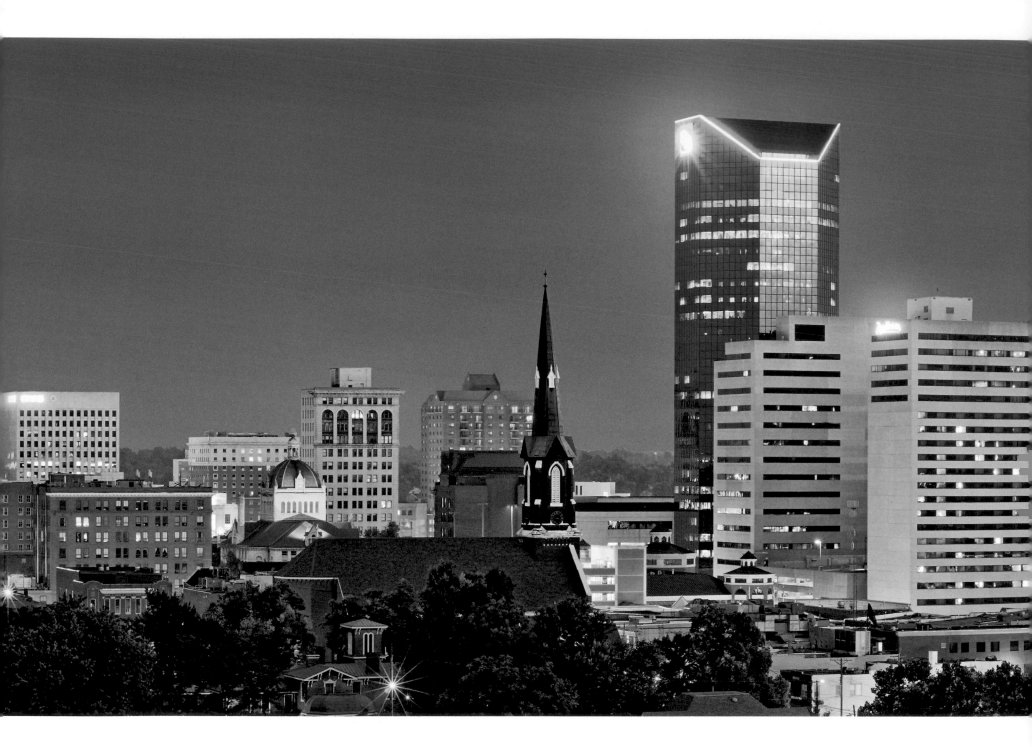

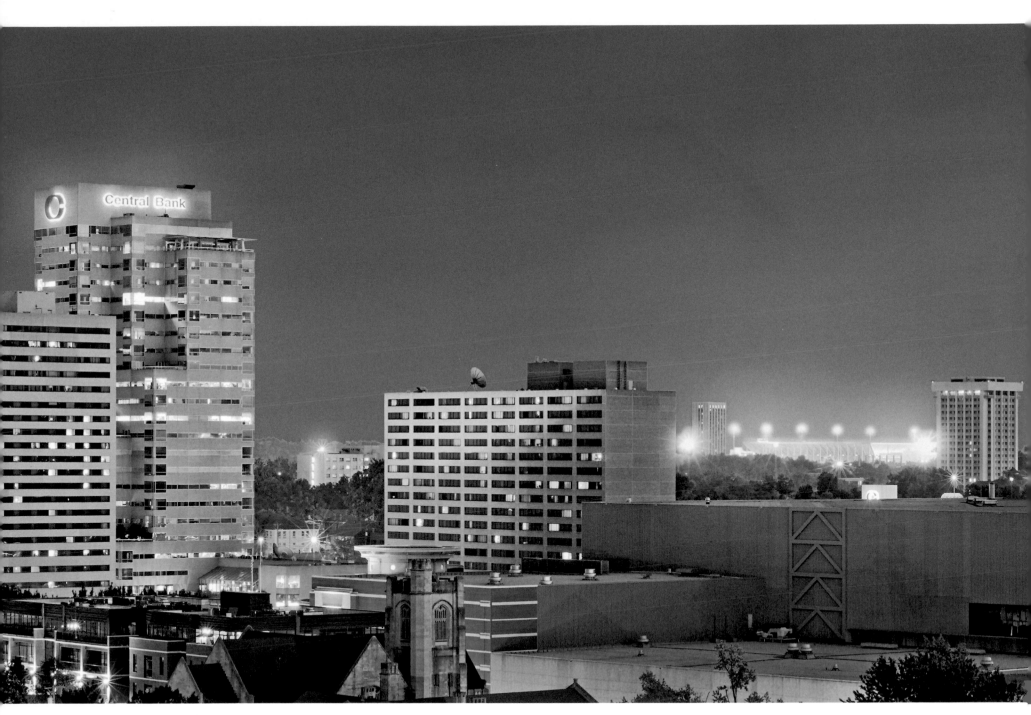

Lexington skyline at night • Fayette County

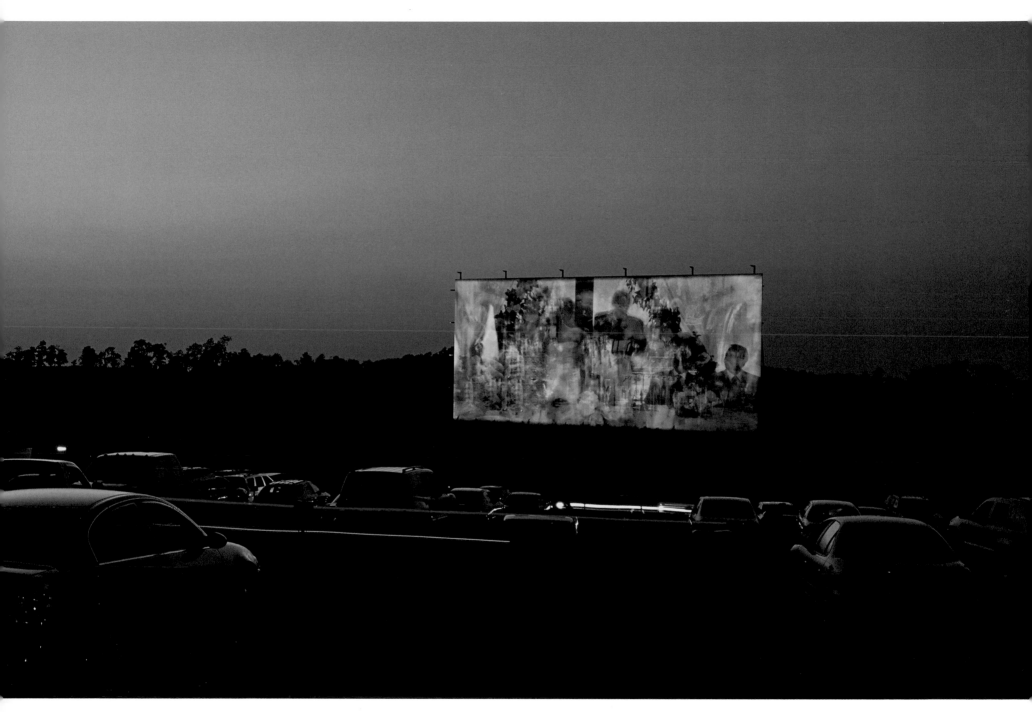

Drive-In theater • Bourbon County

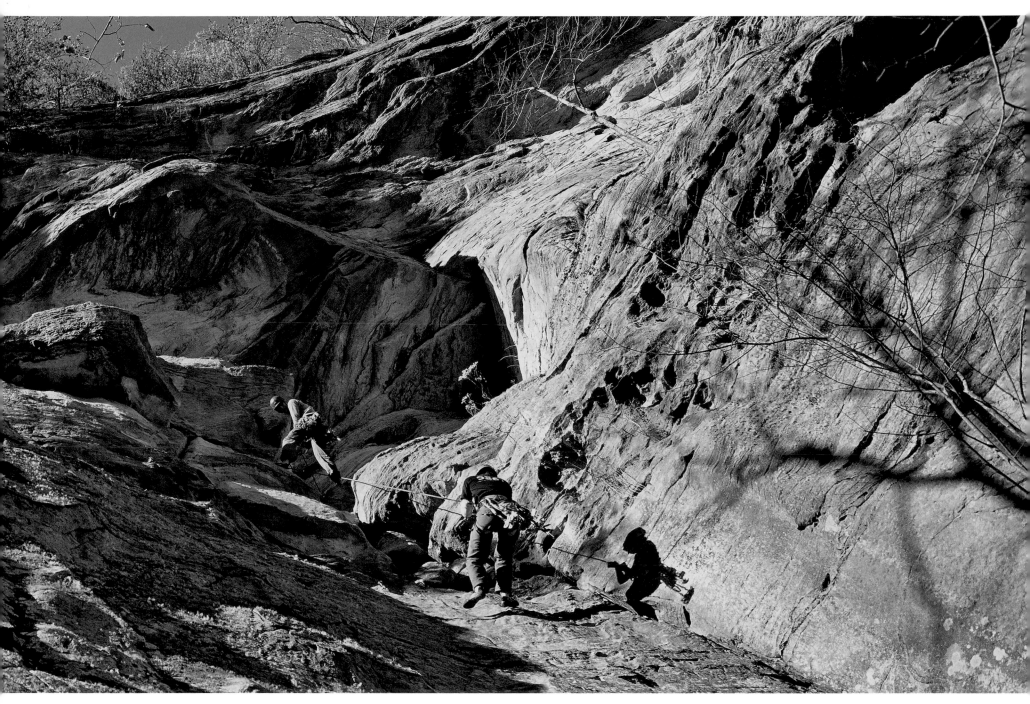

Rock climbing at Red River Gorge • Wolfe County

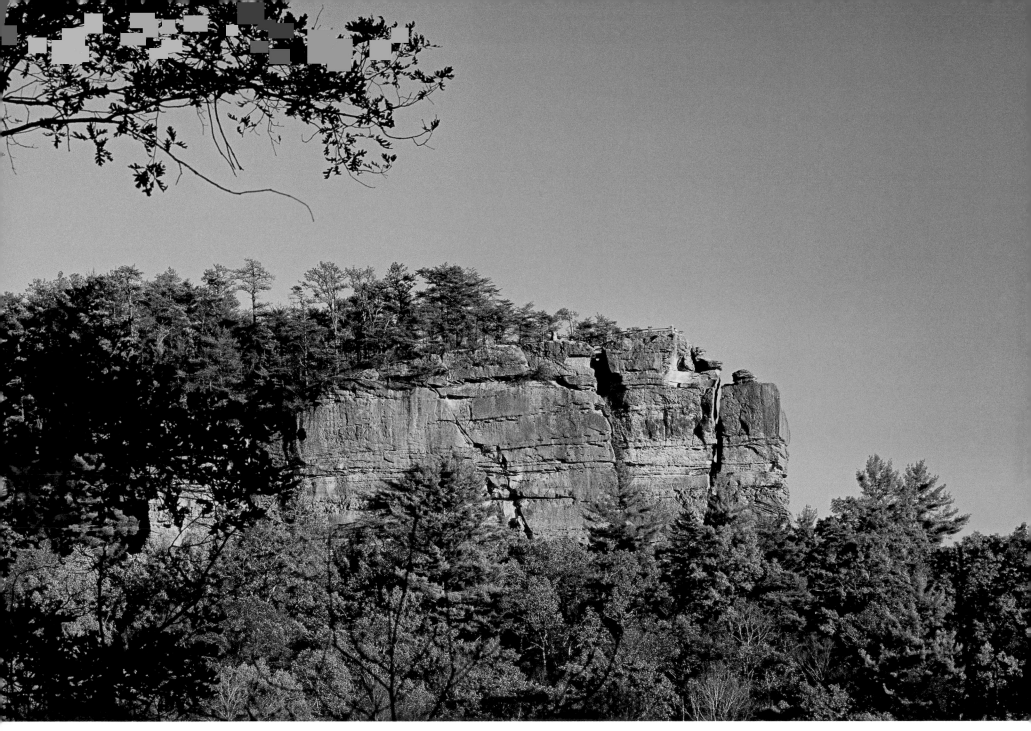

Chimney Top • Wolfe County

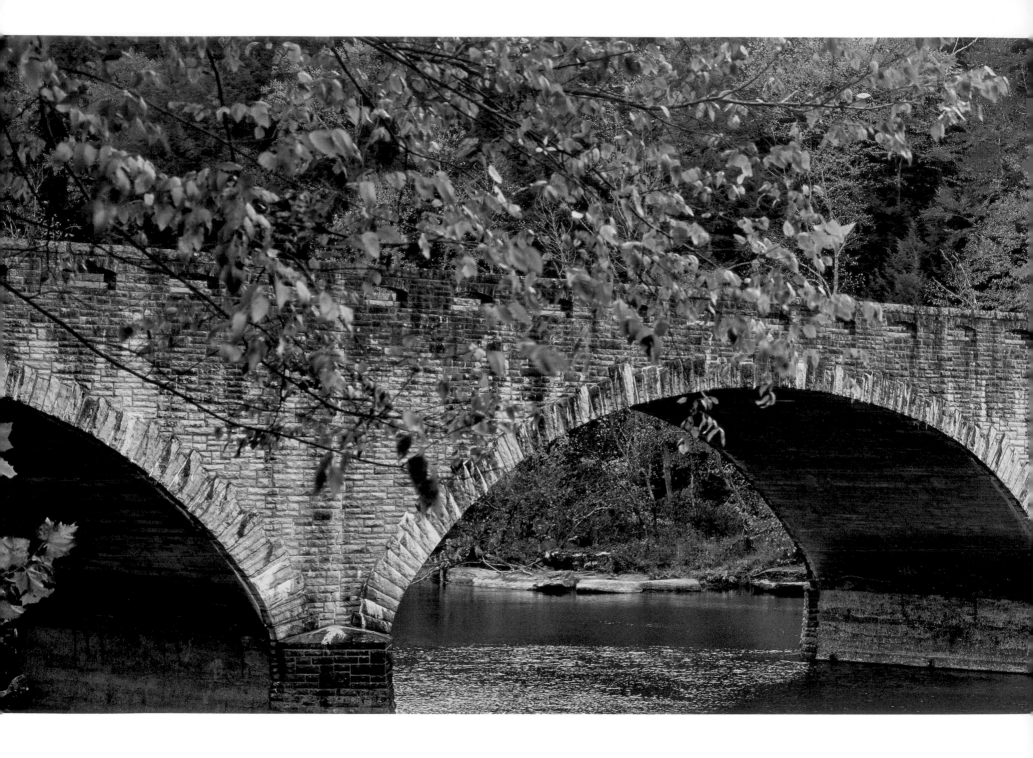

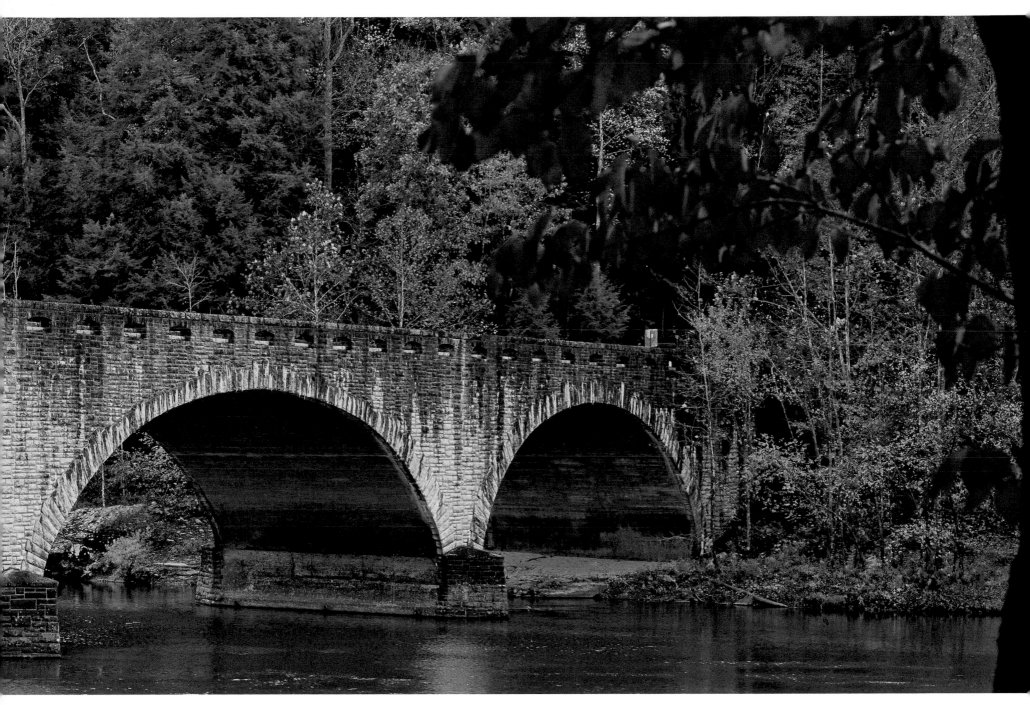

Stone bridge above Cumberland Falls • Whitley County

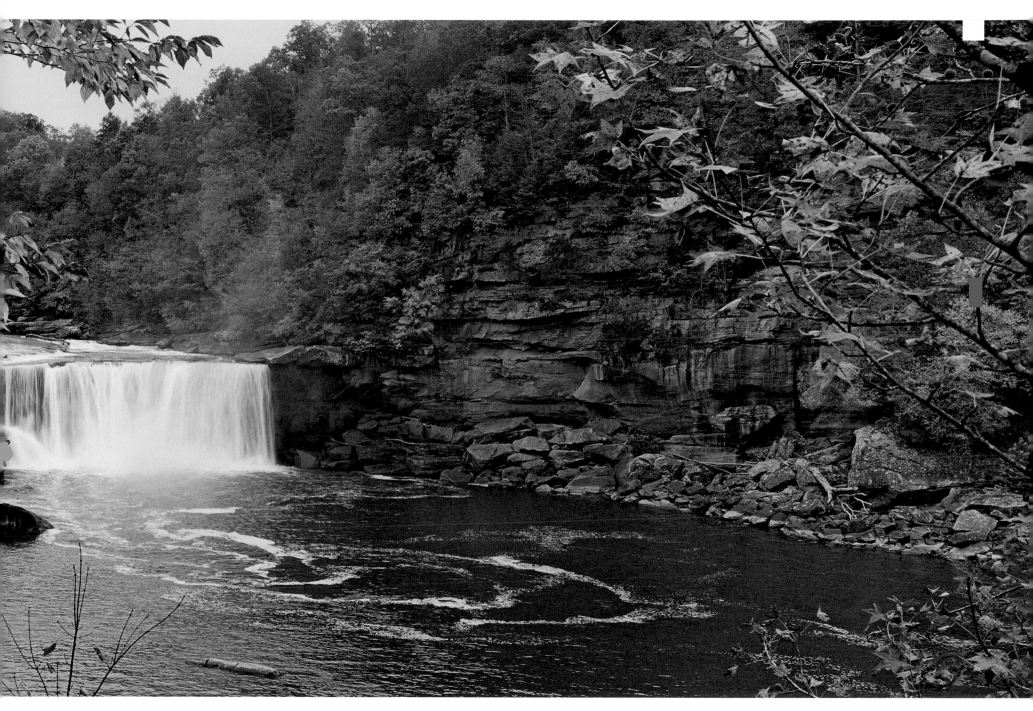

Cumberland Falls • Whitley County

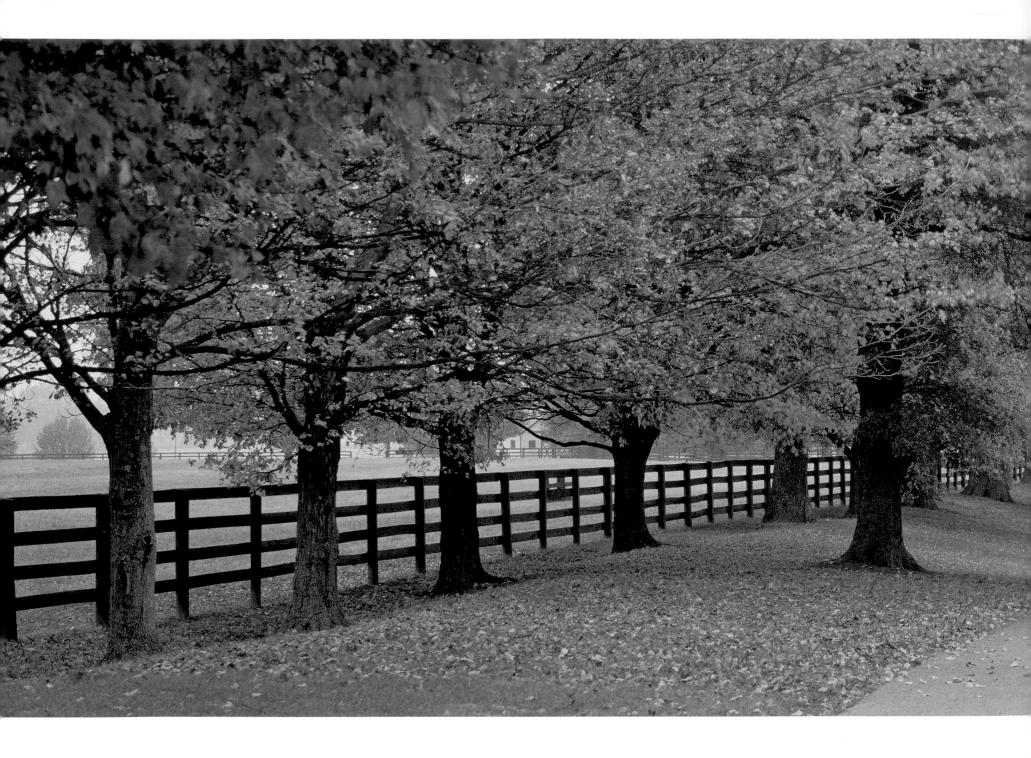

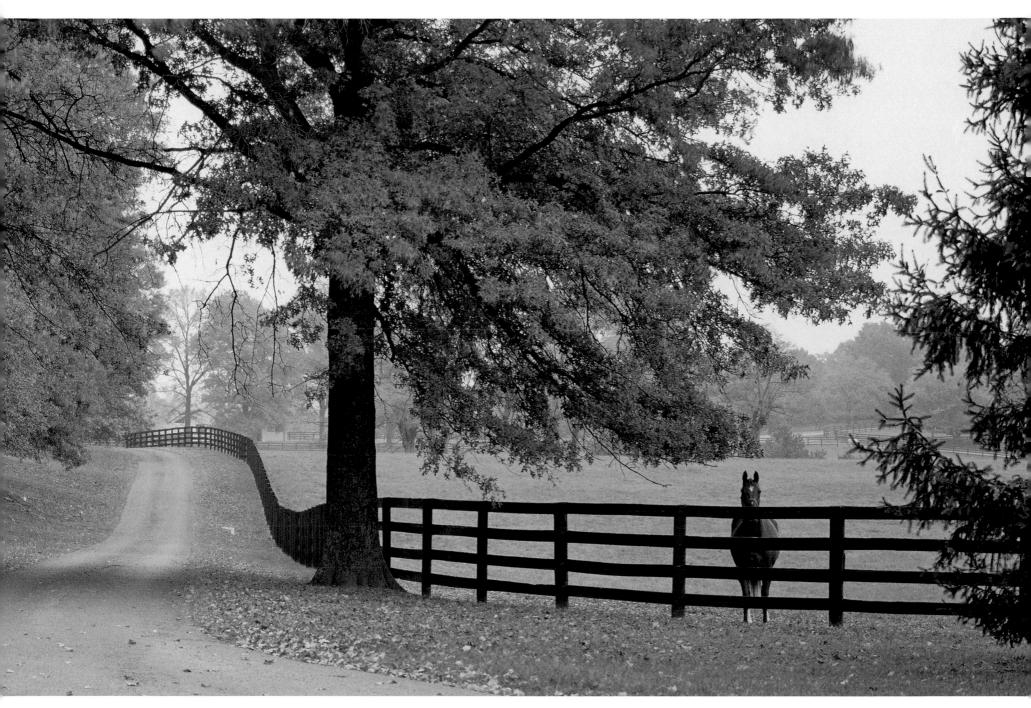

Autumn in the Bluegrass • Fayette County

Autumn in Kingdom Come • Letcher County

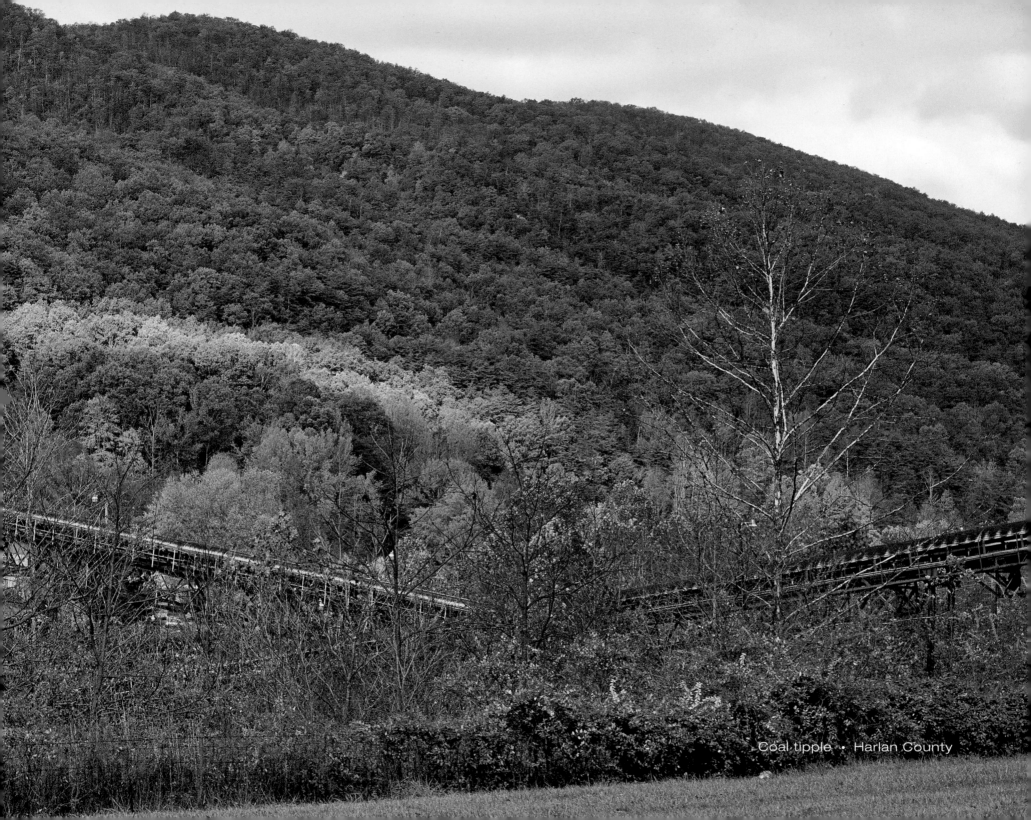

Coal tipple • Harlan County

Long and winding road • Letcher County

Cathedral Basilica of the Assumption • Kenton County

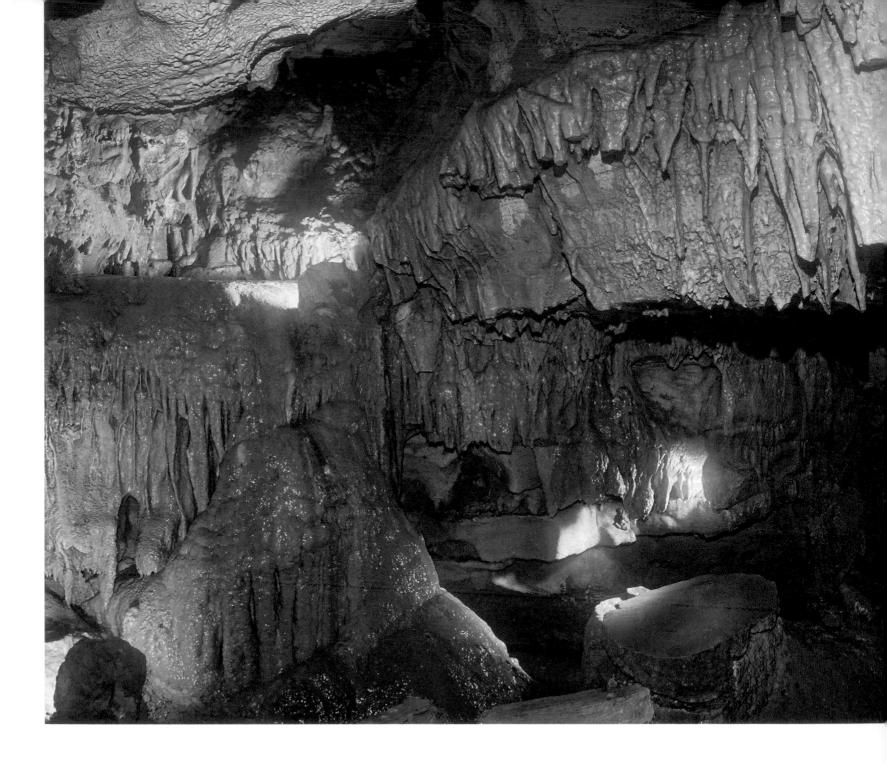

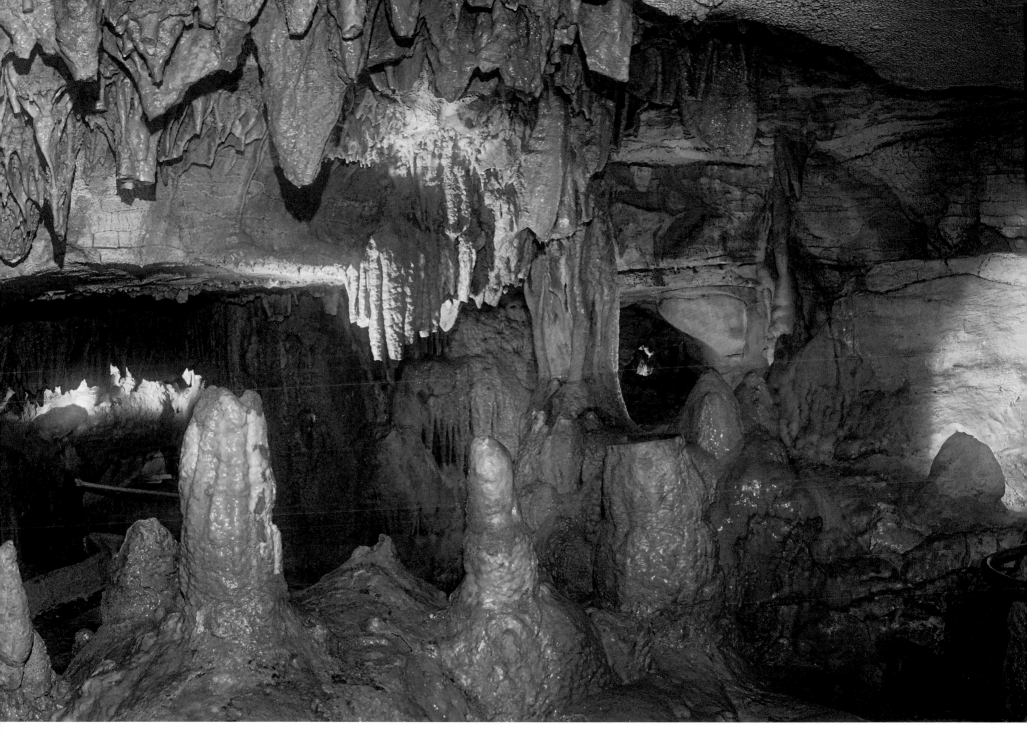

Historic Diamond Caverns • Barren County

Downtown historic Winchester • Clark County

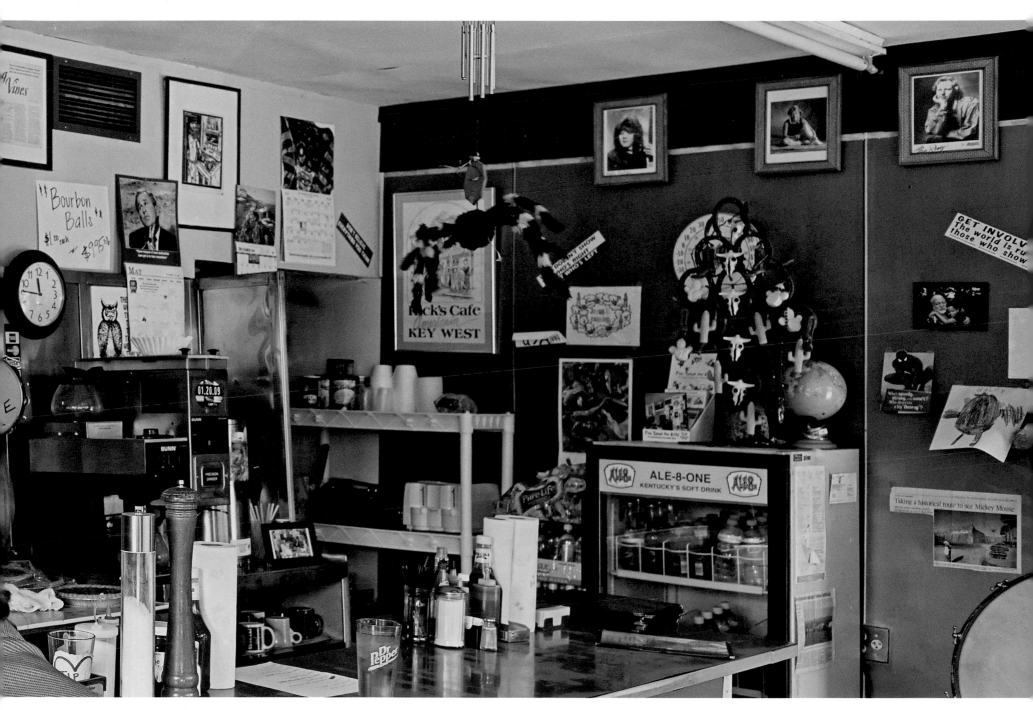

White Light Diner • Franklin County

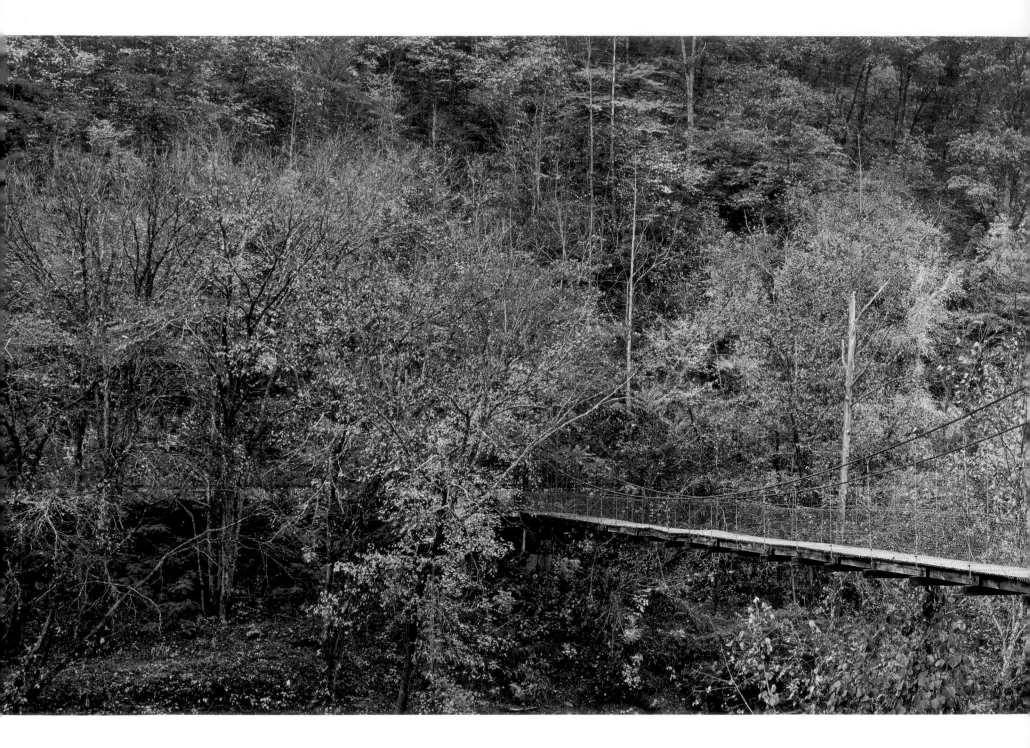

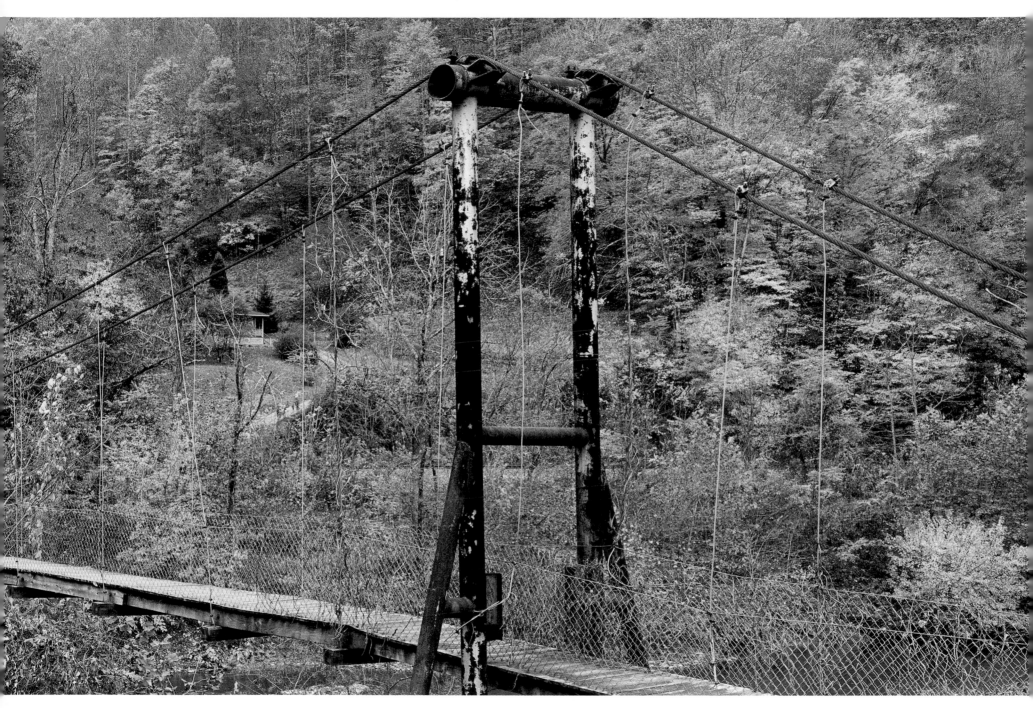

The long way home • Eastern Kentucky

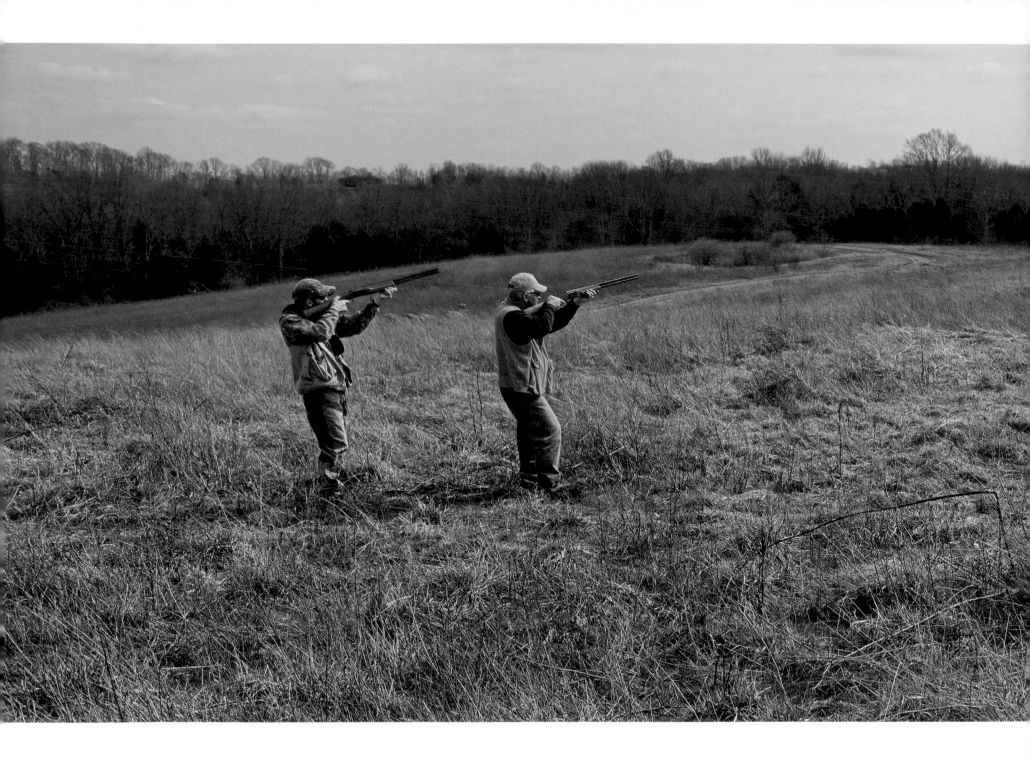

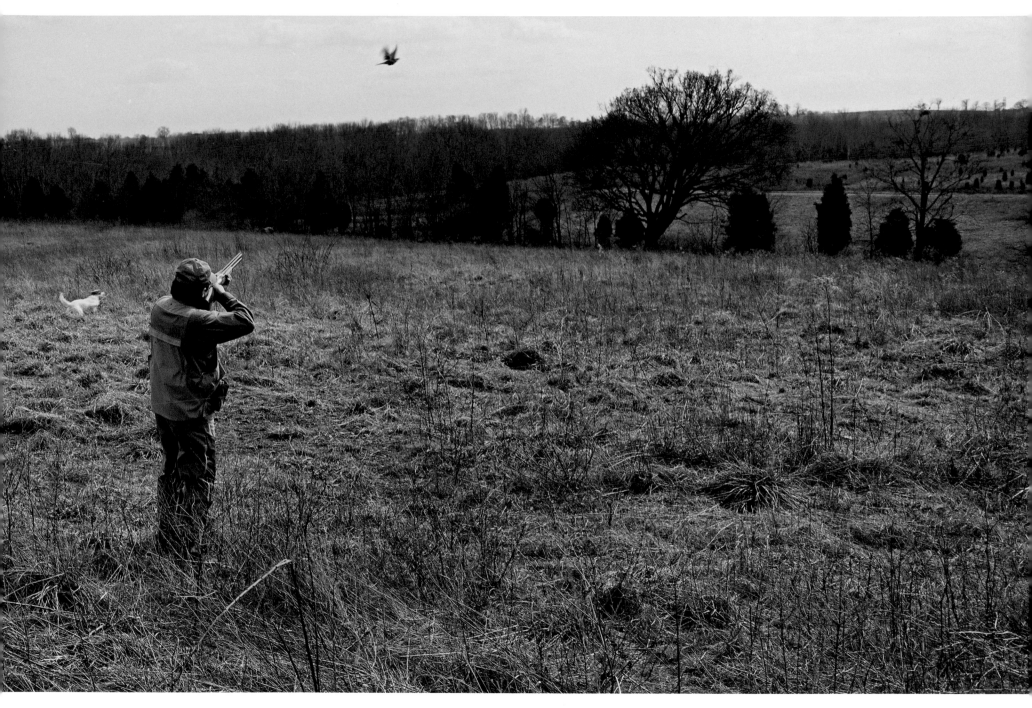

Three brothers • Jessamine County

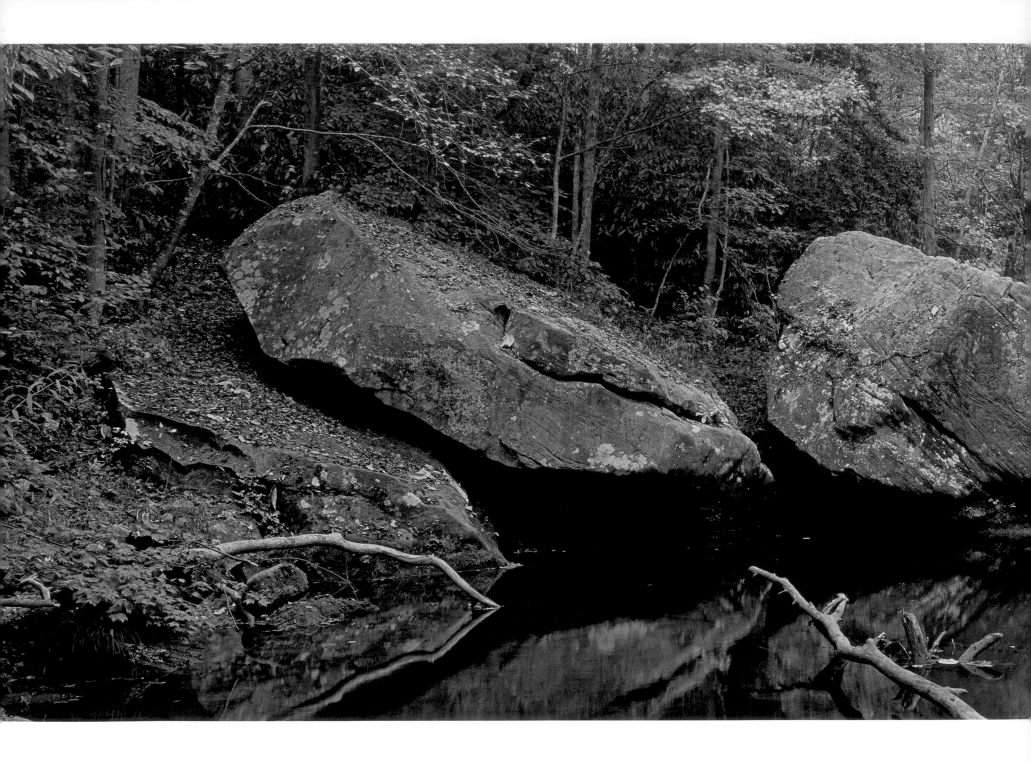

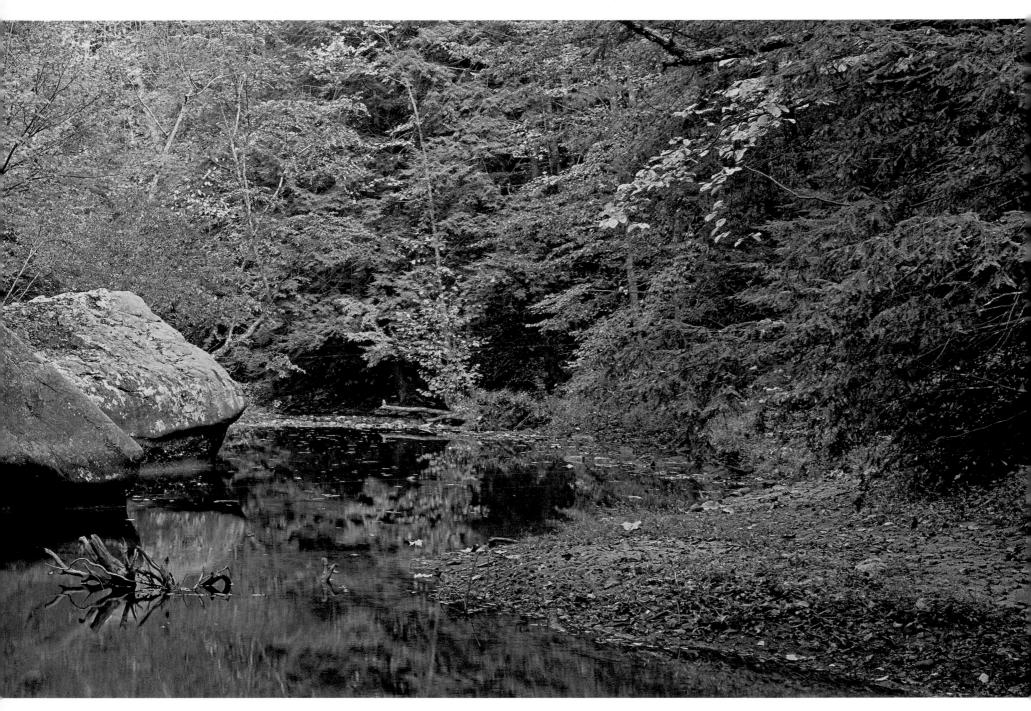

Swift Camp Creek • Wolfe County

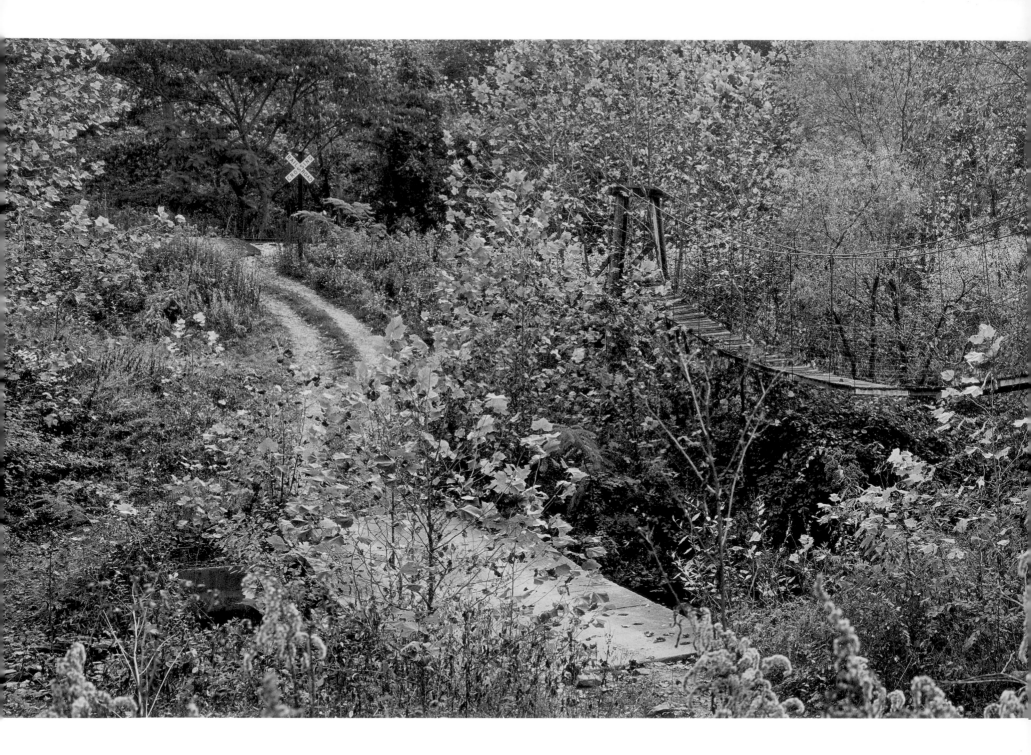

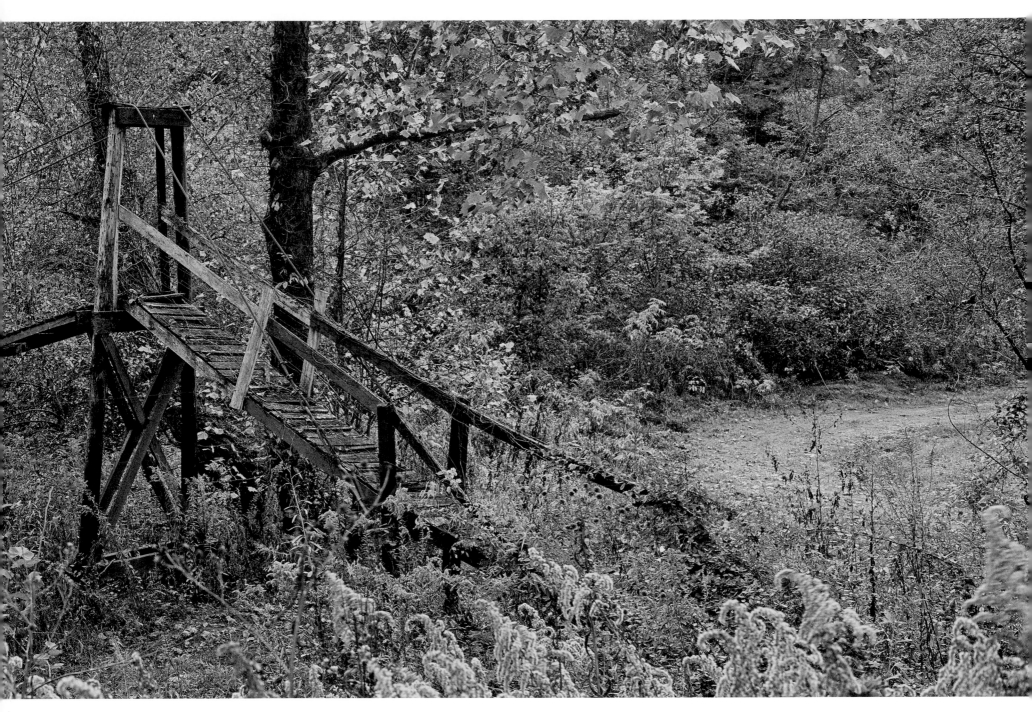

Swinging bridge and railroad • Clay County

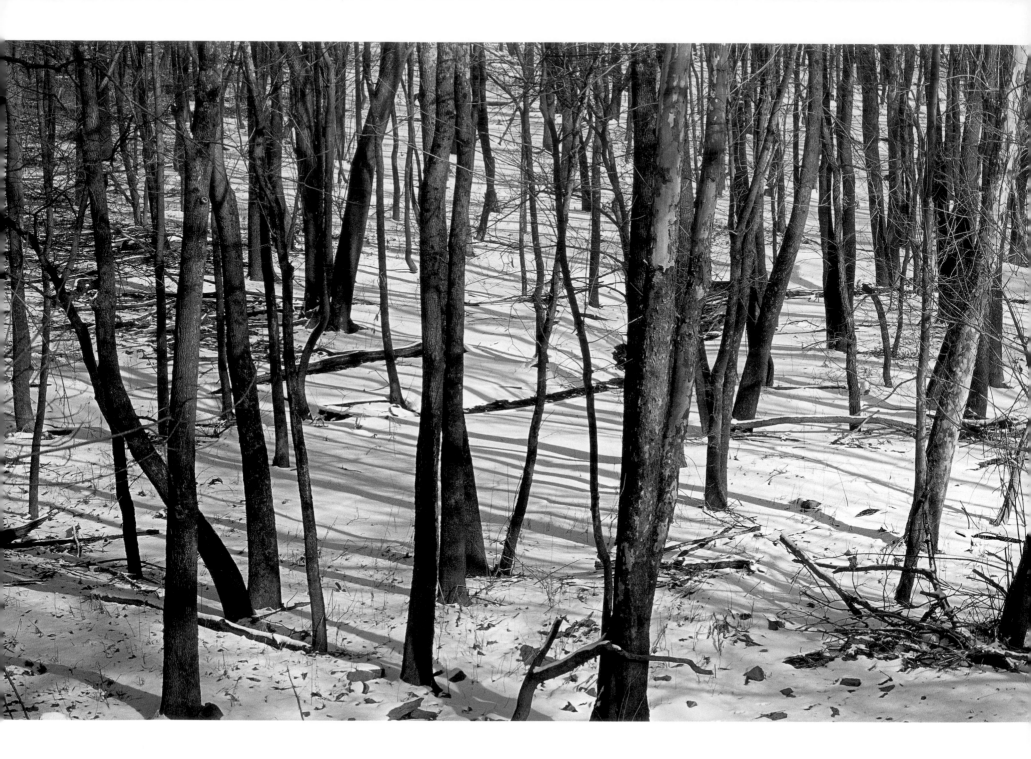

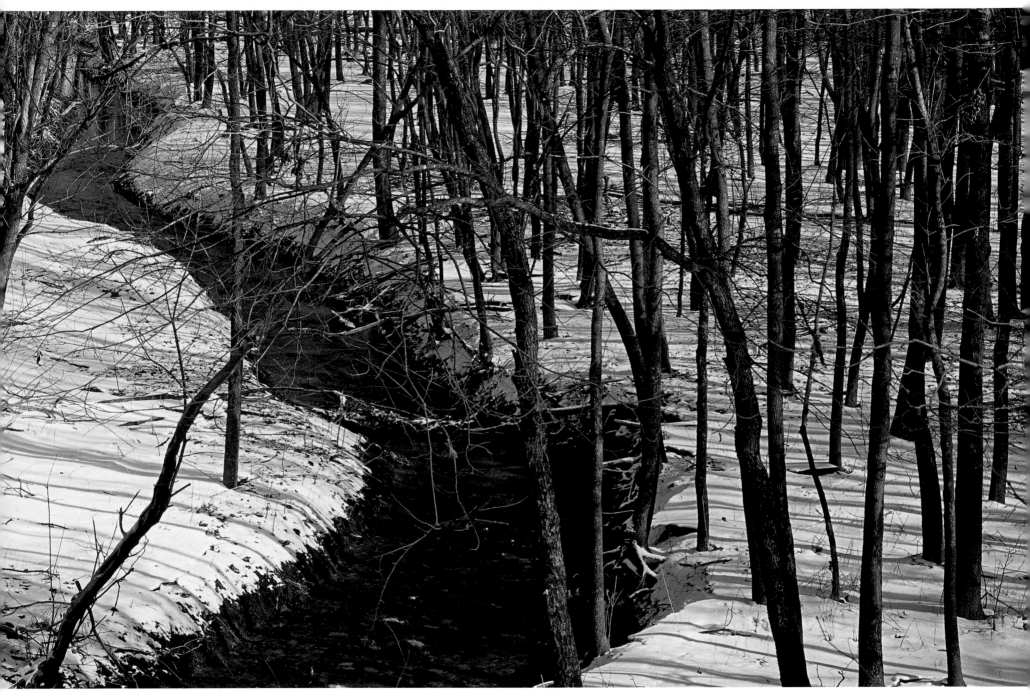

A crooked creek in the snow • Woodford County

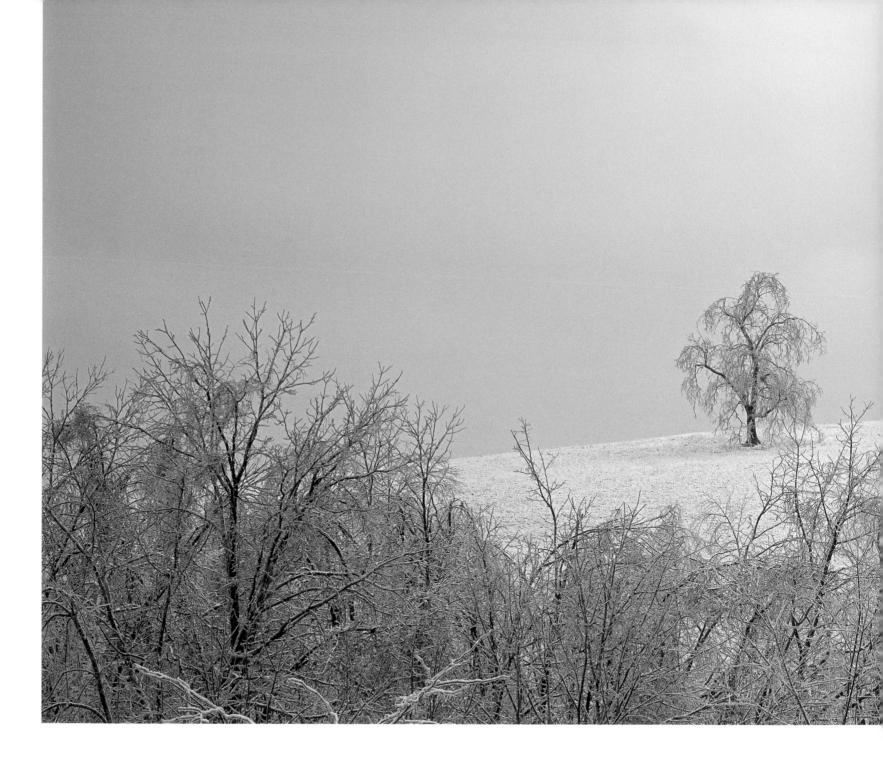

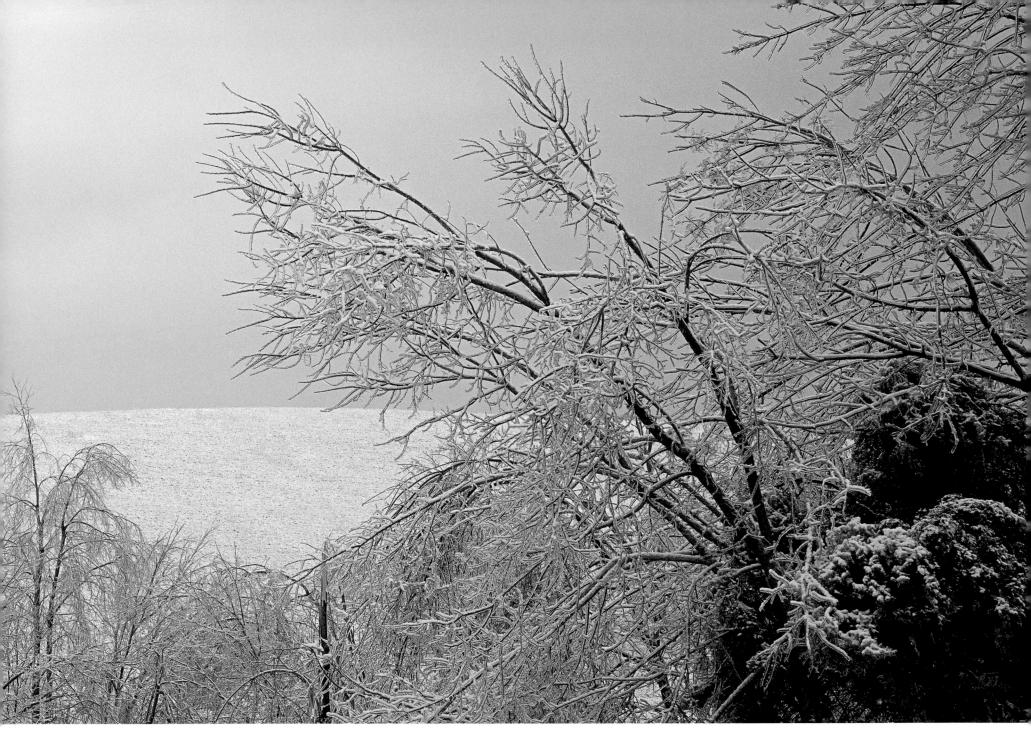

Ice storm and lone tree • Garrard County

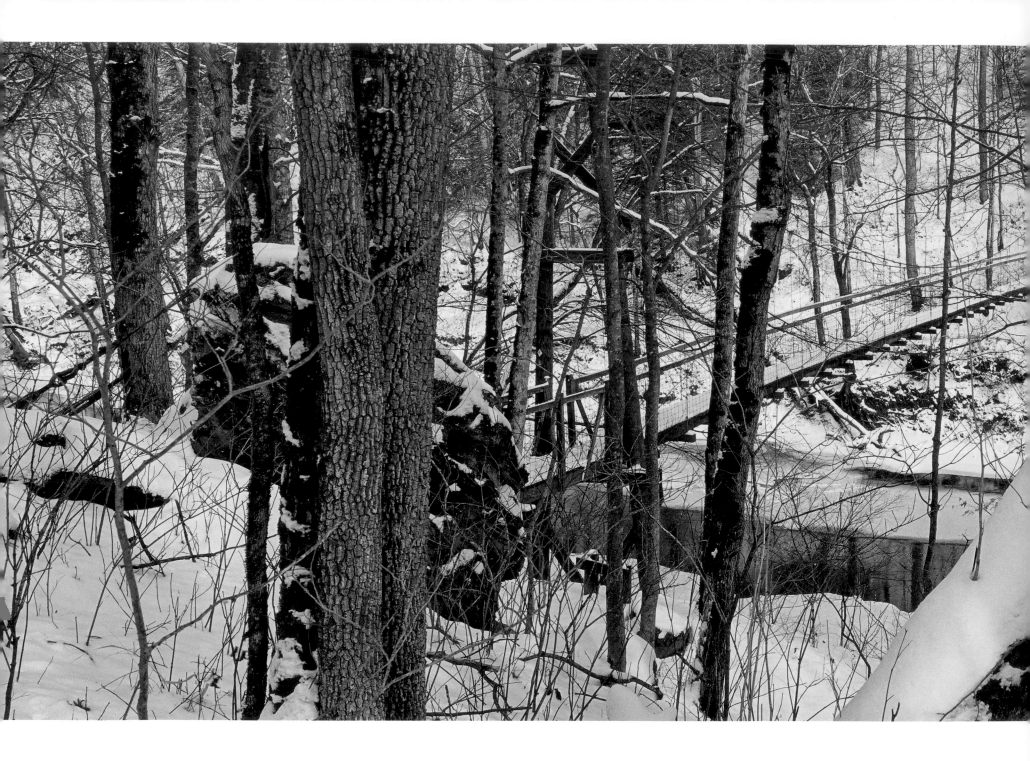

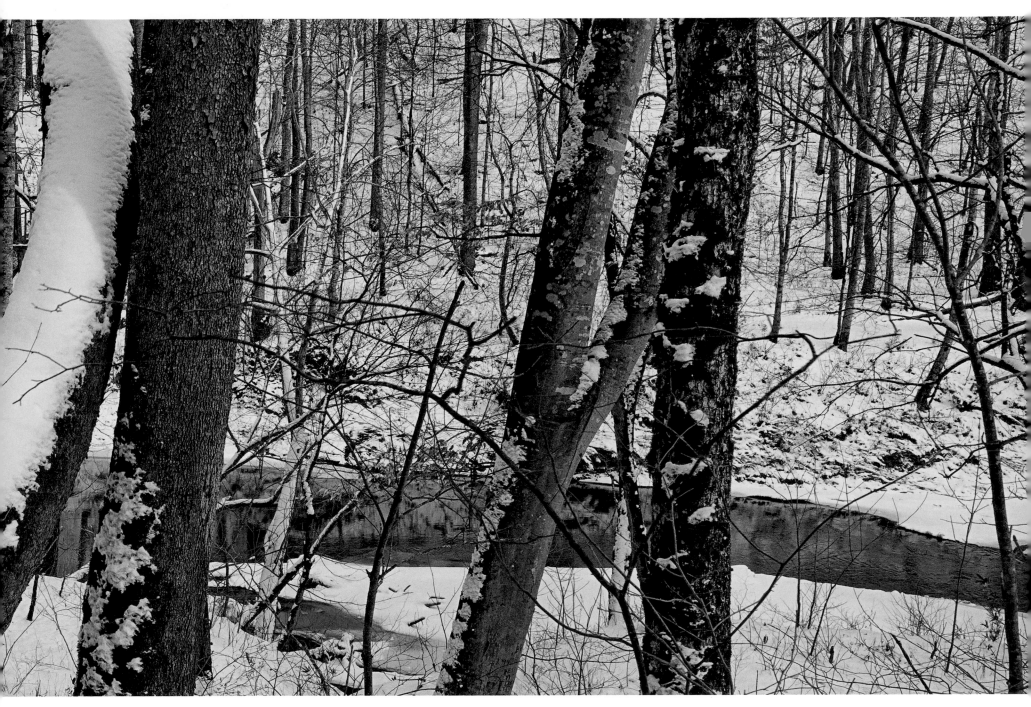

Suspension bridge in snow • Wolfe County

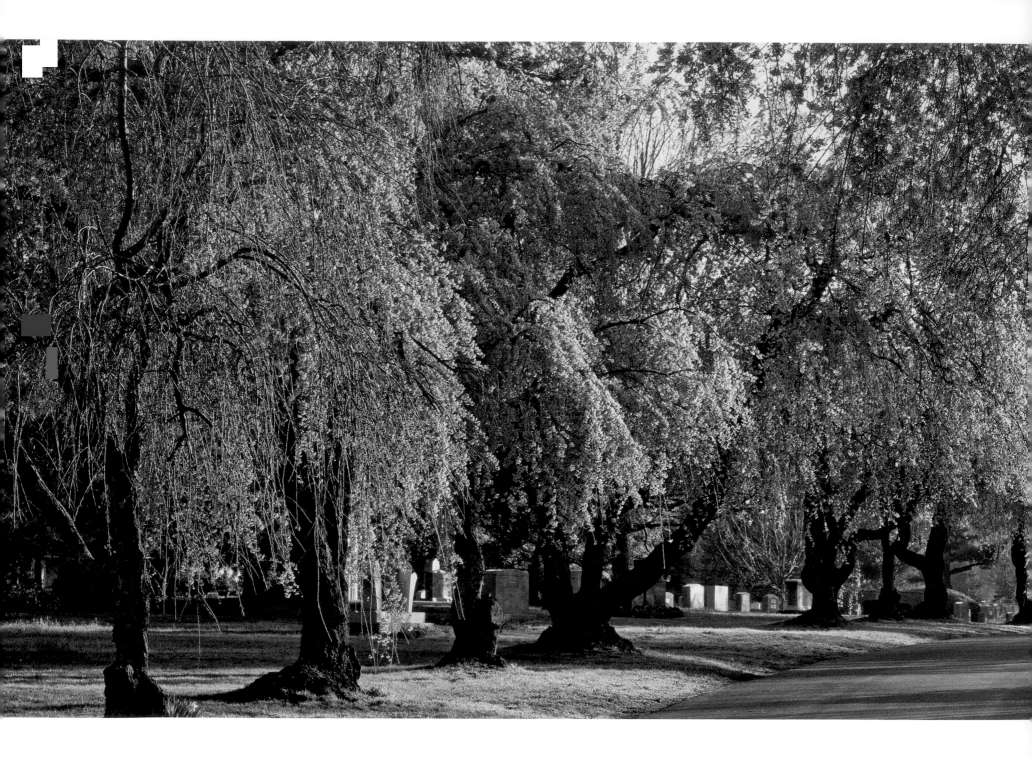

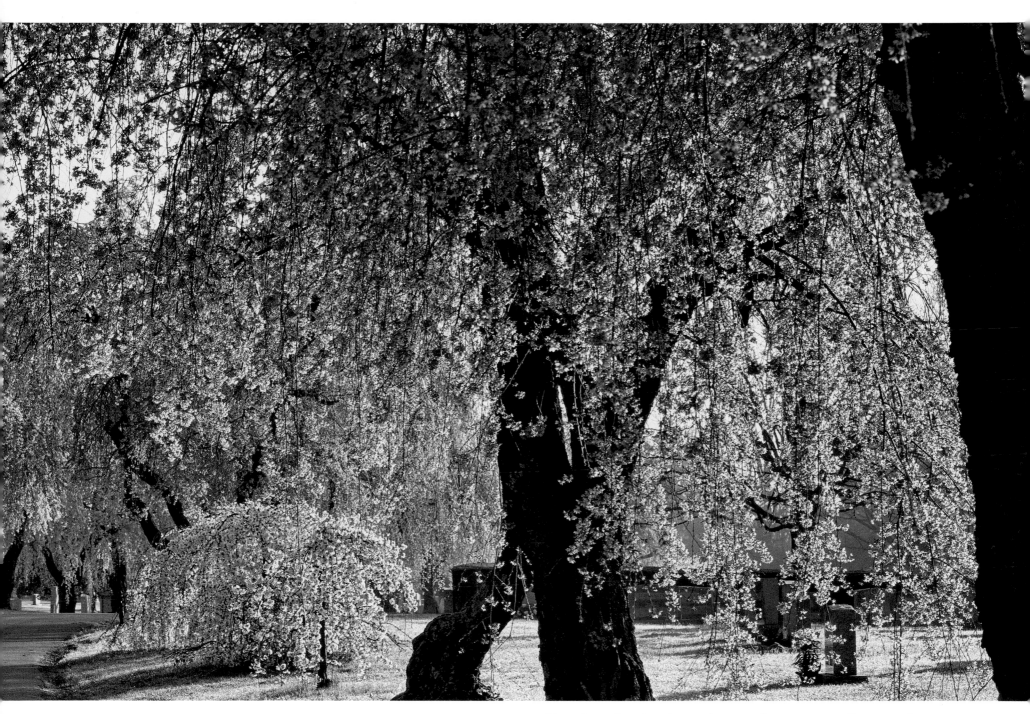

Weeping cherries in Lexington Cemetery • Fayette County

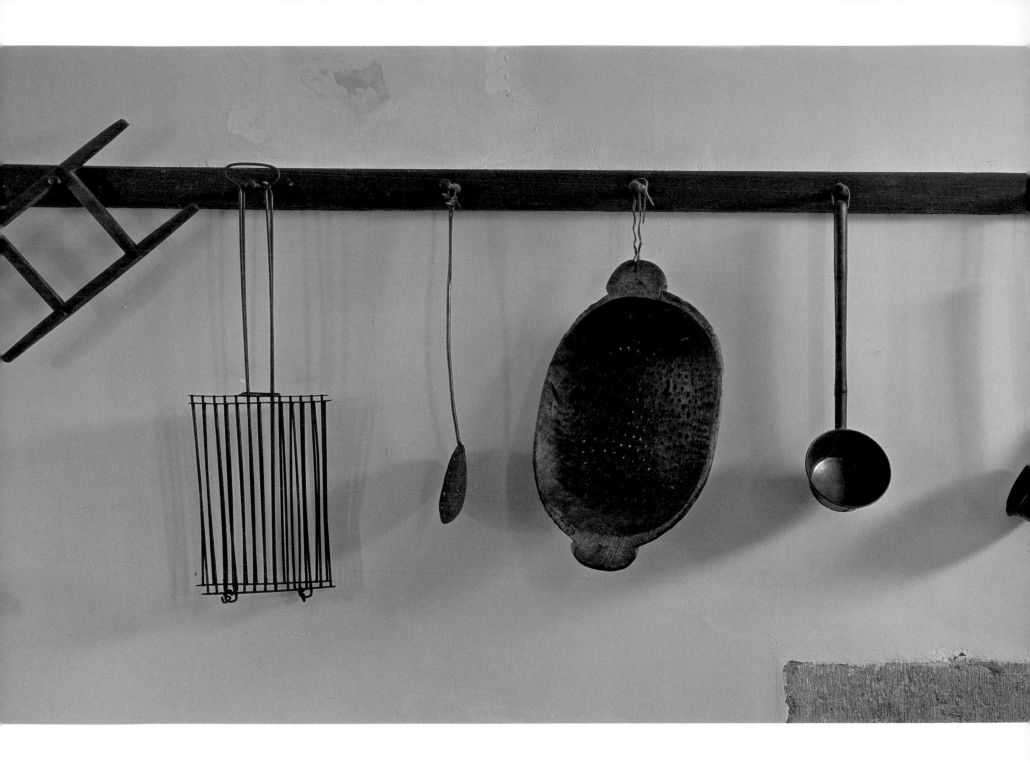

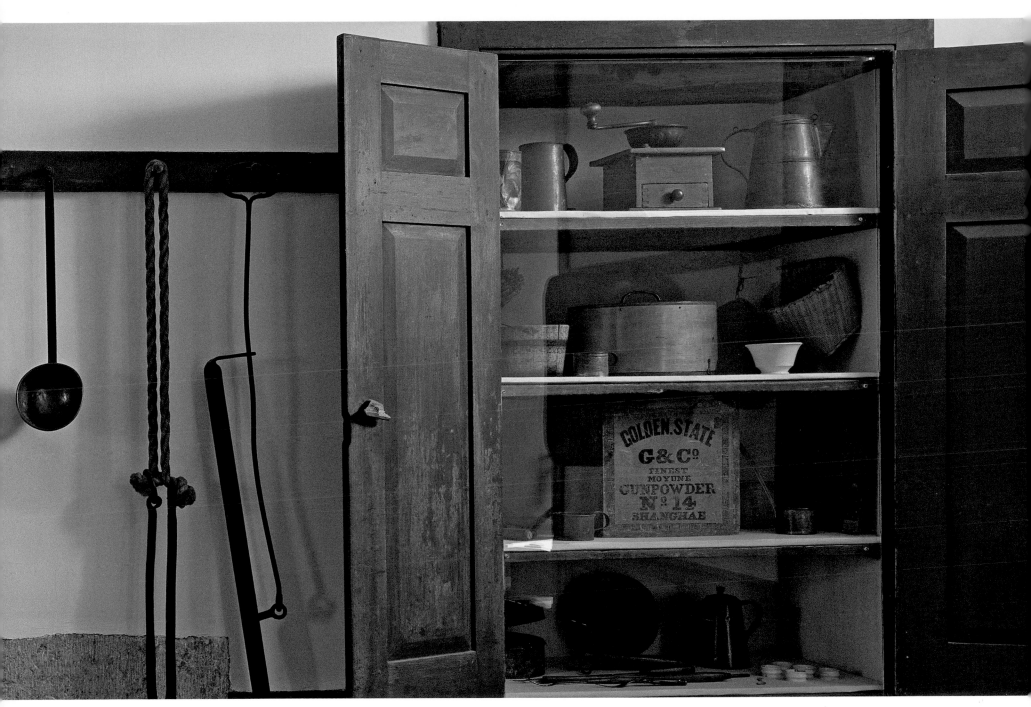

Kitchen at Shaker Village • Mercer County

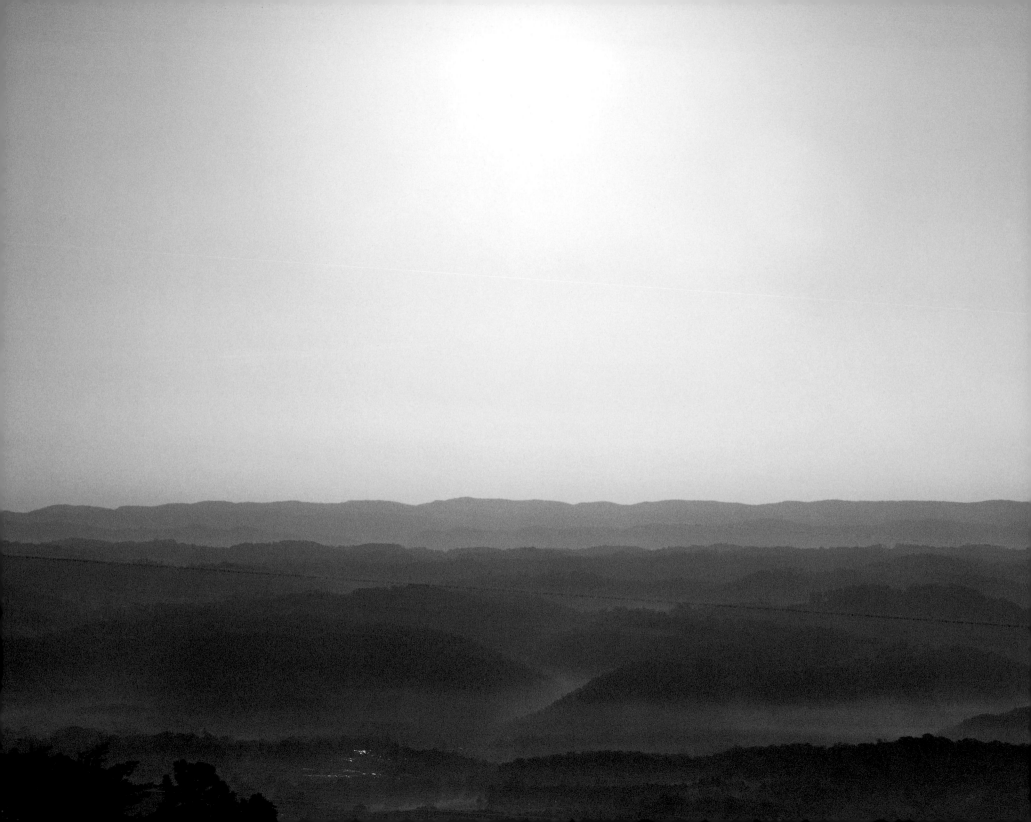

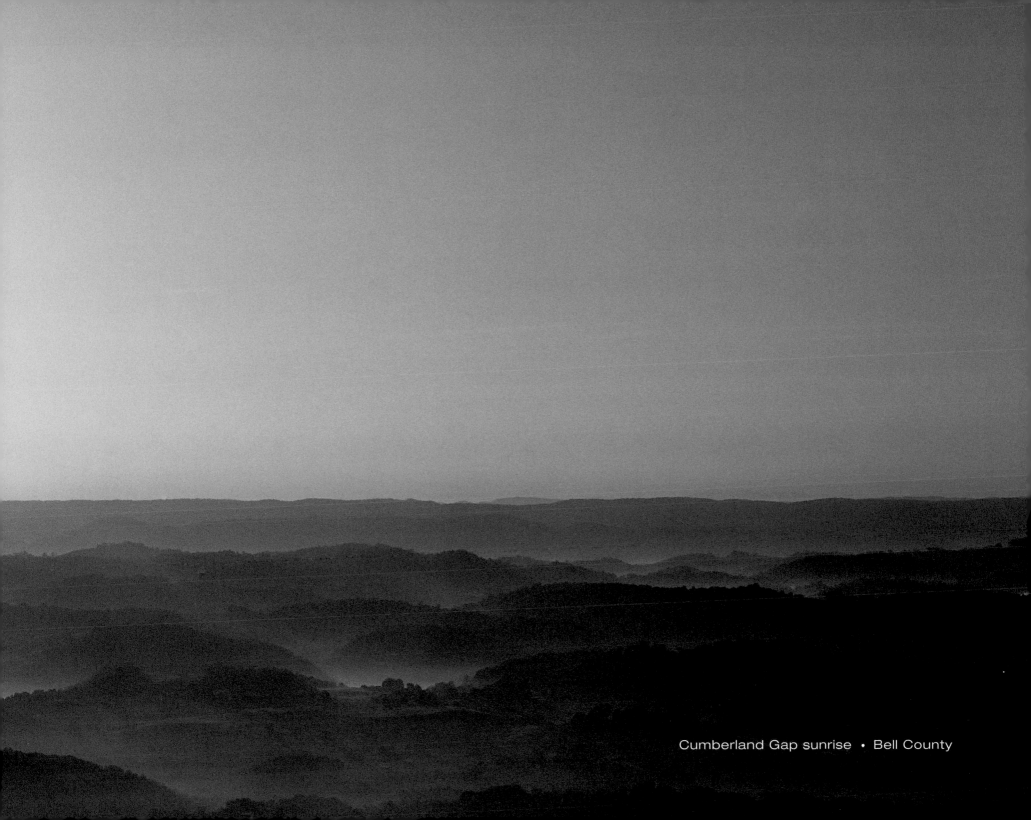
Cumberland Gap sunrise • Bell County

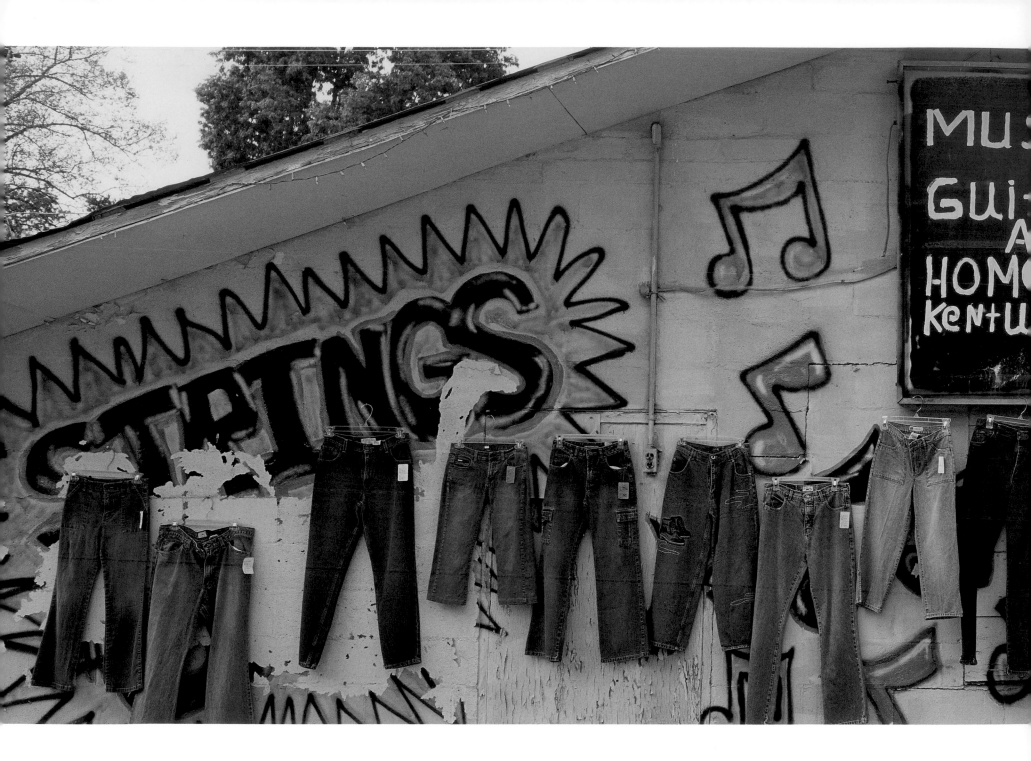

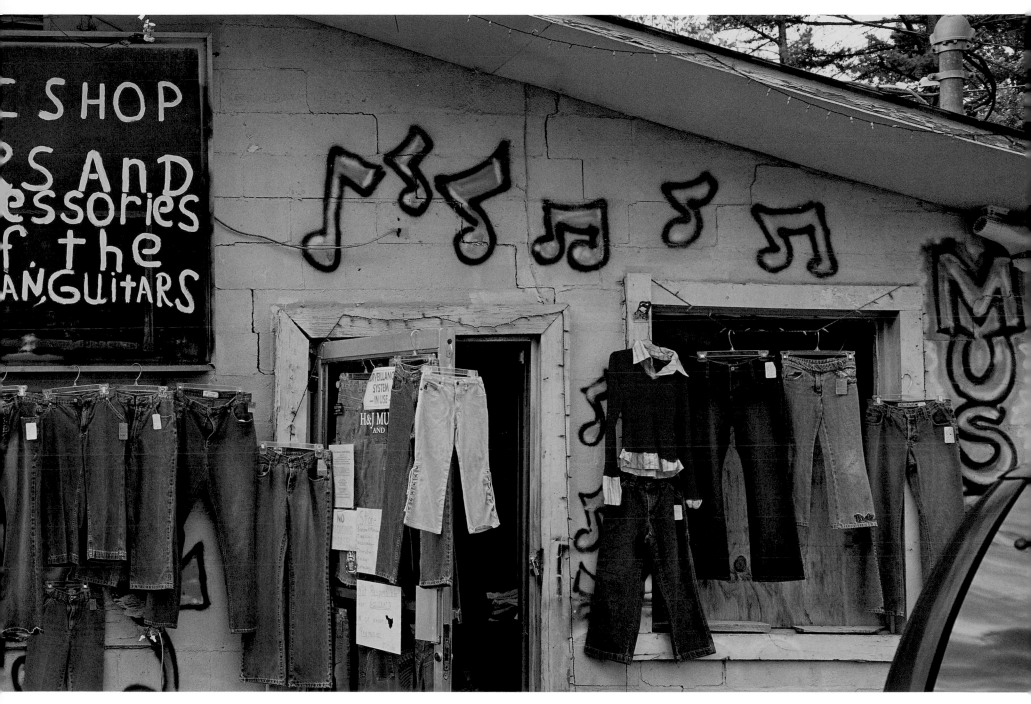

Music shop • Lee County

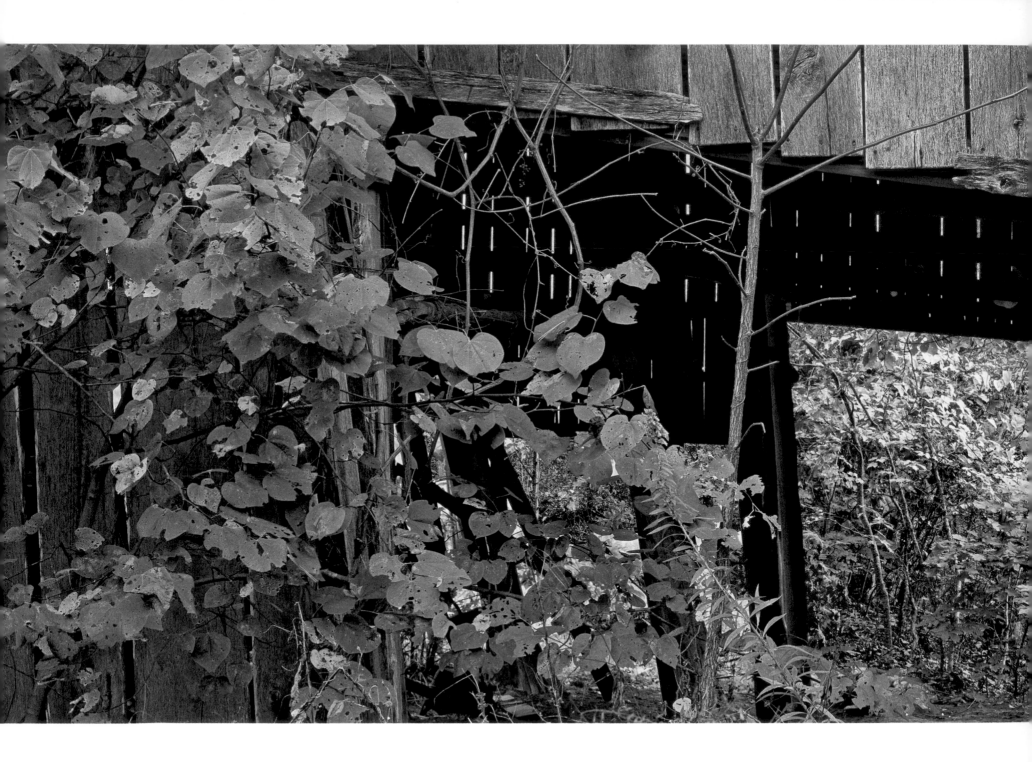

Leaning barn • Southeastern Kentucky

Country store • Pulaski County

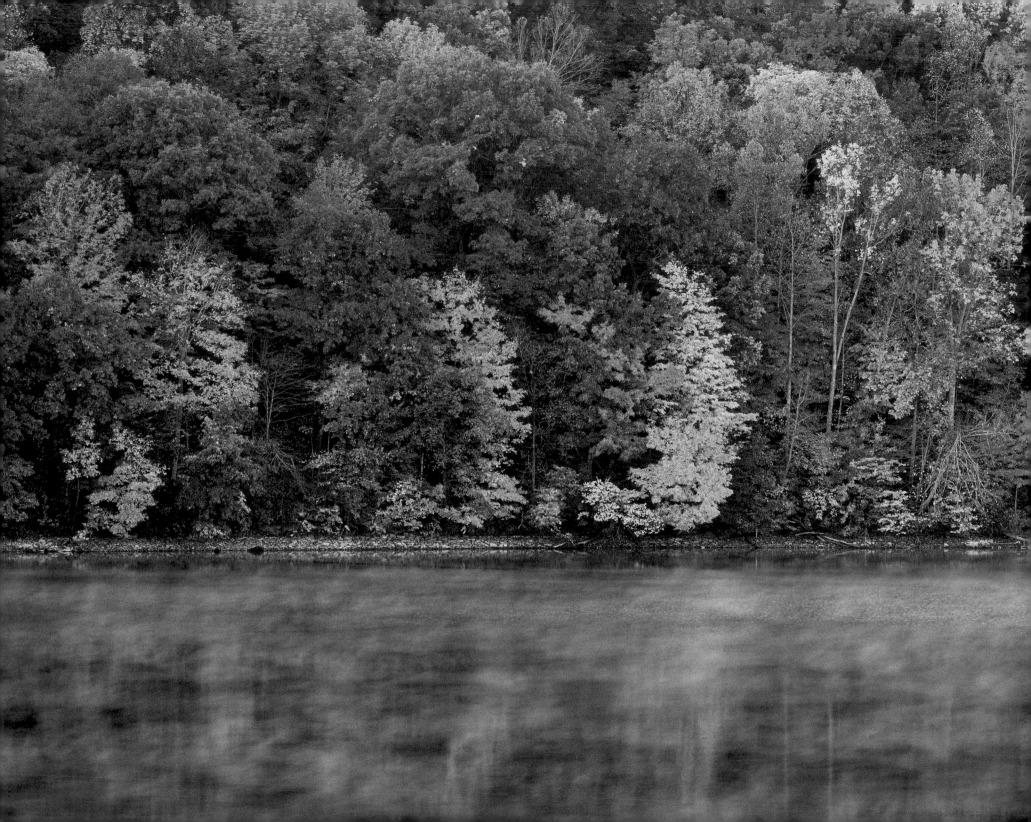

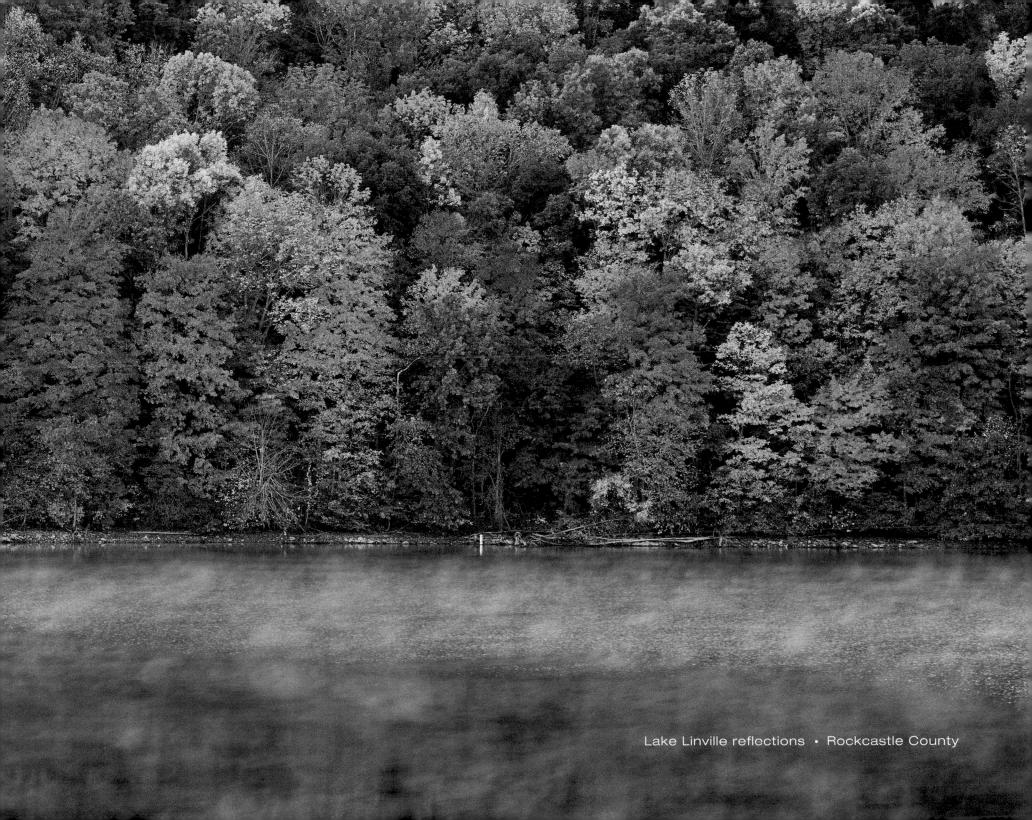

Lake Linville reflections • Rockcastle County

Trumpet vine on rock wall • Fayette County

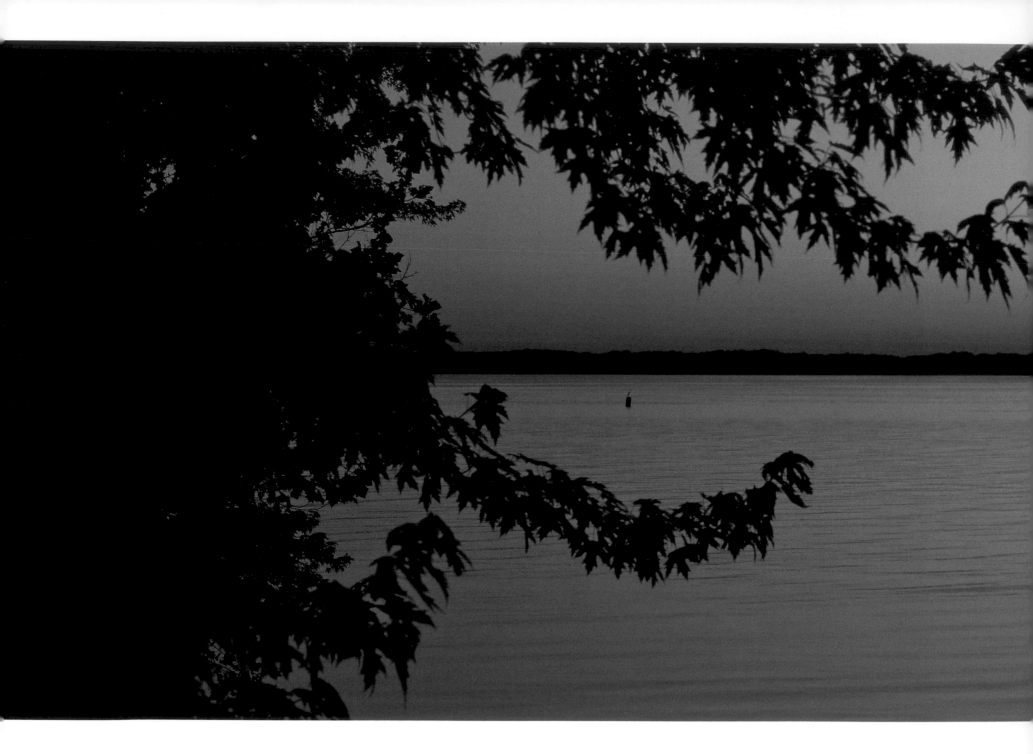

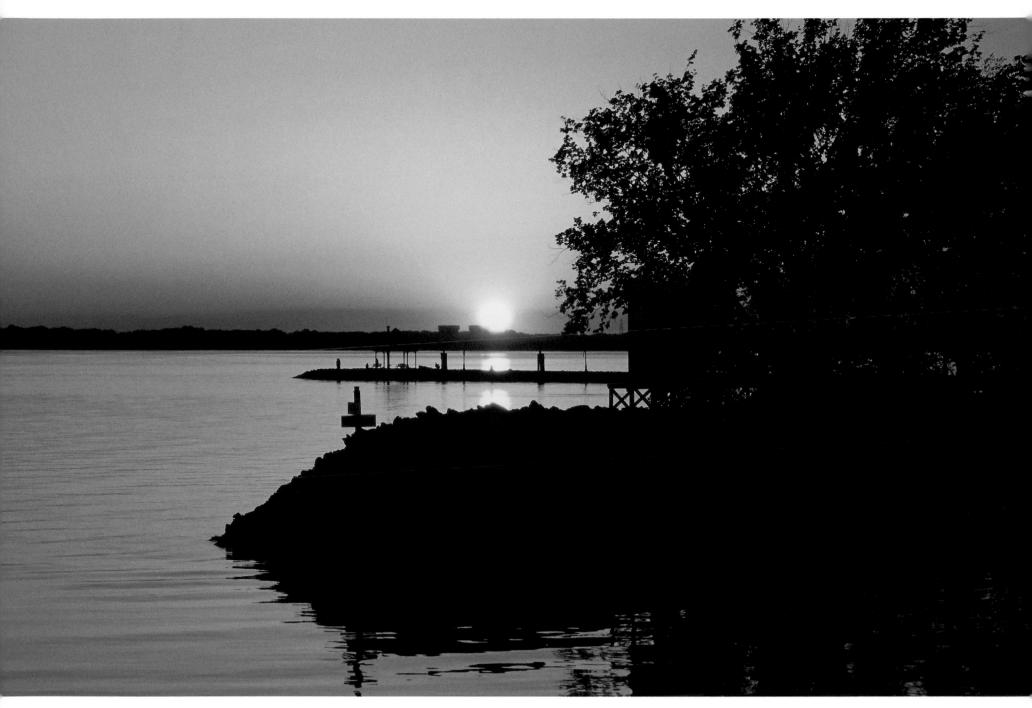

Sunset at Land Between the Lakes • Livingston County

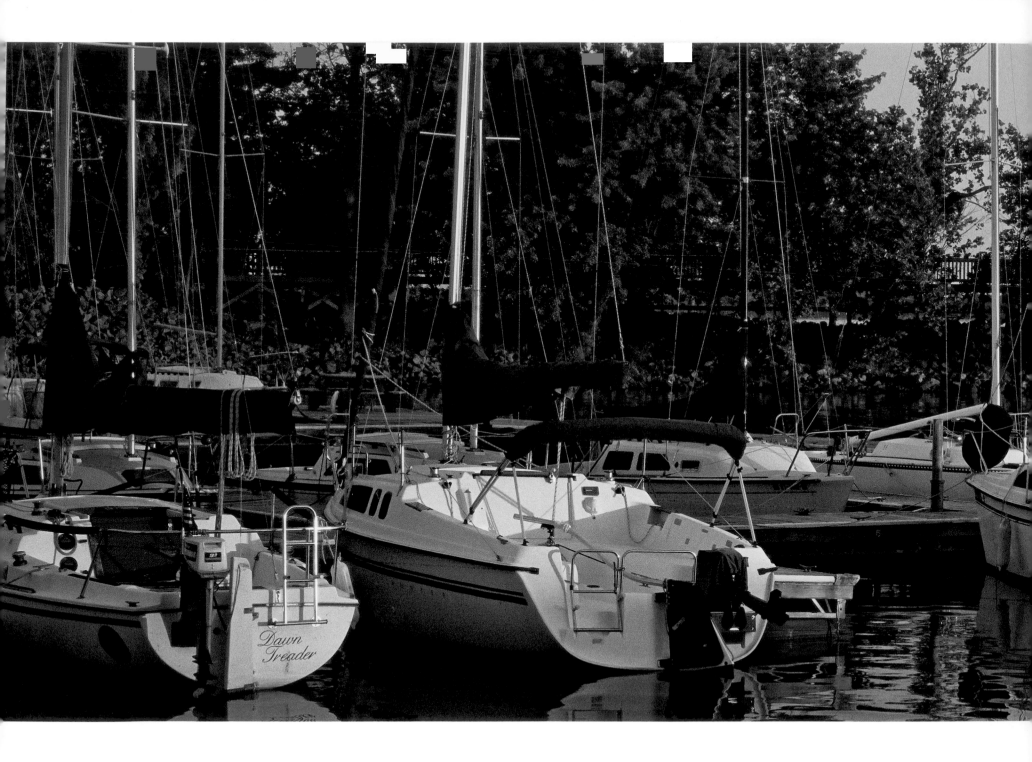

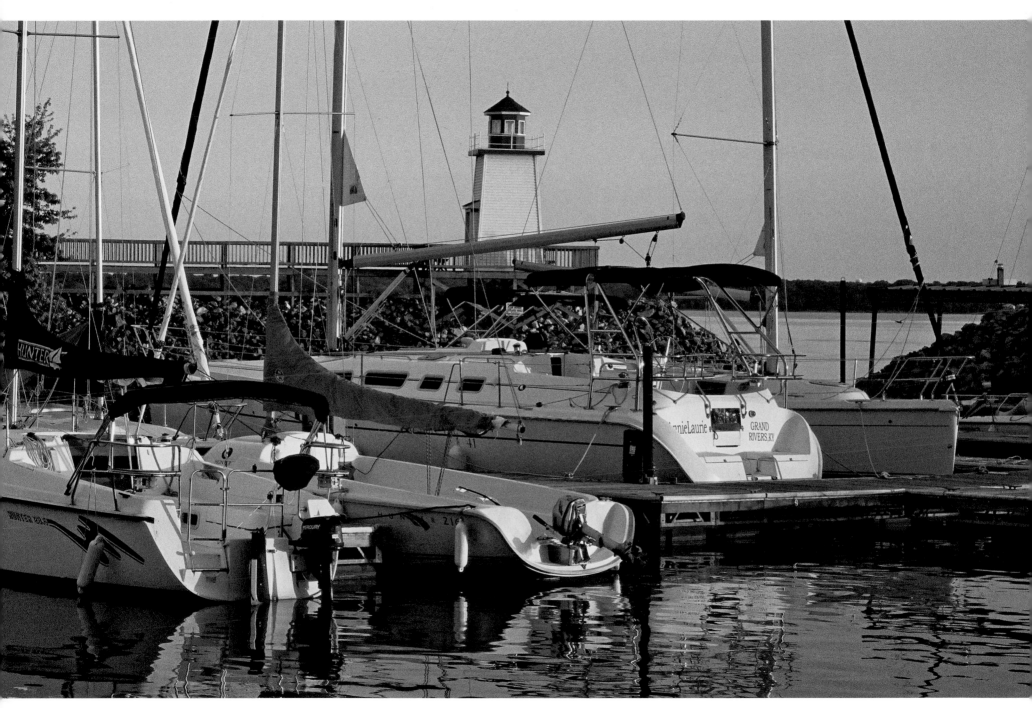

Sunset at Grand Rivers • Livingston County

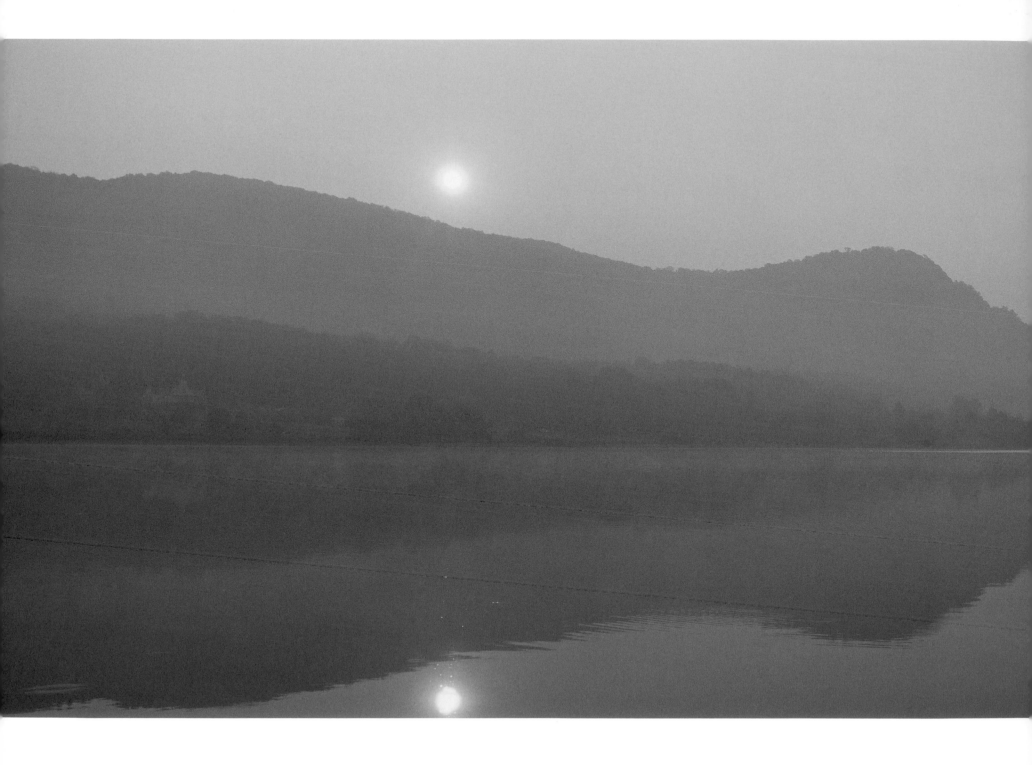

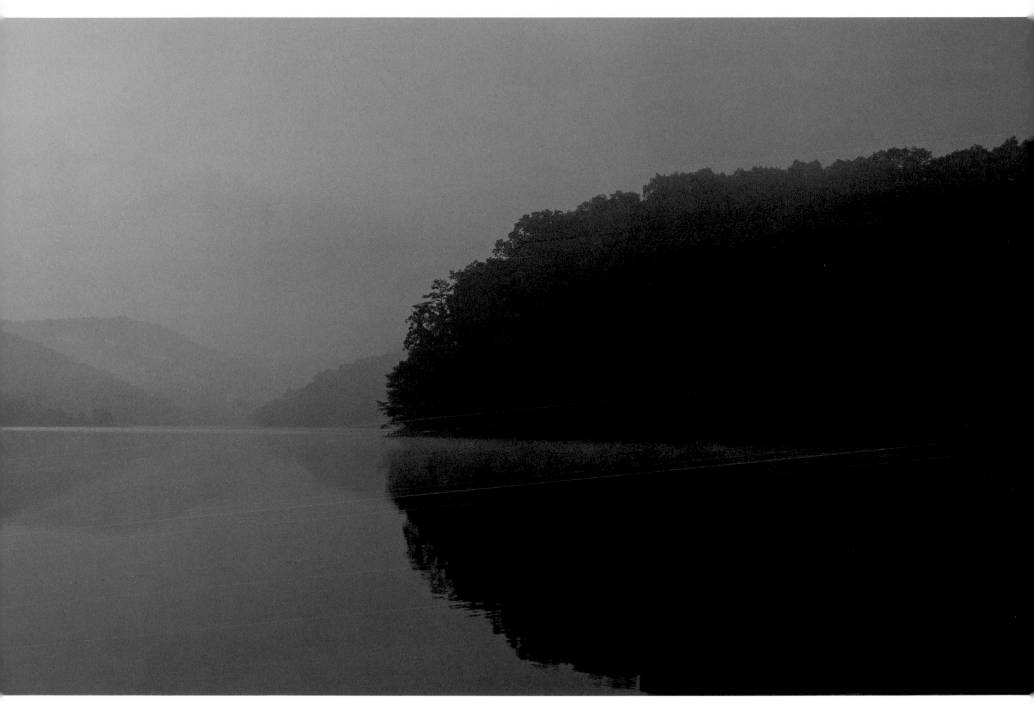

Sunrise at Owsley Fork Reservoir • Madison County

TECHNICAL NOTES

As an artist it is imperative to stretch and grow; over the years, I have worked with a variety of camera formats and systems. Trying to "see" and experience life through the viewfinder of a panoramic camera is rewarding and equally challenging. The photographs in this book are not simply cropped images, but were created with the unique advantages and challenges of a dedicated panoramic camera.

Three panoramic cameras were used to capture images in the first edition of Kentucky Wide, published in October 2006. I used one panoramic rangefinder camera, the Hasselblad XPan, to shoot all the images in this book. It is a film camera that exposes approximately 1¾ frames of 35mm film for the panoramic format. Many photographers enjoy rangefinder cameras, such as the Leicas, but I am not a big fan. While it is lightweight and great in low light, I find it difficult to focus and the etched lines in the viewfinder only give an approximate framing of the actual exposed film. However, the 45mm and 90mm lenses are amazingly sharp.

I have been a pioneer in the digital photography world, which is now an industry standard and how I shoot most commercial jobs; however, all of the images in this book were shot with 35mm Fuji transparency film. The inherent nature of transparency film renders color more vividly with moderate contrast and finer grain. Jeff Whatley at National Geographic Imaging made a Heidelberg drums scan (300mb each) of each image and Richard Sisk made the meticulous color correction to match the original film as closely as possible.

Photography has never been easier and more affordable, which is a good thing. However, I believe the accessibility and affordability of equipment does little to insure the quality of work. Image processing software is a component of digital photography (for me as well), but I believe that all too often, the color is simply intensified to compensate for a less than average image. The viewer then responds emotionally to the vibrancy of color without evaluating the design, composition or tonality of the image. Please pardon my rant; many who know me may recall that my first love was black and white photography!

It would have been easier and certainly less expensive to digitally stitch these images together in Photoshop, but I chose to create them with a dedicated film camera because of the purity of the process (with the exception of two images). It is my hope that these images bring happiness and peace to your heart, as well as an appreciation for the Creator who made this for our enjoyment and stewardship.

Holy, holy, holy is the Lord God Almighty; the whole earth is full of his glory.
–Isaiah 6:3

Jeff Rogers
May 29, 2009